On the Laws of the Poetic Art

THE A. W. MELLON LECTURES

IN THE FINE ARTS · 1992

THE NATIONAL GALLERY OF ART

WASHINGTON, D.C.

BOLLINGEN SERIES XXXV: 41

PRINCETON UNIVERSITY PRESS

Anthony Hecht

On the Laws of the Poetic Art

Copyright © 1995 by the Trustees of the National Gallery of Art, Washington, D.C.
Published by Princeton University Press, 41 William Street, Princeton, New Jersey 08540
In the United Kingdom: Princeton University Press, Chichester, West Sussex

This is the forty-first volume of the A. W. Mellon Lectures in the Fine Arts, which are
delivered annually at the National Gallery of Art, Washington. The volumes of lectures
constitute Number XXXV in Bollingen Series, sponsored by Bollingen Foundation.

Chapter 3 originally appeared in abridged form in *The Yale Review*, April 1993.

Library of Congress Cataloging-in-Publication Data

Hecht, Anthony
On the laws of the poetic art / Anthony Hecht.
p. cm. — (Bollingen series ; XXXV, 41. The A.W. Mellon lectures in the fine arts ; 1992)
Six lectures delivered 1992 at the National Gallery of Art, Washington, D.C.; the text of the
first lecture, which was abridged for presentation, has been restored to its original length.
"The National Gallery of Art, Washington, D.C."
Includes index.
Contents: Poetry and painting — Poetry and music — Paradise and wilderness — Public and
private art — The contrariety of impulses — Art and morality.
ISBN 0-691—04363-9
1. Ut pictura poesis (Aesthetics) 2. Arts. I. National Gallery of Art
(U.S.) II. Title. III. Series: Bollingen series ; 35, 41. IV. Series: A.W. Mellon lectures
in the fine arts ; 1992.
NX175.H4 1995
700'.1—dc20 94-32716

Princeton University Press books are printed on acid-free paper, and meet the guidelines for
permanence and durability of the Committee on Production Guidelines for
Book Longevity of the Council on Library Resources

Printed in the United States of America

10 9 8 7 6 5 4 3 2 1
10 9 8 7 6 5 4 3 2 1
(Pbk.)

DESIGNED BY LAURY A. EGAN

ACKNOWLEDGMENTS

Thanks are due to the following publishers and individuals for granting permission to quote poetry from their books: Farrar, Straus & Giroux, Inc., from *The Complete Poems 1927–1979* by Elizabeth Bishop, copyright © 1979, 1983 by Alice Helen Methfessel. Houghton Mifflin Company, "Her Kind," from *To Bedlam and Part Way Back* by Anne Sexton, copyright © 1960 by Anne Sexton, © renewed 1988 by Linda G. Sexton. Simon & Schuster, lines from "In Distrust of Merits" from *Collected Poems of Marianne Moore*, copyright © 1944, © renewed 1972 by Marianne Moore. Alfred Knopf, Inc., from *Unfinished Painting: Poems* by Mary Jo Salter, copyright © 1989, and from *The Collected Poems of Wallace Stevens*, copyright © 1974; in the British Commonwealth, Faber & Faber Limited, from *Collected Poems of Wallace Stevens*. Jonathan Cape, from *The Poetry of Robert Frost*, edited by Edward Connery Lathem; in the United States, Henry Holt and Company. Jessie C. Cunningham, from *Collected Poems & Epigrams of J. V. Cunningham*, copyright © 1977. New Directions Publishing Corporation, from *Selected Poems* by William Carlos Williams, copyright © 1963. Random House, from *Collected Poems* by W. H. Auden, copyright © 1991. *Portable Lower East Side*, from "Wild Thing."

To William and Emily Maxwell,
Jon and Jill Stallworthy,
And in memory of
William Arrowsmith and O. B. Hardison

Now, it's too late for me to begin shovelling and sifting at alphabeds and grammar-books. I'm getting to be a old bird, and I want to take it easy. But I want some reading—some fine bold reading, some splendid book in a gorging Lord-Mayor's-Show of wollumes" (probably meaning gorgeous, but misled by association of ideas); "as'll reach right down your pint of view, and take time to go by you. How can I get that reading, Wegg? By," tapping him on the breast with the head of his thick stick, "paying a man truly qualified to do it, so much an hour (say twopence) to come and do it."

"Hem! Flattered, sir, I am sure," said Wegg, beginning to regard himself in quite a new light. "Hem! This is the offer you mentioned, sir?"

"Yes. Do you like it?" . . .

"Half-a-crown," said Wegg, meditating. "Yes. (It ain't much, sir.) Half-a-crown."

"Per week, you know."

"Per week. Yes. As to the amount of strain upon the intellect now. Was you thinking at all of poetry?" Mr. Wegg inquired, musing.

"Would it come dearer?" Mr. Boffin asked.

"It would come dearer," Mr. Wegg returned. "For when a person comes to grind off poetry night after night, it is but right he should expect to be paid for its weakening effect on his mind."

<div align="center">

CHARLES DICKENS
Our Mutual Friend

I hate all Boets and Bainters.
GEORGE I

</div>

CONTENTS

PREFACE

When, with ample advance notice, I was asked by Henry A. Millon of the National Gallery of Art whether I would be willing to give the Andrew W. Mellon Lectures in the Fine Arts for 1992, I was seriously and suitably daunted, thinking not only of the task itself, but of the impossibility of emulating the distinction and achievements of earlier lecturers in the series, and I confessed to myself truthfully, if in borrowed words, that it was an honor that I dreamed not of. I asked for, and was given, quite some time to come to a decision, and that time was crowded with spasms of pride at the invitation, and genuine qualms about any attempt on my part to follow in the path of such predecessors as Jacques Maritain, Etienne Gilson, Kenneth Clark, E. H. Gombrich, John Pope-Hennessy, and Isaiah Berlin. The torment of the inner debate that ensued was perhaps slightly muted by the fact that while it was going on I was busily engaged in completing a long book on W. H. Auden, as well as teaching; and these activities, with demands and deadlines of their own, served to divert and thereby to soothe and quiet my anxieties. Perhaps too much. Perhaps it may be set down to too easy a sedation of my fears that I made the choice a nicer wisdom would have declined. That is no doubt for the reader and the critic to declare, and I must now steel myself for their judgments. But I may say that I was swayed not alone by the glamour of the invitation, the stature of those eminent predecessors, and the chance to add my own name to so illustrious a roster as was already inscribed in the Mellon series, but also by the encouragement and opportunity to set down in comparatively informal style some of the notions, beliefs, or instincts that have governed my reading and writing of poetry over something like half a century, and to present them in the grandeur of a setting—the auditorium of the East Wing of the National Gallery—that cannot have many rivals.

The temptation was too great, and I succumbed. And now I must belatedly ask forbearance of my readers. While some of the most distinguished Mellon lecturers labored to transform their lectures into long and scholarly books that are now celebrated studies and intellectual landmarks—I am thinking of *The Nude* by Kenneth Clark and E. H. Gombrich's *Art and Illusion*, to name only two—I have unrepentantly (and perhaps timorously) left my text much as it was delivered. For this reason a reader will find that I have paid scarcely any attention to the question of prosody, which might be thought properly to belong to any discussion of poetry and

music such as I try to offer in my second lecture. While these are considerations of the first importance, they do not galvanize the interest or sympathy of a lecture audience, and I have scanted them accordingly. I have, however, tampered with the first lecture. When I began to write, I was so carried away that my first lecture ran well beyond the decent boundaries of an hour's discourse, and the usual proprieties demanded that I cut it to a length that would not presume upon the indulgence of a listening audience. I have taken the liberty here of restoring it to its original length, and a careful reader will see how heedlessly I overshot my mark.

But in maintaining the lecture format I have tried to avail myself of those liberties of informality and rhetorical strategy that belong to a spoken presentation of a certain length. The density, the specific gravity, of such scholarly books as have appeared in the series demand a reader's leisurely perusal, as well as time for considerations and reconsiderations. I have so conceived my materials as to make them comparatively easily assimilable during a stretch of time not uncomfortably long, and with the pleasant diversion of some entertaining, as well as occasionally beautiful, pictures.

The illustrations were themselves a part of my temptation. During the many years of my teaching career I have worked without the support (or distraction) of visual aids, conscientiously concerned to keep the puzzles, excitements, and beauties of the written text constantly before the eyes and minds of my students. I had long entertained a kind of professional envy of art historians, who could easily dazzle an audience with instantly apprehensible visual luxuries. But beautiful pictures, I knew instinctively, are tricky and ensnaring. In his posthumous volume, *Argufying*, William Empson writes, "On one occasion when the Buddha was preaching, the magic of his words became too much for him and he rose forty feet into the air, but he shouted down to the audience begging them to pay no attention; it would all be over in a moment, and wasn't of the smallest interest compared to what he was saying."[1] And slides, though perhaps not quite comparable to such an act of levitation, can be diverting enough that an audience could be lulled and enticed from its better judgment.

I am sufficiently aware of this to be able innocently (I think) to avoid self-congratulation when I say that the audience at my lectures was uncommonly generous in its response, attentive and hospitable to all my presentations. And I think it worth noting here that in addition to the seductive pleasures of projected images on a large screen, copies of the poems and passages of dramatic verse discussed were distributed to the audience, so that a reasoned examination and a serious critical scrutiny of particular texts was not languidly avoided.

A word is perhaps in order about my title. I hope it will be understood that I am not presuming to lay down the law. Indeed, I almost equally fear that I shall be accused of mincing matters to such a degree that no laws whatever are even discernible. What I intend, with a polite bow to Cicero's *De senectute* or Montaigne's *On the Education of Boys*, is the informal, speculative discourse that addresses a topic with no pretensions to exhaustiveness. I have earnestly tried to avoid the polemical and the doctrinaire, though many of the matters I touch upon have been hotly contested by writers and critics through the ages. Moreover, what follows in these pages was composed and delivered at a time when the arts community and the National Endowment for the Arts were under attack on what amounted to "legal" grounds by members of Congress, religious leaders, and ultraconservative politicians in and out of office. So readers should not be surprised to find that the "moralists" so deftly pilloried by Joseph Conrad in the first of these lectures reappear in louder, cruder, and more brazen shapes in the last one.

Candor demands that I acknowledge that the avoidance of polemical and doctrinaire positions is not always so easy as it might seem, and many unconscious agendas may well have insinuated themselves into my discourse. There is no *quod erat demonstrandum* in the discussion of such matters. I make these comments by way of reminding myself that whatever views I have advanced in these pages are surely the provisional views of an individual with certain tastes, a certain background and education, and they are not to be taken by me or anyone else as incised, marmoreal verities. Be that as it may, I am fully aware that I think of poetry as properly governed by laws, which are often the better for being implicit rather than explicit; and which signify something more than supine obedience to tyrannies of style or the dictates of others. I ventured once to write about them in a poem, a fragment of which I take the liberty of reproducing here. The poem is called "Peripeteia," and it takes place in a theater, starting just before the lights are dimmed and the curtain is raised.

> And then the cool, drawn-out anticipation,
> Not of the play itself, but the false dusk
> And equally false night when the houselights
> Obey some planetary rheostat
> And bring a stillness on. It is that stillness
> I wait for.
> Before it comes,
> Whether we like it or not, we are a crowd,

Foul-breathed, gum-chewing, fat with arrogance,
Passion, opinion, and appetite for blood.
But in that instant, which the mind protracts,
From dim to dark before the curtain rises,
Each of us is miraculously alone
In calm, invulnerable isolation,
Neither a neighbor nor a fellow but,
As at the beginning and end, a single soul,
With all the sweet and sour of loneliness.
I, as a connoisseur of loneliness,
Savor it richly, and set it down
In an endless umber landscape, a stubble field
Under a lilac, electric, storm-flushed sky,
Where, in companionship with worthless stones,
Mica-flecked, or at best some rusty quartz,
I stood in childhood, waiting for things to mend.
A useful discipline, perhaps. One that might lead
To solitary, self-denying work
That issues in something harmless, like a poem,
Governed by laws that stand for other laws,
Both of which aim, through kindred disciplines,
At the soul's knowledge and habiliment.
In any case, in a self-granted freedom,
The mind, lone regent of itself, prolongs
The dark and silence; mirrors itself, delights
In consciousness of consciousness, alone,
Sufficient, nimble, touched with a small grace.[2]

It would be less than honest of me to ignore the fact that most *ars poeticas* and doctrinaire statements by poets about poetry are likely to be, whether consciously or not, defenses of their own habitual practices as poets. Eliot's criticism, especially "Tradition and the Individual Talent," is now increasingly seen as an apologia for his poetry and his personal sensibility; and this is the more ironic since that particular essay proposes the importance of the "impersonality" of the poet. There is nothing wrong with promoting such views except when, as sometimes happens, a poet seems to adopt a peremptory tone, as though uttering inviolable truths about the art that neither time, taste, nor poetic invention should be allowed to vary. Robert Frost, for example, composed a "definition" of poetry, of the way a poem comes, or ought to come, into being. It is, in

effect, a philosophy of composition. He called it "The Figure a Poem Makes," and was sufficiently pleased with it to affix it as a preface to every edition of his collected poems from 1939 onward. So the brief passage from it that I want to quote here is likely to be reasonably familiar. Of a poem's origins and life, Frost writes,

> It begins in delight, it inclines to the impulse, it assumes direction with the first line laid down, it runs a course of lucky events, and ends in a clarification of life—not necessarily a great clarification, such as sects and cults are founded on, but in a momentary stay against confusion. It has denouement. It has an outcome that though unforeseen was predestined from the first image of the original mood —and indeed from the very mood. It is but a trick poem and no poem at all if the best of it was thought of first and saved for the last. It finds its own name as it goes and discovers the best waiting for it in some final phrase at once wise and sad—the happy-sad blend of the drinking song.
>
> No tears in the writer, no tears in the reader. No surprise for the writer, no surprise for the reader.[3]

What needs special notice here is Frost's insistence that the conception and the writing of a poem be so spontaneous and unpremeditated that it resemble the song of Shelley's skylark. As I have observed before about this account, it is jaunty, freewheeling, and very attractive for its air of youthful, picaresque confidence. We like that; it sounds right. Pioneering, risky, independent. It has the fine, carefree, and unbounded spirit of improvised narrative, a journey almost allegorical because destiny will make sure it comes out all right in the end. We like it because it sounds like a life story in which the will of heaven perfectly accords with the breezy, uncalculating innocence of the hero. This is what inspiration ought to be. The question it raises, however, is: How much of this is voluntary self-deception? The matter of whether a poet can foresee the end of the poem may well have to do with the clarity of the poet's mind, the nature of the poet's unconscious; and a poet who is sufficiently slow-witted might revel in an almost constant state of astonishment at the surprises the poem unfolds in the course of composition. To take but one statement that plausibly confutes Frost's position, let me quote C. S. Lewis in *English Literature in the Sixteenth Century*: "In a poem by Skelton anything may happen, and Skelton has no more notion than you what it will be. That is his charm; the charm of the amateur. But Dunbar is professional through and through; the accomplished master of one tradition that goes back to *Be-*

owulf and of another that goes back to the Troubadours. All his effects are calculated and nearly all are successful; the last line of each poem was in view before he wrote the first."[4]

I do not cite Lewis (who, after all, is no poet) by way of establishing that Robert Frost is an amateur. Some of his contemporary rivals thought him, if anything, too professional. But I mean to suggest at least two things. What Frost said was conveniently self-serving and self-defining. He would have had to acknowledge, if pressed, that not all poets found his ways of writing best, or even useful. He would have had to admit that it was impossible to write a villanelle without knowing, after writing the first three lines, how it was going to end. The same formal constraints govern a ballade. To be sure, Frost never wrote villanelles or ballades, but it would have been rash of him to declare that it was wicked or wrong ever to have written any, or maintain that they are unpleasant or inferior kinds of poetry. In addition, it could be argued with some persuasiveness that Dante had a pretty clear idea of the whole form and design of the *Commedia* long before he got to the end.

I have one further cavil with Frost's comment; it concerns his quite dogmatic assertion "No tears in the writer, no tears in the reader." My quibble with this is twofold. First, I have known some singularly bad poets who are invariably moved to tears by the recitation of their own poems, to the exquisite embarrassment of everyone else. One man in particular became positively rheumy-eyed when he read to me in private some wretched verses of his own. The corollary, Dr. Johnson's declaration that in Milton's *Lycidas* no real grief is expressed ("passion runs not after remote allusions and obscure opinions. Passion plucks no berries from the myrtle and ivy, nor calls upon Arethuse and Mincius, nor tells of rough *satyrs* and *fauns with cloven heel*. Where there is leisure for fiction, there is little grief")[5] has not in the least diminished the beauty, the grandeur, or the deep funereal music of that poem, which remains one of the great achievements of English verse in any period. And Frost's view is further challenged by some lines in W. H. Auden's *Letter to Lord Byron*.

> Professor Housman was I think the first
> To say in print how very stimulating
> The little ills by which mankind is cursed,
> The colds, the aches, the pains are to creating;
> Indeed one hardly goes too far in stating
> That many a flawless lyric may be due
> Not to a lover's broken heart, but 'flu.[6]

It seems fitting that Auden's name should be raised at this point. I mentioned above that I had been at work on a book about him when I was first invited to give these lectures, and I began work on the lectures themselves immediately after finishing that book. In addressing my new task, I felt I ought to take decent pains not to permit the lectures to become an appendix to the earlier book, and, teeming as my mind was with all matters pertaining to Auden, I ought to suppress them as well as I could, and in any case avoid continuing arguments left over from that finished work, nor, like a ruminant, digest them for a second time. I tried to exorcise the ghost of Auden, and forbid him to drift into this new undertaking of mine. The reader will discover that I was not wholly successful in this, and Auden's presence still lurks about various concerns in these pages, and can be discovered especially in the notes.

The notes. I must explain with a sense of chagrin that they were composed as much as a year or more after the lectures themselves were written and delivered. The interval was occupied by pressing matters: the composition of an introduction to the sonnets for the New Cambridge Shakespeare Series, for which there was a Damoclean deadline, and the beginning of a new book of poems undertaken in collaboration with the artist Leonard Baskin. The consequence of this delay was that when at last I set about annotation, it was often nerve-rackingly difficult for me to locate some of my original sources, and so my text from time to time presents apothegms and stray bits of wisdom the origins of which I can no longer recall or trace. For this I must beg the reader's patience and indulgence.

My general sense of indebtedness to poets, critics, and teachers will I hope be clear enough, and is not the less gratefully felt when, on occasion, I venture to differ from one or another of them. None of these ideas was parentless, like Aphrodite, though I should not wish to appear to charge my betters with errors or misconceptions that are entirely my own. In any case, one's intellectual debts, by the time one approaches my age, are difficult when not impossible to trace, and would probably be of minor interest to a reader.

But it is my particular pleasure to acknowledge very specific debts about which there is no uncertainty, and to express here my delighted and uncomplicated gratitude to the benefactors from whom they were incurred. First of all, to J. Carter Brown, then Director of the National Gallery of Art, and to Henry A. Millon, Dean of the Center for Advanced Study of the Visual Arts, I owe the honor of my appointment, and I hope they will feel that what follows justifies their confidence in me. To Steve Mansbach

and Randi Nordeen, both of Mr. Millon's staff, I am obliged for all manner of assistance during my tenure as lecturer, from help with parking and the making of slide transparencies to guidance though the catacombs of the museum buildings and advice about illustrations. Others who are friends, former students, and colleagues, and who helped and advised me in countless different ways, deserve my deepest thanks: Denis Donoghue, Harry Ford, Frank Glazer, Mark Leithauser, John Pfordresher, Jeffrey Popovish, Raymond Reno, and Jason Rosenblatt. I must thank the Trustees of the National Gallery for allowing me to take part in this illustrious series, and Elizabeth Powers, my editor at Princeton University Press, for her abiding patience and unfailing courtesy. Her thoughtful assistant, Elizabeth Johnson, was also particularly helpful. I am furthermore indebted to my copyeditor, Jane Lincoln Taylor, a former student of mine, who saved me from many a humiliating error. To Joan Reuss I owe thanks for the typing of this book through various drafts, and for her undeviating good humor with a bothersome task. Finally, I owe more than I can easily say to the devotion, patience, and continued interest of my beloved wife and our son. I have learned from both in innumerable ways, and have never failed to receive from them a loving and invaluable support.

On the Laws of the Poetic Art

I

Poetry and Painting

Still—in a way—nobody sees a flower—really—it is so small—we haven't time—and to see takes time, like to have a friend takes time.

<div align="center">Georgia O'Keefe</div>

Painting is poetry which is seen and not heard, and poetry is a painting which is heard but not seen.

<div align="center">Leonardo da Vinci

"Paragone," or, First Part of the Book of Painting</div>

WITH A MIXTURE of levity and wry self-mockery that it is impossible to separate, George Santayana once characterized himself with the words, "I am an ignorant man, almost a poet." And what are poor poets to do, following lamely behind him into the thickets and minefields of aesthetic discourse, knowing themselves to be far more ignorant than Santayana? which is not only mortifying, but suggests that they would do well to keep their mouths shut. They might, of course, appeal to ignorance as a positive virtue, and, in the manner of the pastoral poets, affirm that the "silly thoughts" Milton ascribes to the shepherds at the Nativity were precisely an index of their unique wisdom, affording them the first sight of the child, and the first audition of the choiring angels singing of peace on earth. And if they were pedantically inclined, they might go on to derive Milton's word "silly" from the German *selig*, which means "blessed" or "holy." For my part, I hope to negotiate a cunning passage between the deficits and virtues of ignorance, and like a shrewd Odysseus, with the help of the gods, to find my way among the perils that abound. Even the most cursory survey of the philosophic literature has shown me that I cannot hope to provide definitive answers, so you will find me relying with all my trust upon what I know as a practicing poet, and what more than forty years of teaching poetry has granted me.

Though my specific purview must, for the most part, be confined to poetry, I will be obliged, for reasons I expect to make clear in a moment, to consider some of the other arts as well, and you shall find me addressing, with what I hope will be a suitable diffidence, some of the problems that attend upon the arts of music, painting, and even architecture.

The very fact that these are joined together under the heading of "arts" declares that they have something in common; the branch of philosophy called "aesthetics" is concerned to spell out as rigorously and definitively as possible what common properties these may be. I shall begin my audacious journey by proposing a few ideas, some of them borrowed, some my own, on this topic.

The familiarity as well as the antiquity of these common properties may be attested to by Plutarch's observation that "Simonides addressed painting as silent poetry, and poetry as speaking painting."[1] Ben Jonson, in his prose discourse on the arts in general and poetry in particular, says

> *Poetry* and *Picture* are Arts of like nature; and both are busy about imitation. . . . For they both invent, faine, and devise many things, and accommodate all they invent to the use, and service of nature. Yet of the two, the Pen is more noble, then the Pencill. For the one

can speak to the Understanding; the other, but to the Sense. They both behold pleasure and profit as their common object; but should abstain from all base pleasures, lest they should err from their end: and while they seek to better men's minds, destroy their manners.[2]

(One may parenthetically smile at Jonson's partiality in behalf of poetry, but it is worth remembering that the "sense" is not so far divorced from the "understanding" but that in English, German, Italian, and French the word for "see" is a synonym for "understand," as we know when someone says, "I see what you mean.")

Furthermore, regarding the association of the arts, when Bernard Berenson tries to describe what is most admirable about the choicest Venetian painters, he finds himself obliged to resort to the language of the other arts: "the better Venetian paintings present such a harmony of intention and execution as distinguishes the highest achievements of genuine poets. Their mastery over color is the first thing that attracts most people to the painters of Venice. Their coloring not only gives direct pleasure to the eye but acts like music upon the moods, stimulating thought and memory in much the same way as a work by a great composer."[3]

Let me commence my own observations by affirming what may be called the paradoxical nature of the arts, or what Schopenhauer refers to as their inherent "discord." The arts almost invariably express or embody conflicting impulses, not simply in their meanings but in their very natures. They are engaged in the business of going beyond the limits of their means. In so doing they not infrequently resort to poaching on one another's territories, and appropriating techniques and devices that it might be said were not native to them. I will start with illustrations from the art of painting, because I intend to suggest further on the curious ways in which painting and literature, with special reference to poetry, are related. My second lecture will attempt something of the same sort with regard to music.

Kenneth Clark, the art historian, tells us that "Constable said that the best lesson on art he ever had was contained in the words, 'Remember light and shadow never stand still.'"[4] Painting, by its very nature, is only able to present its subject in a state of absolute rest. So Constable's valuable lesson points to the difficulty that he was concerned to overcome or, to put it another way, the deficiency of his métier, which it was his business to remedy. Joshua Reynolds famously declared: "A painter must compensate for the natural deficiencies of his art." Yet this is only the beginning of the problems painters must address. They must also, if they

are representational painters, give us the impression of three dimensions while presenting them on a flat plane. This presentation in depth is conferred not only by the technique of perspective, but by what may be called atmospheric depth as well, by chiaroscuro. They may be concerned to persuade us that they are presenting the transient, the evanescent, fleeting impressions that almost evade us, as well as, for example, the veiled luminosity of pearls, the more intricate light that lines the curved walls of a globule of water at rest on a blade of grass, the still more intricate vectors of reflected light, rebounding among solid objects, the weight of brocaded dresses, the dull glint of armor, the delicate agitation of treetops in a mild breeze, the activity of clouds, the dull translucence of thick ice, the very feel of leather, of bark, of silk, or of fruit.

We are shown as well things suddenly or characteristically in motion: wind-ruffled water surfaces or the storms in the paintings of Turner. What should strike us about these effects is that they convey convincingly precisely the fleetness of a passing moment in defiance not only of their natural character, but as a kind of triumph the more to be admired when we pause to realize that nature did not stand still for the artist, and that what we see as a captured instant must have taken that artist hours, and perhaps days, to render. The American artist Raphaelle Peale held an exhibition, in 1785, of "moving pictures" inspired by the Eidophusikon that Philip James de Loutherbourg had presented in London earlier in the 1780s. The intention was, by using colored lights and even sounds, "with *changeable* effects, imitating nature in various *movements*," as Nicolai Cikovsky, Jr., reports, to present "such transient conditions and effects as dawn and nightfall, a rain storm with thunder and lightening and rainbow, fire, and rushing and falling water."[5]

This triumph over obstacles is something we admire in other aspects of the artist's work. There are, for example, such works as frescoed ceilings and mosaics that can only properly be seen intelligibly at a great distance, and we must wonder how the artist managed who made them and had, in the nature of things, to be very close to them in their making. This sense of difficulties overcome is at least a part of our pleasure in the artist's performance, and is to be experienced not only in the rendering of nature in motion but in the presentation of human beings. They are sometimes depicted in the midst of motion, sometimes the strenuous action of battle. But consider merely those presentations of them at what may be their most tranquil and serene. They may be presented to us, as Aristotle says in his *Poetics*, as either better than they are, or as indeed they are, or as worse than they are. Aristotle assigns the last category to the characters of Com-

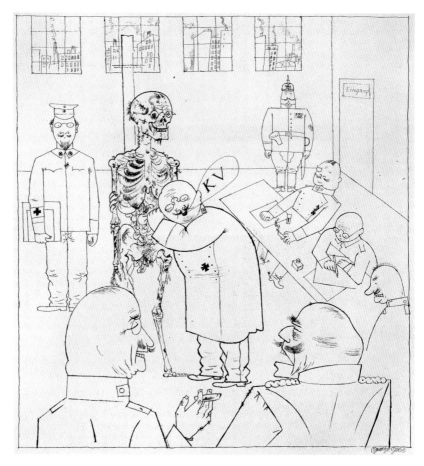

1. George Grosz, *Fit for Active Service*

edy, and we may locate them in, for example, the satiric pictures of George Grosz, whose initial targets of military corruption and war profiteering enlarge to take in the whole German middle class (fig. 1). And we may recognize them as well in many paintings of various kinds of sinners by Hieronymus Bosch—as, for example, in the tormentors of Christ in the painting *The Crowning with Thorns* (fig. 2).

Those, on the other hand, who are made to look "better" than they are may be made so by the kind of flattery we assume is employed when the sitter is of royal blood, or is in a position of great power or wealth. Consider, for example, John Singer Sargent's painting *The Wyndham Sisters*

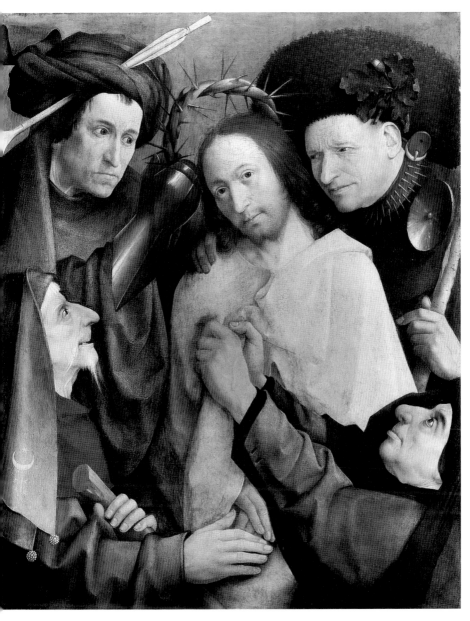

2. Hieronymus Bosch, *The Crowning with Thorns*

(fig. 3) in the Metropolitan, as well as *The Acheson Sisters* (fig. 4) at Chatsworth. These ladies are represented as lovely, but denied any individuality or character; they are shown to us as essentially ornamental and aristocratic, not unlike the white flowers in the painting of the Wyndhams, to which those ladies are obviously meant to be compared. The paintings are something in the nature of elaborate compliments by a gallant and talented, though suitably remote, impersonal, and gentlemanly admirer.

Most of the presidential portraits in the White House are craven in their servility, the notable exceptions being the earliest, by the greatest artists of the greatest presidents, including Gilbert Stuart's portrait of Washington. But portraits are astonishing in the variety of their meanings and uses, apart from politics and propaganda. An artist like Holbein, who often embellished his portraits with the explicit age of the sitter, presented the viewer with a kind of documentary and precise fixative in which we glimpse someone preserved at an instant in the midst of the flux of time (fig. 5). We immediately are prompted to ask ourselves: what will the subject's future wife think of him in this moment of his youth? What will his children think, or his grandchildren? As time goes on his descendants will become remote enough to view his portrait almost as impartially as any gallery visitor. But the very precision of that inscription of his age still invites our thoughts about what he might have looked like when younger, or what he would become when greatly advanced in years. That little notation, "in his twenty-eighth year," resembles the inscriptions we may find in family photograph albums, where, in some unfamiliar hand, a picture is labeled "Far Rockaway, Summer, 1932." A whole departed era, along with a penumbra of personal history, is evoked in this way.

And the portraitist may also make subjects into something like iconic figures who are no longer simply persons, but take on an almost allegorical grandeur of symbolic weight. This is what happens, I think, to Whistler's mother in the painting he called *Arrangement in Grey and Black*, a title that, in its belligerent aestheticism, virtually ignores the human presence it might be expected to describe (fig. 6). But the person depicted is little short of the personification of patience, resignation, and endurance, just as the memorial statue to the deceased wife of Henry Adams in Rock Creek Cemetery by Augustus Saint-Gaudens has ceased to be the embodiment of its subject, and has taken on the personification of Grief, or Ultimate Serenity (fig. 7). In fact, the Saint-Gaudens statue may achieve its effect in what amounts to the opposite way from Whistler's portrait. Whistler painted a particular woman whom he made allegorical or

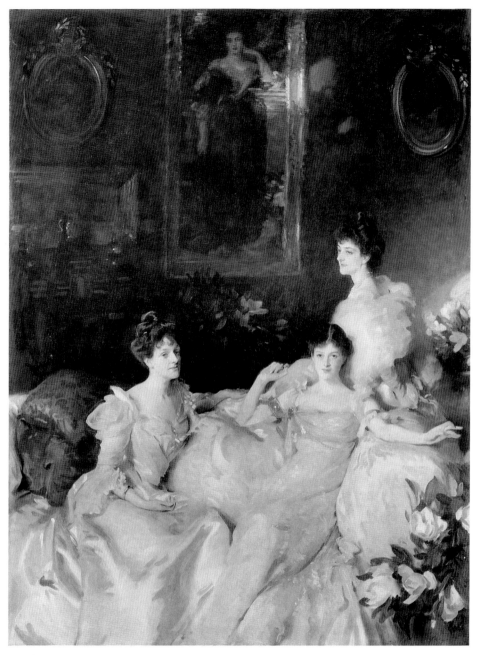

3. John Singer Sargent, *The Wyndham Sisters*

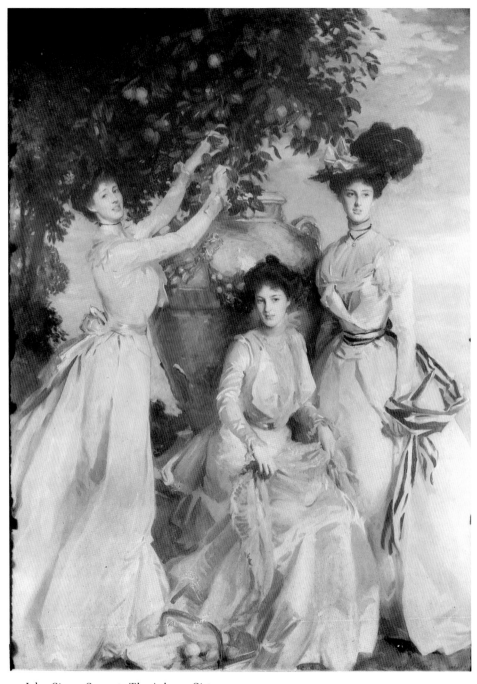

4. John Singer Sargent, *The Acheson Sisters*

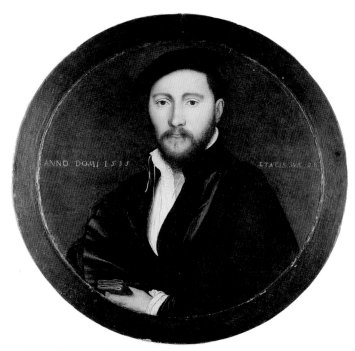

5. Hans Holbein, *Portrait of a Man*

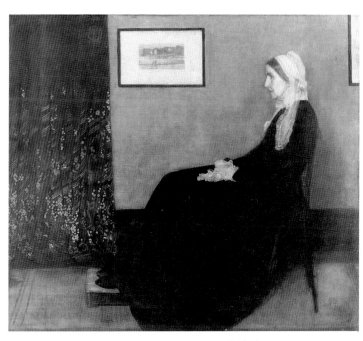

6. James Whistler, *Arrangement in Grey and Black*

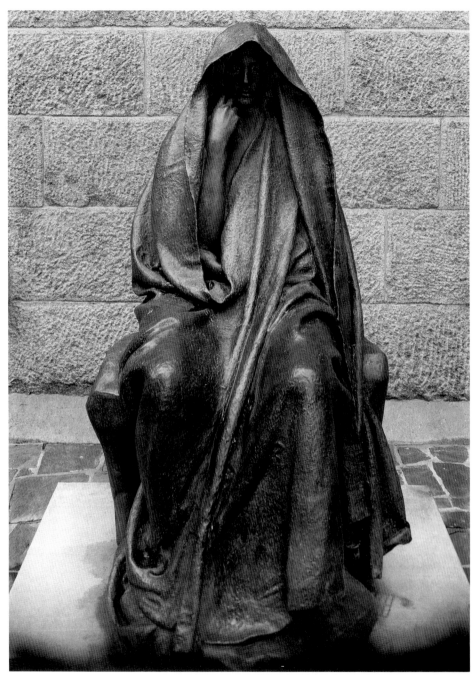

7. Augustus Saint-Gaudens, Adams Memorial

symbolic; Saint-Gaudens may not have worked either from a photograph or from a recollection of his subject, and the figure in his sculpture may initially seem no more than an allegorical figure. But she is presented with much of her face hooded by enveloping drapery. Clover Adams committed suicide by drinking the chemicals of a photography darkroom; the sculpted figure suggests an absolute and silent withdrawal from the world, and may therefore be more personal and representative than it at first appears. The painting depersonalizes a real person; the statue personalizes the impersonal.

As for Aristotle's third category of men depicted as they actually are, "warts-and-all" portraits such as Cromwell's, these may in the end be the most penetrating and illuminating on a human level, and they are most movingly to be seen in some of the portraits by Rembrandt, including his self-portraits. We are not, of course, to assume that painting is always inspired by what is conventionally called beauty. John Constable wrote, "The sound of water escaping from mill-dams . . . willows, old rotten planks, slimy posts, and brickwork, I love such things. . . . Those scenes made me a painter, and I am grateful."[6]

Still lifes, too, can carry overtones and meaning beyond the simple representation of the objects presented, and sometimes they are expressly symbolic, as, for example, astrolabes and compasses are symbolic of learning, musical instruments of the arts, and food of our quotidian need for nourishment. But simple kitchen appurtenances can be rendered with such devotional attention as to amount almost to what the poet W. H. Auden defines as prayer. Auden wrote, "Whenever a man so concentrates his attention—be it on a landscape or a poem or a geometrical problem or an idol or the True God—that he completely forgets his own ego and desires in listening to what the other [by which Auden means, in the case of painting, the subject] has to say to him, he is praying."[7] We recognize this "prayer" in what we loosely call the astonishing "fidelity" of certain kinds of painterly effect, though in truth it has nothing to do with fidelity, being as much a matter of illusion as, for example, Cubist painting. But a painter's success at presenting the sensation of the slime of fish, the softness of fur, the visual complexity of a bossed and knobbled glass goblet, half filled with wine, and lit with the convex diminished image of a distant mullioned window—these attest to a superior attention to the world we all inhabit, along with an ability to translate that world into a pigmented, precise record.

And all this, moreover, within the confines of a frame. The frame, indeed, may constitute one of the most challenging parts of the painter's

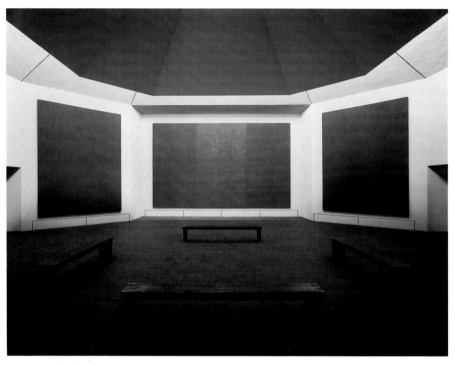

8. Mark Rothko, Northeast, north, and northwest paintings from the Rothko Chapel, Houston

achievement, since nothing in our visual experience is framed; and yet a good painting persuades us that everything relevant is contained within the borders of the painting itself, and whatever remains outside is either more of the same or is trivial by comparison. The framed limits of a painting may be thought roughly to correspond to what in drama Aristotle calls the "plot." "A well-constructed plot cannot either begin or end at any point one likes," Aristotle asserts, and it is because the genius knows just how to tailor the action of the drama that Aristotle singles out Sophocles for particular praise.

It remains for me to say at least a brief word about nonrepresentational art, since the kinds I have so far mentioned clearly have a relationship to literary and poetic domains. There are, of course, many varieties of nonrepresentational painting. These may sometimes suggest an undecipherable calligraphy, a puzzle that, like a mandala, can produce, upon prolonged inspection, something very much like a trance state. But I

shall, for my own purposes, address myself to the work of Mark Rothko. His characteristic paintings, canvases composed of square or rectangular areas of pure color, resting softly upon one another, as sky or cloud may be thought to rest upon the earth at some indistinct horizon, are all emphatically free from any real suggestion of representation, and seem almost to have been painted in obedience to the biblical proscription against the making of graven images. Indeed, his eloquent murals for the Rothko Chapel at Houston, made of fading and strengthening luminosities, seem, as Robert Hughes has astutely suggested, deeply religious (fig. 8). Hughes writes that "in their slow construction, their faith in the absolute communicative power of colour, and their exquisite sense of nuance, they should perhaps be seen as a prolongation into the late twentieth century of a line drawn between Mallarmé and Monet—the subtle, atomistic consciousness of Symbolism. . . . This, however, was not enough for Rothko," Hughes continues. "He was not only a Jew but a Russian Jew, obsessed with the moral possibility that his art could go beyond pleasure and carry the full burden of religious meaning—the patriarchal weight, in fact, of the Old Testament." Yet having come this near to a religious assessment of the paintings in the chapel, Hughes seems oddly to withdraw and reject his own suggestions as he remarks about these murals: "All the world has drained out of them, leaving only a void. Whether it is The Void, as glimpsed by mystics, or simply an impressively theatrical emptiness, is not easily determined, and one's guesses depend on one's expectation. In effect, the Rothko Chapel is the last silence of Romanticism . . . art, in a convulsion of pessimistic inwardness, is meant to replace the world."[8]

With a diffidence born of my respect for Mr. Hughes and his great learning, I wish to dissent from his final judgment. That, of course, is not easy to do because, as he himself acknowledges, the intent of these paintings "is not easily determined." Nevertheless, it seems to me that art replaces the world only in the most effete and trifling kinds of aestheticism, and such a doctrine, along with pessimistic inwardness, would in no way conform to any serious religious feeling. It seems to me instead that the paintings, designed specifically for this chapel, allude to the God who, in speaking to Moses, in Exodus 33:20, declares: "Thou canst not see my face: for there shall no man see me and live."

These preliminary observations have been meant to suggest how paintings may take on almost literary qualities, and I have not even bothered to mention those narrative paintings or historical tableaux with which you are likely to be especially familiar. It is virtually impossible to depict any part of the story of the synoptic Gospels without recalling in some degree

the specific literary texts on which such paintings are based. And you will doubtless have anticipated the drift of my discourse by recalling how vivid the "visual" element in poetry can often be. I want to proceed to exemplify that with a particular instance, but before I do so it seems to me worth remembering that often enough modern poets and critics have succumbed to a simplistic doctrine, pronounced, with all the truculence of a challenging manifesto, by William Carlos Williams: "No ideas but in things." A great deal not only of modern poetry but of modern literary criticism as well seems to endorse this view. T. S. Eliot's famous formulation about the "objective correlative" was but another way of saying that the poet's emotions, feelings, and thoughts must find a suitable embodiment in the concretions of the world. In his famous essay "The Metaphysical Poets," he wrote:

> Tennyson and Browning are poets, and they think; but they do not feel their thought as immediately as the odour of a rose. A thought to Donne was an experience; it modified his sensibility. When a poet's mind is perfectly equipped for its work, it is constantly amalgamating disparate experience; the ordinary man's experience is chaotic, irregular, fragmentary. The latter falls in love, or reads Spinoza, and these two experiences have nothing to do with each other, or with the noise of the typewriter or the smell of cooking; in the mind of the poet these experiences are always forming new wholes. . . . The sentimental age began early in the eighteenth century, and continued. The poets revolted against the ratiocinative, the descriptive; they thought and felt by fits, unbalanced; they reflected. In one or two passages of Shelley's *Triumph of Life*, in the second *Hyperion*, there are traces of a struggle toward unification of sensibility. But Keats and Shelley died, and Tennyson and Browning ruminated.[9]

Lest there be any confusion on the point, let me state immediately that I am perfectly aware that Eliot's formulation about the "objective correlative" does not come from his essay on the Metaphysicals, but appears instead in the celebrated dismissal of *Hamlet*. There he says, "The only way of expressing emotion in the form of art is by finding an 'objective correlative'; in other words, a set of objects, a situation, a chain of events which shall be the formula of that *particular* emotion; such that when the external facts, which must terminate in sensory experience, are given, the emotion is immediately evoked."[10] Emotions generated by sensory experience strongly resemble Donne's capacity to "feel his thought as imme-

diately as the odour of a rose." They also point to that quality of concretion that has often been prized both by poets and by their critics.

John Crowe Ransom, for example, who is not usually thought to share the views of Eliot, nevertheless wrote of the Imagists (whose very name constituted a radical position with regard to the goals of poetry):

> The Imagists were important figures in the history of our poetry, and they were both theorists and creators. It was their intention to present things in their thinginess, of *Dinge* in their *Dinglichkeit*; and to such an extent had the public lost its sense of *Dinglichkeit* that their redirection was wholesome. What the public was inclined to seek in poetry was ideas, whether large ones or small ones, grand ones or pretty ones, certainly ideas to live by and die by, but what the Imagists identified with the stuff of poetry was, simply, things.[11]

Later in this essay Ransom goes on to explain that "the way to obtain the true *Dinglichkeit* of a formal dinner or a landscape or a beloved person is to approach the object as such, and in humility; then it unfolds its nature which we are unprepared for if we have put our trust in the simple idea which attempted to represent it."[12] And what Ransom is saying here bears a strong resemblance to what Gerard Manley Hopkins, borrowing his terminology from the scholastic language of Duns Scotus, called *haecceitas*: the thinginess of a thing—its absolute unique singularity, distinct from what medieval philosophers called an "essence," which they used as a term applied to universals. Hopkins's own term for *haecceitas* was "inscape" (as Ransom's was "texture"), and Ransom would have inclined to subscribe to Hopkins's assertion that "all words mean either things or the relations of things."

It is little short of remarkable to find something so near to an apparent consensus among such diverse poets, whose actual practice in the art could not have more firmly distinguished them from one another. And there is, I think, a special shrewdness in Ransom's identification of the taste, the appetite, the poetic tendency they were all trying to oppose. It is one to which I shall return in my final lecture: it is the pietistic notion that it is the office of poetry to provide spiritual uplift, ideas to live and die by, elevating maxims, the cloudier the better, and the more disembodied the safer. It was an approved Victorian taste, and has its strong advocates in the world today.

But it is worth recalling now, in the midst of the various triumphs of concretion, and the almost universal endorsement of Dr. Williams's slogan

"No ideas but in things," that there is a fine body of excellent poetry, some of it of the very first class, that comes close to being devoid of any imagery. Not only does it lack the "things" that modern doctrine seems to find indispensable, but it also contrives to avoid the pitfalls of moral platitudes for which a popular appetite is always salivating. Let me suggest a few such poems from various poetic periods. First, two of Shakespeare's most impressive sonnets: "Farewell, thou art too dear for my possessing," and "Th' expense of spirit in a waste of shame." Robert Frost's "Provide, Provide." The fifth section of T. S. Eliot's "East Coker." Thomas Wyatt's "Forget Not Yet." These poems, and many others like them, are not devoid of metaphors, or even an occasional image, but such images are incidental to their chief effect, which is largely rhetorical. Let me offer a particularly happy instance of the kind of success this poetry can enjoy when well performed by a modern practitioner. The poet from whom I quote is J. V. Cunningham, and his poem is called "For My Contemporaries."

> How time reverses
> The proud in heart!
> I now make verses
> Who aimed at art.
>
> But I sleep well.
> Ambitious boys
> Whose big lines swell
> With spiritual noise,
>
> Despise me not,
> And be not queasy
> To praise somewhat:
> Verse is not easy.
>
> But rage who will.
> Time that procured me
> Good sense and skill
> Of madness cured me.[13]

This is poetry in what is called "the plain style": carefully wrought, unornamented, spare, and graceful. It bears a kinship to Latin epigrams and certain kinds of satiric verse that were popular in the eighteenth century. Of Cunningham the critic Yvor Winters wrote that he is "the most distinguished poet writing today and one of the finest in the language." If Winters was given to extravagance in this view, he was nevertheless defending

a kind of poetry that had been slighted by the modern prejudice in favor of those concretions that tended to turn poets in the direction of painting.

But so strong has the painterly partiality become in our modern era among poets that one could make a virtual anthology of poems based precisely on particular paintings. Such poems would include Auden's based on Breughel's *Fall of Icarus*, Robert Lowell's sonnet on Titian's painting of Charles V, W. D. Snodgrass's several poems based on paintings by Matisse, Vuillard, Manet, Monet, and van Gogh, Donald Justice's "Anonymous Drawing," based on a Renaissance work recorded with nothing less than Renaissance accuracy, Richard Wilbur's poem about *A Dutch Courtyard*, which is now in the National Gallery, as well as his poem about Degas—poems, moreover, by Elizabeth Bishop, John Ashbery, John Berryman, Randall Jarrell, Dr. Williams himself, and too many others to list. In addition to poems based on particular paintings or drawings there are those more generally influenced by the work of visual artists, not only painters but photographers and cinematographers. Gustave Flaubert, for example, was much impressed by the accomplishments of early photographers, and this capacity to render the visible world with great precision must have influenced the following brief passage from early in the third chapter of *Madame Bovary.*

> One day he got there about three o'clock. Everybody was in the fields. He went into the kitchen, but did not at once catch sight of Emma; the outside shutters were closed. Through the chinks of the wood the sun sent across the flooring long, fine rays that were broken at the corners of the furniture and trembled along the ceiling. Some flies on the table were crawling up the glasses that had been used, and buzzing as they drowned themselves in the dregs of the cider. The daylight that came in by the chimney made velvet of the soot at the back of the fireplace, and touched with blue the cold cinders. Between the window and the hearth Emma was sewing; she wore no fichu; he could see small drops of perspiration on her bare shoulders.
>
> After the fashion of country folks she asked him to have something to drink. He said no; she insisted, and at last laughingly offered to have a glass of liquor with him. So she went to fetch a bottle of curaçao from the cupboard, reached down two small glasses, filled one of them to the brim, poured scarcely anything into the other, and, having clinked glasses, carried hers to her mouth. As it was almost empty she bent back to drink, her head thrown back, her lips pouting, her neck on the strain. She laughed at getting none of it,

while with the tip of her tongue passing between her small teeth she
licked drop by drop the bottom of her glass.[14]

It could be claimed that these two paragraphs constitute an epitome of the
entire novel—or at least of Emma's endless craving for experiences that
were never to be hers because they were unreal and belonged entirely to
the realm of her imagination. Be that as it may, the visual vividness of the
passage is especially striking. I do not know of any statement regarding this
yearning, this restless ambition to render the visible world in words, that is
more persuasive and arresting than the one in Joseph Conrad's preface to
his novel *The Nigger of the "Narcissus."*

> A work that aspires, however humbly, to the condition of art should
> carry its justification in every line. And art itself may be defined as a
> single-minded attempt to render the highest kind of justice to the
> visible universe, by bringing to light the truth, manifold and one,
> underlying its every aspect. It is an attempt to find in its forms, in its
> colors, in its light, in its shadows, in the aspects of matter and in the
> facts of life, what of each is fundamental, what is enduring and
> essential—their one illuminating and convincing quality—the very
> truth of their existence. . . . The sincere endeavor to accomplish
> that creative task, to go as far on that road as his strength will carry
> him, to go undeterred by faltering, weariness, or reproach, is the only
> valid justification for the worker in prose. And if his conscience is
> clear, his answer to those who in the fullness of a wisdom which
> looks for immediate profit, demand specifically to be edified, con-
> soled, amused; who demand to be promptly improved, or encour-
> aged, or frightened, or shocked, or charmed, must run thus:—My
> task which I am trying to achieve is, by the power of the written word,
> to make you hear, to make you feel—it is, before all, to make you
> *see.* That—and no more, and it is everything. If I succeed, you shall
> find there, according to your deserts, encouragement, consolation,
> fear, charm, all you demand—and, perhaps, also that glimpse of
> truth for which you have forgotten to ask.[15]

The philistines Conrad identifies as wanting to be improved or consoled
were just those very moralists against whom Dr. Williams, his contempor-
aries, and his disciples were in revolt. They are as busy among us today as
they were in Victorian times. But I must draw your attention now partic-
ularly to Conrad's description of his task, a matter usually thought quite
ordinary when it is thought of at all, but despite that, no less miraculous

when it is achieved: "by the power of the written word, to make you hear, to make you feel—it is, before all, to make you *see*. That—and no more, and it is everything." To set before your eyes an assortment of the characters of the alphabet, disposed and divided according to an established code, meant to make them correspond to the way we talk to one another, and to be able to derive from this coded arrangement not merely the sound of a voice (though that is a great deal), nor the feel of a dramatic situation (though that is a great deal more), but the visual appearance of something quite apart from and beyond the inked letters on the white page, ought at least periodically to astonish us, even as we remember that it was the Latin poet Horace who declared, "Poetry is like painting. . . . Some attracts you more if you stand near, some if you're further off. . . . One gives pleasure once, one will please if you look it over ten times."[16] And this alliance, or, if you like, affinity between the two arts was represented in allegorical form in a painting by Angelica Kauffmann titled *Poetry Embracing Painting* (fig. 9).[17]

A testimony to the importance of direct ocular experience and its incontestable empirical value to the artist is described in the story I have read somewhere that J. M. W. Turner, in his eagerness to see and fully to experience a storm at sea, asked a sea captain on whose storm-beleaguered ship he was a passenger to bind him, like Odysseus, to the mainmast, so that nothing of the sea and the ship's behavior should escape his notice. There is no question that his magnificent paintings of such storms are anything but literal renderings (fig. 10). Yet it is not improbable to think of them as originating in firsthand experience. This firsthand experience is not devoid of a full emotional component, which in Turner's case involves something bordering on reverence and awe. But we never are allowed to doubt that whatever majesty may be conveyed by these paintings, they began in simple, straightforward inspection. And that very kind of fidelity is the subject of Elizabeth Bishop's poem titled "Sandpiper."

> The roaring alongside he takes for granted,
> and that every so often the world is bound to shake.
> He runs, he runs to the south, finical, awkward,
> in a state of controlled panic, a student of Blake.
>
> The beach hisses like fat. On his left, a sheet
> of interrupting water comes and goes
> and glazes over his dark and brittle feet.
> He runs, he runs straight through it, watching his toes.

—Watching, rather, the spaces of sand between them,
where (no detail too small) the Atlantic drains
rapidly backwards and downwards. As he runs,
he stares at the dragging grains.

The world is a mist. And then the world is
minute and vast and clear. The tide
is higher or lower. He couldn't tell you which.
His beak is focussed; he is preoccupied,

looking for something, something, something.
Poor bird, he is obsessed!
The millions of grains are black, white, tan, and gray,
mixed with quartz grains, rose and amethyst.[18]

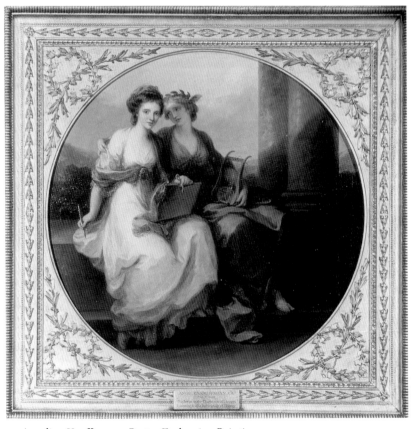

9. Angelica Kauffmann, *Poetry Embracing Painting*

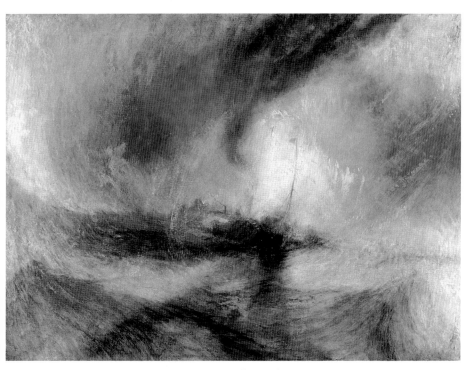

10. William Turner, *Snow-Storm: Steam-Boat off a Harbour's Mouth*

There is great humility in Bishop's title; it surely conveys nothing of the grandeur and sweep of the Turner paintings I mentioned just above. Yet in its own way it, too, is a deeply personal work, concerned with ocular or empirical knowledge, rendered in the midst of the experience of great threat. The sandpiper lives in what is called "a state of controlled panic," and in a world that is always changing, never stable, literally shaken, as by something that, given the small size of the bird, must seem nothing less than seismographic. This is, of course, because of the regular crashing of breakers. The bird is called "a student of Blake" in reference to the first line of one of Blake's poems: "To see a World in a Grain of Sand." The capacity to do this, Blake declares in his poem, is one of a number of "Auguries of Innocence," which is Blake's title, and his poem goes on to enumerate and catalogue other traits that augur this innocence, and the horrors that compass it about. It all begins, however, with inspection. In Bishop's poem, the bird watches his toes, or "rather, the spaces of sand

between them," while beside him the whole Atlantic drains away in momentary ebb. It will immediately come flooding back to create "a mist," and again drain away, leaving everything "minute and vast and clear." Such momentary glimpses of what we call "reality" are granted to some of us from time to time, depending, in part, on the scope of our purview and, perhaps, the quality of our innocence. The bird's obsession seems modest enough; he is "looking, looking, looking," always at grains of sand. But that is, first of all, the beginning of fidelity to a visible aspect of experience that, Blake assures us, could reveal a whole world. It is a fidelity to artistic practice as well, threatened by regular seismographic shocks that need deliberately to be ignored. Indeed, such conscious, active "ignoring" is nothing less than a strategy to maintain sanity in a world of constant upheaval. And if we study the work, and the life, of Elizabeth Bishop we will know that dangers threatened her from the outset, beginning with her father's death when she was a mere child, and followed almost immediately by her mother's collapse into insanity, requiring permanent institutionalization. These facts are delicately and indirectly alluded to in a few of her poems and in one of her short stories. And her own fear of instability was real and lifelong. It may not be too much to claim that something of the same sort troubled Turner. His mother died insane when he was in his twenties, and it is possible that he sought the refuge in painting that can be provided by acute attention to the visible world, which is, in the very nature of things, a constant obsession with *the present tense*, and a purposeful disregard of past and future.

Attention to the visible world of nature is surely a demanding obligation to the present instant at the expense of all else. But art is certainly capable of retrospection, or evoking and appealing to memory. Like both poetry and music, it employs what we may call "quotation." A painting may recall the work of an earlier artist, either deliberately or unconsciously; and it can require the viewer to remember earlier contexts, to see them strangely, significantly, or shockingly revived in new ones.

Let me present what seems to me a beautiful illustration (a painterly term, though what I mean to present is a poem) of this kind of echoing, in this case not verbal but visual. It is a poem by Mary Jo Salter, called "The Rebirth of Venus." (See fig. 11.)

> He's knelt to fish her face up from the sidewalk
> all morning, and at last some shoppers gather
> to see it drawn—wide-eyed, and dry as chalk—
> whole from the sea of dreams. It's she. None other

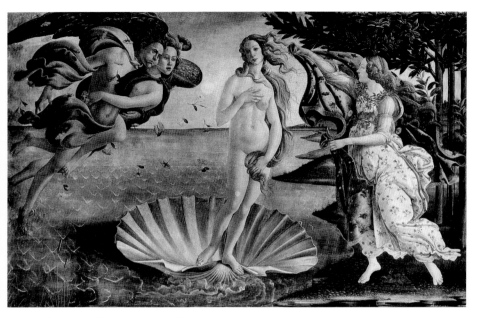

11. Sandro Botticelli, *The Birth of Venus*

than the other one who's copied in the book
he copies from, that woman men divined
ages before a painter let them look
into the eyes their eyes had had in mind.

Love's called him too, today, though she has taught
him in her beauty to love best
the one who first had formed her from a thought.
One square of pavement, like a headstone (lest

anyone mistake where credit lies),
reads BOTTICELLI, but the long-closed dates
suggest, instead, a view of centuries
coming unbracketed, as if the gates

might swing wide to admit, here, in the sun,
one humble man into the pantheon
older and more exalted than her own.
 Slow gods of Art, late into afternoon

let there be light: a few of us drop the wish
into his glinting coinbox like a well,
remembering the forecast. Yet he won't rush
her finish, though it means she'll have no shell

to harbor in, it's clear enough the rain
will swamp her like a tide, and lion-hearted
he'll set off, black umbrella sprung again,
envisioning faces where the streets have parted.[19]

There is so much to admire about this poem that it only adds to the joy to think how much Plato would have hated it. Plato maintained that the only real world was immaterial and ideal, and the actual world we inhabit is only an inferior imitation of the ideal. Furthermore he maintained that art, because it imitates only our physical world, is at two removes from the ideal one, and the more contemptible for being so. What, then, would he have made of this poem (by definition an imitation) about a chalk-drawn copy (another imitation) of a reproduction of a Botticelli painting that was, at best, three removes from the real? Yet there is so much grace, dexterity, and brimming, affectionate intelligence in these lines that it would take a die-hard Platonist to dislike them. They recall not only the iconic painting, irreverently known as *Venus on the Half-Shell*, but the myth of her birth (her Greek name, Aphrodite, means "born of the foam") so that it is from the sea that she must be, in several senses of the word, "drawn." It is Love who calls the artist to his vocation, by her beauty and her divinity, but she calls him to acknowledge the beauty created by his forerunners, which this humble sidewalk artist dutifully does. Yet because of his devotion to her, he is admitted to a pantheon older than her own, because art antedates the Olympian hierarchy. Nevertheless, if she is dredged from the sea, she is destined by the coming rainstorm to be washed away, only to be recalled again and again. The rain that drowns her will sprout an umbrella, and nourish the valiant artist whose job it is to retrieve these commanding images from improbable depths. This fishing expedition for the ultimate catch of beauty expressed as Love is carried out in the poem by a marvelous sinuosity of syntax, which weaves its way among the firmly, formally rhymed and metered quatrains with a suppleness and agility that in itself is expressive of that mastery art demands of even its humblest practitioners.

This is, however, like others I have instanced, a poem about a particular painting. Yet sometimes a poet may have in mind not a single work of art but, let us say, an artist's manner, a style of seeing the world that we can identify either with a particular artist or with a period in the history of

art. Here, for example, is a short poem by Arthur Symons, probably best known as the author of *The Symbolist Movement in Literature*, a work that greatly influenced the course of the career of T. S. Eliot. The poem bears what seems a strikingly Whistlerian title.

At Dieppe: Grey and Green

The grey-green stretch of sandy grass,
Indefinitely desolate;
A sea of lead, a sky of slate;
Already autumn in the air, alas!

One stark monotony of stone,
The long hotel, acutely white,
Against the after-sunset light
Withers grey-green, and takes the grass's tone.

Listless and endless it outlies,
And means, to you and me, no more
Than any pebble on the shore,
Or this indifferent moment as it dies. [20]

There is something decidedly French about this, and it inheres in more than the title. [21] It is to be seen in the posture of cool detachment belied by an underlying note of bitterness in the viewing of the scene. That anyone in particular might be intended as auditor is only slenderly suggested in the final stanza. The putative neutrality of the speaker's feelings is symbolized by the neutrality of grey and green, each diminishing the effect of the other. The hotel, ostensibly a site of community and activity, is seen merely as an object in fading, failing light. The grey of the title is emphasized by the leaden tones of the water, the slate tones of the sky, so that such green as exists has little chance of any liveliness, and offers instead a bleakness appropriate to the autumn season. The dilution thus expressed may well correspond to something about the relationship of the speaker and the person addressed. It is possible that a once-intimate relationship has now waned to indifference, an indifference in which everything and every moment is equally valueless and ephemeral. It is a tone of disenchantment, a sadness repudiated by a mocking stoicism, that we find also in Laforgue, and in early Eliot as well. Yet whatever it may owe to its French poetic predecessors, it is unequivocally pictorial, and its vacant, vacated starkness—as of an out-of-season, closed-up resort—is perfectly fitting in a poem dedicated to a painter, as this one is to Walter Sickert. [22]

I turn now to what shall be my final exhibit in this discussion of the

connections between painting and poetry. It is a complex poem in five parts, and once again it is not derived—so far as I know—from a particular painting, but seems instead to show the influence of a particular style (Impressionism) and one of that style's leading exponents (Monet). The poem is by Wallace Stevens, and called "Sea Surface Full of Clouds."

<center>I</center>

In that November off Tehuantepec,
The slopping of the sea grew still one night
And in the morning summer hued the deck

And made one think of rosy chocolate
And gilt umbrellas. Paradisal green
Gave suavity to the perplexed machine

Of ocean, which like limpid water lay.
Who, then, in that ambrosial latitude
Out of the light evolved the moving blooms,

Who, then, evolved the sea-blooms from the clouds
Diffusing balm in that Pacific calm?
C'était mon enfant, mon bijou, mon âme.

The sea-clouds whitened far below the calm
And moved, as blooms move, in the swimming green
And in its watery radiance, while the hue

Of heaven in antique reflection rolled
Round those flotillas. And sometimes the sea
Poured brilliant iris on the glistening blue.

<center>II</center>

In that November off Tehuantepec
The slopping of the sea grew still one night.
At breakfast jelly yellow streaked the deck

And made one think of chop-house chocolate
And sham unbrellas. And a sham-like green
Capped summer-seeming on the tense machine

Of ocean, which in sinister flatness lay.
Who, then, beheld the rising of the clouds
That strode submerged in that malevolent sheen,

Who saw the mortal massives of the blooms
Of water moving on the water-floor?
C'était mon frère du ciel, ma vie, mon or.

The gongs rang loudly as the windy booms
Hoo-hooed it in the darkened ocean-blooms.
The gongs grew still. And then blue heaven spread

Its crystalline pendentives on the sea
And the macabre of the water-glooms
In an enormous undulation fled.

III

In that November off Tehuantepec,
The slopping of the sea grew still one night
And a pale silver patterned on the deck

And made one think of porcelain chocolate
And pied umbrellas. An uncertain green,
Piano-polished, held the tranced machine

Of ocean, as a prelude holds and holds.
Who, seeing silver petals of white blooms
Unfolding in the water, feeling sure

Of the milk within the saltiest spurge, heard, then,
The sea unfolding in the sunken clouds?
Oh! C'était mon extase et mon amour.

So deeply sunken were they that the shrouds,
The shrouding shadows, made the petals black
Until the rolling heaven made them blue,

A blue beyond the rainy hyacinth,
And smiting the crevasses of the leaves
Deluged the ocean with a sapphire blue.

IV

In that November off Tehuantepec
The night-long slopping of the sea grew still.
A mallow morning dozed upon the deck

And made one think of musky chocolate
And frail umbrellas. A too-fluent green
Suggested malice in the dry machine

Of ocean, pondering dank stratagem.
Who then beheld the figures of the clouds
Like blooms secluded in the thick marine?

Like blooms? Like damasks that were shaken off
From the loosed girdles in the spangling must.
C'était ma foi, la nonchalance divine.

The nakedness would rise and suddenly turn
Salt masks of beard and mouths of bellowing,
Would—But more suddenly the heaven rolled

Its bluest sea-clouds in the thinking green,
And the nakedness became the broadest blooms,
Mile-mallows that a mallow sun cajoled.

V

In that November off Tehuantepec
Night stilled the slopping of the sea. The day
Came, bowing and voluble, upon the deck,

Good clown. . . . One thought of Chinese chocolate
And large umbrellas. And a motley green
Followed the drift of the obese machine

Of ocean, perfected in indolence.
What pistache one, ingenious and droll,
Beheld the sovereign clouds as jugglery

And the sea as turquoise-turbaned Sambo, neat
At tossing saucers—cloudy-conjuring sea?
C'était mon esprit bâtard, l'ignominie.

The sovereign clouds came clustering. The conch
Of loyal conjuration trumped. The wind
Of green blooms turning crisped the motley hue

To clearing opalescence. Then the sea
And heaven rolled as one and from the two
Came fresh transfigurings of freshest blue.[23]

My all-too-sketchy commentary on this poem must begin with a few bald facts. So far as I have been able to determine, Stevens never found himself the luxuriating passenger of a sailing yacht anchored off the coast of Tehuantepec. But in October (not November) 1923, he and his wife took a fifteen-day cruise from New York to California, by way of the Panama Canal, and the cruise ship passed by the Tehuantepec coast without docking or pausing in any way. What the poem presents is therefore an imagined experience of being moored off the Mexican coast for at least four days.

You may have anticipated me in supposing that I want to match this set of poems with one of Monet's water-lily paintings, or with a number of them, and I think they are probably relevant to Stevens' purposes in a general way, and may indeed have played a part in his thought. But I wish instead to make a different and less literal kind of comparison. For whereas Monet's water lilies are simply a group of paintings that are linked only by having a common subject, what the poem presents is very emphatically something seen and experienced in carefully matched, precisely duplicated, yet subtly varied ways. The poem insists on its parallels, and its deviations from parallels. It resembles, in consequence, Monet's famous series of paintings of the façade of the cathedral at Rouen, depicted at various hours of the day (figs. 12 and 13).

For the record, let us review the parallels among what we may consider the five panels of Stevens' poem. They all have the same first line. They all mention chocolate and umbrellas. They all compare the ocean to a machine of one sort or another. This comparison, in all five panels, is immediately followed by a rhetorical question about who it was that witnessed this oceanic imagery. The rhetorical question is then answered in French. And there follow two closing tercets, which turn us away from the viewer to regard once again the thing viewed.

The poem presents, to borrow a musical analogue, five variations on a theme. The theme concerns the transformations of reality that are engendered simultaneously by the witnessing imagination and the object of its contemplation—in this case, the ocean (which is in constant motion) and the reflections of the sky and clouds that inhabit it. Four of the five panels present a morning view after a night of calm. (The exception is the third, or middle, panel, which begins at night, and moves into an approaching dawn.) I want to propose to you that the chocolate and umbrellas, which seem so fanciful as to be almost unassimilable into the sense of the poem—a sort of defiant Surrealism—are in fact perfectly suitable nautical details. The chocolate refers to the mahogany wood of the ship's deck,

always modified by an adjective that indicates the variations in the morning light the viewer beholds on different mornings. The umbrellas, similarly awarded varying modifiers, are the furled sails of the ship, which, riding at anchor, would of necessity have its sails gathered, in the manner of a rolled umbrella. The French line in every stanza changes because the viewer, too, changes—changes because time changes everything and because the imagination is a fertile activity. As for the machine of the ocean, the French meaning of the word includes the idea of machination, scheme, or plot, as well as a system—for example, the bodily system. These are all active in themselves, and the ocean in this poem, as well as the viewer, is a transforming instrument.

The first panel is the loveliest and most innocent in a visual sense. Paradisal green is to be mixed with the hue of heaven; the ocean is Pacific, both noun and adjective; the latitude ambrosial. The antique reflection of heaven, the blue of iris (which means rainbow) poured out upon the blue of sea in which the blue of sky is reflected, are all pictorial and traditional, as "antique" suggests. In addition, the sheer power of the imagination to transform reality is vividly expressed in the first tercet, which begins in a literal November, but in which the morning light hues the deck with a gorgeous, retrospective "summer."

The second panel ingeniously hints to us that, whereas it is commonplace for the artificial to seem real (and the whole Platonic and Aristotelian doctrine of imitation is based on this idea), in point of fact the real often takes on the character of the artificial. Everything viewed is now conjectural, a mere matter of appearances, as though some indecipherable meaning were submerged in "summer-seeming" and "sham-like green." The ocean has become sinister, its sheen is malevolent, and the blooms are mortal massives that move deeply on the "water-floor" instead of on the surface. Suddenly there are "gongs," which sound ominously before they are suddenly silenced at the very moment the "macabre of the water-glooms / In an enormous undulation" flee. A sly reference is here being made to a poem by Yeats, called "Byzantium." That poem ends with an image of the "gong-tormented sea" as a symbol of mutability, and the whole poem is about death and the dream of escaping from it. Stevens is more tentative, but mortality lurks all about this second panel of his poem, insisting on how illusory is the "summer-seeming" of images in the November waters.

The third panel is a nocturne (a term that, incidentally, belongs to the discourse of both painting and music). The deck looks porcelain, the furled sails "pied," no doubt with shadows, by the moonlight, which casts

pale silver on the deck. Everything is held as in a spell of darkness and invisibility. For the first time the viewer does not "see" but "hears" the "the sea unfolding in the sunken clouds." The "shrouds" mentioned are both the shroud-lines of the ship that support the mast, and the complex darknesses of the sea at night, which continues its eerie stillness until the approaching dawn at the panel's end returns us to a deluge, both watery and figurative, of sapphire blue.

The fourth panel is the most dramatic, the most mythic, the most literary in its transformations. It presents an answer to the yearning expressed by Wordsworth in the sonnet that begins, "The world is too much with us; / late and soon, / Getting and spending, we lay waste our powers." That sonnet ends, majestically, but not without an inner contradiction,

> —Great God! I'd rather be
> A Pagan suckled in a creed outworn;
> So might I, standing on this pleasant lea,
> Have glimpses that would make me less forlorn;
> Have sight of Proteus rising from the sea;
> Or hear old Triton blow his wreathèd horn.[24]

What Stevens presents in this panel is the strange, "unreal," ambiguous morning light in which things look "musky" and "frail," because our very notion of reality is about to be disturbed. The machine of ocean is "dry," meaning ironic, since it is pondering a dank stratagem. And the clouds that in earlier stanzas had customarily been "blooms" turn out in this one to be "damasks" (which, to be sure, are both roses and plums, but in this context clothes). There is a disrobing going on; a concealed reality is to be revealed. The "spangling must" is a fermenting liquor to make us drunk and visionary, and also a cosmetic powder that belongs with the damasks and loosed girdles that are being discarded. The "nakedness" that "would rise" and turn "salt masks of beard and mouths of bellowing" is the imminent apparition of the god—Poseidon, Proteus, Triton. That nakedness would rise—but again the literal, visual world supervenes, and the "thinking green" of the deified ocean is "clouded" by the "bluest sea-clouds." The French aspect of the viewer who almost was granted this supernatural revelation was *ma foi*, my faith. (I am prepared to acknowledge that Marvell's "green thought in a green shade" may have played its part in the mind of Stevens when he wrote these lines.)

The final panel is intended to be the most blithe, carefree, imaginatively liberating, and entertaining, the least encumbered by literal fidelity. Its imagery is drawn from the circus, the "motley" of Shakespeare's

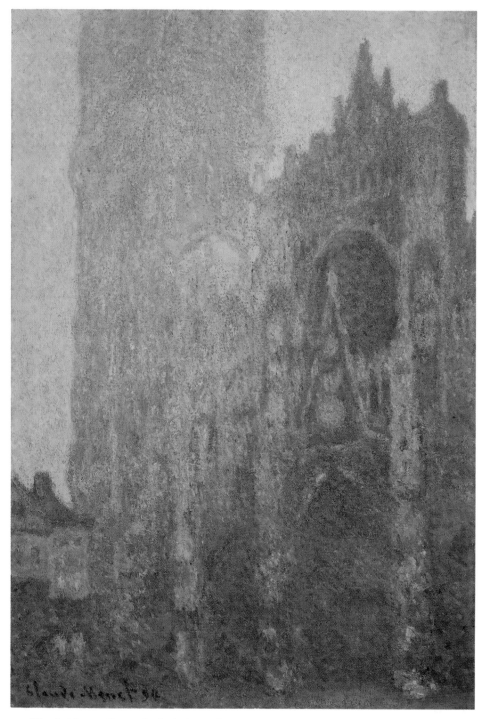

12. Claude Monet, *Rouen Cathedral Façade and Tour d'Albane (Morning Effect)*

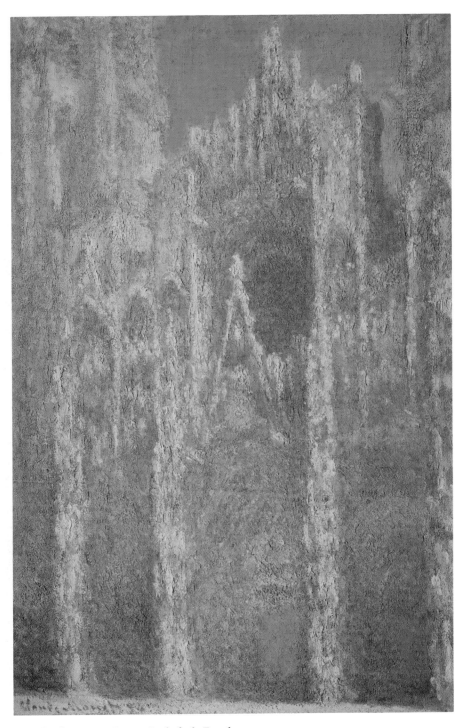

13. Claude Monet, *Rouen Cathedral. Façade*

clowns, but it is also the most problematic, betraying instances of Stevens' incorrigible racism in the name "Sambo," as well as in the modifier of chocolate, in which by "Chinese" the poet means "yellow." There is, it should be added, a confession of embarrassment about this expressed in the French line *"C'était mon esprit bâtard, l'ignominie,"* which could be rendered as, "It was my worser spirit, Shame itself," that saw the sea as Sambo and the whole scene as a clownish performance. Twice the clouds are called "sovereign" because they are above us. The conch, symbol of sea winds, in this case "loyal" to the "sovereign clouds," is a conch of "conjuration," casting spells, invoking something supernatural by the ritual use of a sacred name. It "trumped," that is, trumpeted, as conchs seem to do in mythological depictions, but also trumped, as one does when one wins at a play of cards. And then the sea and heaven join in "fresh transfigurings of freshest blue."

I would be the first to acknowledge that much in this poem I have left undiscussed—though I would add the qualification that my omissions were tailored to the limits of a lecture, and that all the most alien details are susceptible of a cogent explanation. But I must conclude this first lecture on a note of hope that I have made a plausible case for the active and ancient relationship of poetry to painting, and the enormous enrichment these arts offer one another.

II

Poetry and
Music

If music and sweet poetry agree,
As they must needs, the sister and the brother,
Then must the love be great 'twixt thee and me,
Because thou lov'st the one, and I the other.
Dowland to thee is dear, whose heavenly touch
Upon the lute doth ravish human sense;
Spenser to me, whose deep conceit is such
As, passing all conceit, needs no defence.
Thou lov'st to hear the sweet melodious sound
That Phoebus' lute, the queen of music, makes;
And I in deep delight am chiefly drowned
Whenas himself to singing he betakes.
 One god is god of both, as poets feign;
 One knight loves both, and both in thee remain.
RICHARD BARNFIELD
The Passionate Pilgrim

If you say that music is composed of proportion, then I have used similar meanings in painting, as I shall show.
LEONARDO DA VINCI
"Paragone," or, First Part of the Book of Painting

W HEN THOMAS BABINGTON MACAULAY was little more than an infant his parents were already in despair about him because he had not evinced the normal attempts at verbal articulation that were expected at his age. Their anxiety and concern were put at rest one day when a servant spilled some very hot soup or porridge on the child in its high chair, and was overcome with terror and remorse. Young Macaulay is reported to have looked her squarely in the eye, and, with great calm, uttered his first words, which were, "Madam, the agony has abated." Thenceforward, it seems, he became an indefatigable, indeed, an undiscourageable talker. Of him the Reverend Sydney Smith declared, "His enemies might have said before [he went to India] . . . that he talked rather too much; but now [that he has returned] he has occasional flashes of silence that make his conversation perfectly delightful."

I never think of these amusing words without thinking at the same time of the music of Richard Wagner. My point is not that his operas seem interminable, though occasionally they do, but that he writes a kind of music that never draws a breath, that is all legato, that is characterized, for the most part, by slurs and ligatures that bind his notes seamlessly together. What I am describing is decipherable even to a musical semiliterate in viewing Wagner's scores. A purely visual comparison of some pages of Wagner's Prelude to *Tristan and Isolde* (fig. 14), with all its bracketing ligatures, may be easily distinguished from the crystalline clarity of Mozart's coda to the final movement of the "Jupiter" Symphony (fig. 15).

This sustaining of uninterrupted sound, suffocating in its unwillingness to pause for breath, and which, in this, resembles that viscid modern genre known as "elevator music," creates its long-drawn effects by open-ended cadences, which allow for continuous modulation into different keys without coming to a definite close, and by doing this for extended periods of time. It also achieves this effect by the overlapping and interweaving of melodic lines in such a way that, before one of them nears what seems like an end, another has begun.

The views I express here are not mine alone, nor those of tone-deaf philistines in general. The English music critic Richard Capell, writing in the 1920s, found Wagner's music "incoherent, tautologous, morally reprehensible, [and] even boring."[1] And I find myself firmly in agreement with Stravinsky, who, in his book *The Poetics of Music*, declared:

> Wagner's work corresponds to a tendency that is not, properly speaking, a disorder, but one which tries to compensate for a lack of order. The principle of endless melody perfectly illustrates this tendency. It

14. *Tristan und Isolde* by Richard Wagner

15. Symphony No. 41 in C Major (the "Jupiter") by Wolfgang Amadeus Mozart

Ptolomeus

Marinus

Aratus

Strabo

Hipparchus

Polibius

VIRESCIT VVLNERE VERITAS

THE ELEMENTS
OF GEOMETRIE
of the most aunci-
ent Philosopher
EVCLIDE
of Megara.

*Faithfully (now first) tran-
slated into the Englishe toung , by
H. Billingsley, Citizen of London.
Whereunto are annexed certaine
Scholies, Annotations, and Inuenti-
ons, of the best Mathematici-
ens, both of time past , and
in this our age.*

*With a very fruitfull Præface made by M. I. Dee,
specifying the chiefe Mathematicall Sciëces, what
they are, and wherunto commodious: where, also, are
disclosed certaine new Secrets Mathematicall
and Mechanicall, vntill these our daies greatly missed.*

Geometria

Astronomia

Arithmetica

Musica

MERCVRIVS

Imprinted at London by *Iohn Daye.*

17. Jacopo de Barbari, *Portrait of Fra Luca Pacioli with a Young Man*

16. (facing) Title page of Euclid's *Elements*, First English Edition. This impressive title page represents, beneath the presiding images of Day and Night, land and sea, with Time interposed between them, the perfect and harmonious unity of all knowledge. Ptolomeus and Hipparchus represent Astronomy, while Aratus wrote about that subject in verse. Marinus represents philosophy, Strabo geography, and Polybius history, while allegorical figures portray a number of the arts and sciences, and Mercury, god of eloquence, astrology, and music, was honored as mediator between divine and human wisdom. Emanuel Winternitz observes in *Musical Instruments and Their Symbolism in Western Art* (New York: Norton, 1967), "It was for its strictly theoretical foundations that music was regarded as a science in antiquity and kept its place in the *universitas literarum*, beside rhetoric, geometry, arithmetic, dialectic, astronomy, and grammar, and that within the medieval classification of the arts into *artes liberales* and *artes mechanicae* it belonged to the first and nobler class, which imparted an elevated social position to its masters. This was by no means true of the visual artists; Plato ranked them with any other people exercising a skill, such as doctors, farmers, and sailors, and this was still the prevalent view in the *quattrocento*."

is the perpetual becoming of a music that never had any reason for starting, any more than it has any reason for ending. Endless melody thus appears as an insult to the dignity and to the very function of melody which . . . is the musical intonation of a cadenced phrase. Under the influence of Wagner the laws that secure the life of song found themselves violated, and music lost its melodic smile.[2]

It may be worth noting that Stravinsky felt no more warmly toward Wagner's musical heirs. He once remarked, "I would like to admit all [Richard] Strauss operas to whichever purgatory punishes triumphant banality."[3] But it is the strictures on Wagner himself that should be our present concern. For a music that appears to have a reason neither for beginning nor for ending is courting the perils and confusions of formlessness and disorder, as Stravinsky suggests. And music, of all the arts, is the one most closely allied to mathematics—both of them being expressions of abstract numerical systems, and, in their purest natures, nonreferential. And it is nothing if it is not supremely a matter of order.

This identification of mathematics with order (and, by means of that order, with music) is of great antiquity, and is probably most famously expressed in Plato's dialogue *Timaeus*, named for a philosopher who was in large part a Pythagorean, a member of a philosophic school described thus by Aristotle in his *Metaphysics*: "They supposed the elements of numbers to be the elements of all things, and the whole heaven to be a musical scale and a number."[4] In Plato's dialogue Timaeus begins with two standard triangles, the right-angled isosceles and the right-angled scalene in which the hypotenuse is double the shortest side; and out of these he constructs four of the regular solids: the cube, the tetrahedron, the octahedron, and the icosahedron, and these are assumed to be the shapes of the irreducible particles of the four elements of the universe: earth, air, fire, and water, and thus the basic constituents of all organic and inorganic matter. Timaeus, and through his voice, Plato, posited the four regular geometrical solids, plus a fifth, the dodecahedron, as the archetypal forms of the elements from which the cosmos was constructed, and in the *Republic* Plato made mathematics a key to the education of the very soul. He began with arithmetic, the study of abstract number, and proceeded by graduating steps in this manner: plane geometry was to be valued because it was presumed to be based on universal and self-evident truths; solid geometry was the logical progression from the two-dimensional study, and regarded as a rich elaboration of and extrapolation from the former; astronomy followed, not considered as a practical science, but rather as a study of the laws of motion of perfect mathematical bodies—it

was, in other words, a branch of pure mathematics, involving the beauty of the heavens, the harmony of perfect spheres in perfect motion and proportion; then followed harmonics, the science of sounds, as a theory of the harmony and the motion of the spheres; and, finally, dialectics, regarded as the pinnacle of the sciences, the one true method by which the intellect, without recourse to sense perception, is used until a perfect unity and harmony is reached, the idea of the good, the end and final goal of intellectual life.[5] (See fig. 16.)

Those of you who were fortunate enough to have seen the National Gallery's exhibition called *Circa 1492* will probably remember a mesmerizing painting called *Portrait of Fra Luca Pacioli with a Young Man* (fig. 17). Fra Luca was a Franciscan mathematician of great fame in his time, and in the painting he is represented as drawing circular and triangular shapes on a slate clearly marked "Euclid," and as bracketed on either side of the painting by a dodecahedron (resting on a copy of his mathematical works) and a suspended polyhedron. His friar's habit and his mathematical interests should both have sorted well with the title of his most famous work: *De divina proportione*. But, alas, his name is now permanently tainted with intellectual scandal. The charges against him were first raised in Giorgio Vasari's account of the life of Fra Luca's distinguished teacher, Piero della Francesca, one of the greatest of Italian painters, but also known in his own day as a mathematician. "Unhappy indeed is he," writes Vasari,

> who spends a long lifetime in serious study and then is prevented by illness or death from bringing his work to ultimate perfection. Often it happens that the credit is claimed by a presumptuous upstart. Although at long last the truth comes out, for a time at least the laborer is defrauded of his just deserts. Such was the case of Piero della Francesca, who was a master of perspective and mathematics but who first went blind and then died before his books were known to the public. Fra Luca di Borgo [otherwise known as Luca Pacioli], who should have cherished the memory of his master and teacher, Piero, did his best, on the contrary, to obliterate his name, taking to himself all the honor by publishing, as his own, the work of that good old man.[6]

Not content with saying this once, Vasari repeats the accusation near the end of his life of Piero. And sensational as the indictment seems, it has been sustained by the scholarship of the modern art historian Kenneth Clark. It appears that Piero wrote a scholarly work in Latin on the five regular bodies or geometrical solids, *De quinque corporibus regolaribus,*

which he also illustrated. And Clark asserts unequivocally, "It is now proved beyond question that a great part of the *Divina Proportione* [by Luca Pacioli] is an unacknowledged, but practically direct, translation into Italian of Piero's Latin MS."[7] It seems not irrelevant that Pacioli, disdaining Piero's own illustrations, sought the aid of Leonardo da Vinci to illustrate his pilfered text. And like most Renaissance artists of his time, including Alberti and Brunelleschi, Leonardo firmly believed in the mathematical principles of art, declaring in the opening words of his own *Treatise on Painting*, "let no one who is not a mathematician read my works." This widely shared conviction that numbers underlie the structure of the entire cosmos and all its motions has found expression in virtually all the arts, including painting, architecture, music, and poetry. The very word "numbers" was a synonym for poetry, as Hamlet himself attests in his note to Ophelia, which, after the rhetorical declaration in verse of his love, goes on to say, "O dear Ophelia, I am ill at these numbers" (2.2.120). And in *Love's Labour's Lost*, Longaville, one of the noble suitors seeking the hand of one of the ladies in attendance on the Princess of France, in despair at his feeble abilities as a poet, declares, "I fear these stubborn lines lack power to move. . . . These numbers will I tear, and write in prose" (4.3.51–53). There may be no more beautiful expression of cosmic perfection, embodied as Platonic order and articulated as celestial music, than this little lyric by Thomas Campion.

> Rose-cheeked Laura, come,
> Sing thou smoothly with thy beauty's
> Silent music, either other
> Sweetly gracing.
>
> Lovely forms do flow
> From concent divinely framèd;
> Heav'n is music, and thy beauty's
> Birth is heavenly.
>
> These dull notes we sing
> Discords need for helps to grace them;
> Only beauty purely loving
> Knows no discord,
>
> But still moves delight,
> Like clear springs renewed by flowing,
> Ever perfect, ever in them-
> Selves eternal.[8]

Campion's poem, which, you will notice, has no rhymes, was written, he tells us, to illustrate the application of Greek metrical principles to English poetry, and the general trochaic cast to this poem is easily recognized. But the poem rises above any paltry exercise in metrics, or even the conventional praise of a lady's beauty. When the poet says, "These dull notes we sing / Discords need for helps to grace them," he is not denigrating the capacities of mortal singers. The discords are those that constitute a necessary part of traditional diatonic patterns of harmony, which we recognize instantly in that musical device we call a *cadence*, roughly defined as "a progression of chords moving to a harmonic close or point of rest."[9] It is that movement, from the subdominant to the tonic, that we may most easily think of in terms of the so-called resolution from the first syllable to the second in the sung "Amen." To remain, that is to say, with the harmonic structure of the first syllable, repeating it for the second, would fail of a desired conclusion, and leave us in indefinite suspense. This harmonic fact in turn represents figuratively something about the imperfection of our earthly condition, in which discords and other faults have at least the negative virtue of setting off the perfections of absolute harmony and order; by them we can instinctively tell the difference between the pure and the impure. Our chief notion of joy is an experience we understand the better for its contrast with grief; and if we have difficulty understanding the pure joy that is the bliss of heaven, this is at least in part because this heavenly (as well as Platonic) perfection is constant and static, a condition of which we mortals have no experience. This extravagant praise, attributing to a lady nothing less than celestial perfection, may be said to be justified by her name, which is the name of Petrarch's beloved, Laura, a name that inspires poetry, being derived from the laurel sacred to Apollo; in Petrarch's sonnet sequence, Laura was chosen by God for an early death because of her perfection. Hers was, as Romeo says of Juliet, "Beauty too rich for use, for earth too dear" (1.5.49). In Campion's poem, Laura's beauty, being the physical embodiment of perfect order, is itself a "silent music," and music, from at least Pythagoras onward, was associated in one tradition with the cosmic order and the celebrated "music of the spheres." That tradition was classical, but there was another as well, quite independent of the first. It is expressed in what may be its most powerful and beautiful form in the thirty-eighth chapter of the Book of Job, when God answers Job out of the whirlwind. "Answers" is perhaps not quite the right word, since God's response is instead an astonishing catalogue of unanswerable questions, beginning "Where wast thou when I laid the foundations of the earth," and continuing,

Who hath laid the measures thereof, if thou knowest? or who hath stretched the line upon it?

Whereupon are the foundations thereof fashioned? or who laid the cornerstone thereof,

When the morning stars sang together, and all the sons of God shouted for joy?

The final chapters of Job, from thirty-eight to forty-one, have always seemed to me as sublime a poetry as Longinus found in the opening chapter of Genesis. But the particular verses just cited invite our attention because of their imagery drawn from architecture as well as music. Because of its plain necessity and practical function as shelter, architecture has long been regarded as the oldest of the arts, and throughout the Old Testament it is common to describe the earth itself as a building, set upon foundations; the Psalms, Proverbs, Isaiah, Ezekiel, and Zechariah all provide instances of this. The idea of God as the builder-architect of the universe was embraced by the Masonic order, to which Joseph Haydn belonged, as did, in all likelihood, Baron Gottfried van Swieten, who provided Haydn with the libretto, based in large part on Milton's *Paradise Lost*, for the oratorio *The Creation*. As for the singing of the morning stars, this was understood as the choiring of the nine angelic orders, the "intelligences" that moved the nine spheres, coincident with the very movement of Creation itself. This music was believed to have been audible to humans in the persons of Adam and Eve up to the moment of the fall from grace in the Garden of Eden. After this it was beyond the reach of human hearing until one night when it was vouchsafed to a select few. At the time of the Nativity it was heard, according to Luke, by shepherds abiding in the fields, keeping watch over their flocks by night. This music was choired by the "multitude of the heavenly host," praising God, and proclaiming peace on earth and good will toward men. It was made audible to this special audience for a number of reasons. First, they were the only ones awake, which meant that they were the poorest of the poor, all others being comfortably abed and asleep. Their poverty was a certification of their innocence because wealth and power corrupt; hence their "seely," silly, or *selig* thoughts to which Milton alludes. And, finally as shepherds who cared for their otherwise unprotected flocks, they were figurative representatives of the Good Shepherd, who was also the Lamb of God, and who, born that night as a mere child, should one day, in the words of Isaiah, "feed his flock like a shepherd."

Let me return, through the agency of music, to the relationship of

number (hence of music and poetry) to architecture. The great Augustan architectural theorist Vitruvius declared that the design of a temple, which is to say a sacred building, should be based on the exact proportional relationships to be found in the body of what he calls a "well shaped man." The man he envisioned was an idealization, drawn to Vitruvian specifications by Leonardo da Vinci (fig. 18).[10] In his *Third Book of Architecture*, Vitruvius outlines what may be regarded as the ideal proportions of the male anatomy, explaining that

> the human body is so designed by nature that the face, from the chin to the top of the forehead and the lowest roots of the hair, is a tenth part of the whole height; the open hand from the wrist to the tip of the middle finger is just the same; the head from the chin to the crown is an eighth, and with the neck and shoulders from the top of the breast to the lowest roots of the hair a sixth. . . . The length of the foot is one sixth the height of the body; of the forearm one fourth; and the breadth of the breast is also one fourth. The other members, too, have their own symmetrical proportions, and it was by employing them that the famous painters and sculptors of antiquity attained to great and endless renown.
>
> Similarly, in the members of a temple there ought to be the greatest harmony in the symmetrical relations of the different parts to the general magnitude of the whole. Then again, in the human body the central point is naturally the navel. For if a man be placed flat on his back, with hands and feet extended, and a pair of compasses centered at his navel, the fingers and toes of his two hands and feet will touch the circumference of a circle described therefrom. And just as the human body yields a circular outline, so too a square figure may be found from it. For if we measure the distance from the soles of the feet to the top of the head, and then apply that measure to the outstretched arms, the breadth will be found to be the same as the height, as in the case of plane surfaces which are perfectly square.[11]

The intimacy of the linkage between architecture, number or proportion, and music was expressed in the Greek myth in which Amphion, by his skill in playing the harp, was able to summon the stones of the walls of Thebes to assume their proper places. The ideal proportions of the human body shifted about radically even during the classical period, and there were consequently a number of "ideals." In his *History of Ancient Art*, Winckelmann says:

18. Leonardo da Vinci, *Drawing of ideal proportions of man according to Vitruvius' first-century treatise "De Architectura"* (so-called *Vitruvian Man*)

the more ancient style lasted until Phidias; through him and the artists of his time art attained greatness. This style may be called the grand and lofty. From the time of Praxiteles to that of Lysippus and Apelles art acquired more grace and pleasingness; this should be named the beautiful. Some little time subsequent to these artists and their school, art began to decline among their imitators; and we might now add a third style, that of the imitators, until art gradually bowed itself to its fall.[12]

By a sort of Vitruvian analogy, W. H. Auden once conjectured that the extraordinary survival, the sheer persistence of the Italian sonnet form—from Dante's time to our own—might well be based on our unconscious recognition of the happy, or even ideal, proportions, one to another, of its two parts: the eight-line octave and the six-line sestet. For what, after all, Vitruvius is writing about, for all his fractional precision and geometrical appeal, is the intuition that our pleasure in beholding a harmoniously grand and beautiful work of architecture must derive from an unconscious recognition of physical human perfection: a kinesthetic instinct by which in our finest constructions we contrive to see ourselves at our best. I am no expert on the human anatomy, ideal or otherwise, but I believe I can confirm Auden's shrewd supposition in terms of architecture—and the Vitruvian bodily correspondence would therefore follow axiomatically.

My illustration comes from a masterpiece of one of Italy's purest exemplars of the mathematical ideal in architecture: Andrea Palladio, and specifically his Villa Foscari—known as the Malcontenta—on the bank of the Brenta Canal. Consider the ground plan of the villa, as well as the same plan in diagrammatic form, representing the proportional relationships of the interior spaces (fig. 19).[13] Let us characterize the smallest of these spaces by the number 1. We then find that the spaces, reading across from left to right (or vice versa), present the symmetrical, syncopated pattern of 2–1–2–1–2, where 2 is understood as twice the size of 1. If we now read from back to front (i.e., top to bottom), we find the decidedly asymmetrical pattern of 1 and $2/3$, 2 and $1/3$ and 2—though it may be worth adding that the rooms at the front of the house (i.e., at the bottom of the illustration) are the exact average of the other two sequences of rooms. To arrive, finally, at a sense of the general proportions of the whole building, we may express it numerically by the comparison of the total length to the total width, or 8:6—which is precisely the numerical design of the Italian sonnet.

It would be plausible for me to illustrate the relations between poetry and music from the oeuvre of Richard Wagner, who was not only his own

19. Andrea Palladio, Plan for the Villa Foscari

librettist, but whose very technique of leitmotif is itself literary in that a melodic phrase is employed to symbolize an idea or the sort of thematic material that could be stated in words, as well as a means of identifying certain characters in his dramas. But I shall instead take my examples from the work of Claude Debussy. This extraordinary composer may in some ways have been both the most literary and the most pictorial of his tribe, and one who made it his undisguised aim to assimilate the arts to one another. First, he set to music the words of Baudelaire, Mallarmé, Villon, Verlaine, Banville, Charles D'Orleans, Dante Gabriel Rossetti, Alfred de Musset, Pierre Louys, Maeterlinck, Henri de Regnier, and Paul

Valéry, as well as words of his own composition. In addition he wrote incidental music for Gabriel d'Annunzio's *Le martyre de Saint-Sebastien*, and for Shakespeare's *King Lear*; he planned a version of *As You Like It* and worked for ten years on *La chute de la maison Usher*, composing both the libretto and the choral score for an uncompleted opera based on Poe's tale. Among the poems he set to music was one by Verlaine called "Art Poétique," the first line of which is *De la musique avant toute chose* (Music before anything else). Verlaine's poem, an *ars poetica*, and thus a polemical statement or manifesto as well as a theoretical postulate, is of interest in that it articulates a special claim for the kind of beauty to be derived from a combination of precision and vagueness that seemed to be the aim of many of the Symbolists. Verlaine's second stanza reads:

> Il faut aussi que tu n'ailles point
> Choisir tes mots sans quelque méprise:
> Rien de plus cher que la chanson grise
> Où l'Indécis au Précise se joint.

> (Make sure, in the poetic act,
> To choose words loosely, with some splay:
> The best song is the song in gray
> Where the Vague is joined to the Exact.)[14]

Debussy also wrote works that were intended to be pictorial and descriptive, called *Images* and *Estampes*, the latter group, scored for piano, meant as equivalents of Japanese prints by Hokusai and Hiroshige, while the former included *Cloches à travers les feuilles*, *Poisson d'or*, *Reflets dans l'eau*, *La terrasse des audiences au clair de lune*, and, probably most famously, *La mer*. This major work is composed in three movements, of which the first is subtitled "From dawn to noon on the sea," in regard to which Debussy's fellow composer Erik Satie remarked that he liked best the part "at a quarter past eleven." Satie was not above applying this sort of levity to his own works, one of which, for example, is titled *Trois morceaux en forme de poire* (Three pieces in the form of a pear).

It must surely have been someone French who remarked that the most beautiful words in the English language are "cellar door." What, one is disposed to wonder, would be the choices of a Swede or an Indonesian? Each language has its own music; or, more properly, its own varieties of music, for at one time or another the following more or less incommensurate poets have all been held up as model practitioners of the musical component in poetry: Swinburne, Poe, Gerard Manley Hopkins, Dylan

Thomas, Keats, Spenser, Milton, Tennyson. When I consult my own ear, I can claim that certain lines have come, over the years, to be cherished largely for the quality of their music: Herrick's "Melting melodious words, to Lutes of Amber," and George Herbert's "Lovely enchanting language, sugar-cane, / Hony of roses, whither wilt thou flie?" These come to mind, though I immediately think of many more. And the thought leads to questions about the very nature of poetry itself. For the art, like all the other arts, has no orthodoxy; indeed, as soon as anything even approaches the region of the conventional and firmly fixed, it invites rebellion and countermovement. Poetry as an art seems regularly to oscillate between song (with all the devices we associate with musical forms and formalities) and speech as it is commonly spoken by ordinary people. The problem presented by these alternatives ought to be evident; song and the artifices of formality lead in the direction of the artificial, the insincere, the passionless and servile mimicry of established formulas. But speech as a goal leads to chat, to formless rant and ungovernable prolixity. When Wordsworth began the writing of *The Prelude*, composed in that most flexible of English poetic forms, blank verse, he made a note to himself concerning the peculiar dangers to which that form—and therefore he himself as a poet using it—was liable. He wrote:

> Dr. Johnson observed, that in blank verse, the language suffered more distortion to keep it out of prose than any inconvenience to be apprehended from the shackles and circumspection of rhyme. This kind of distortion is the worst fault that poetry can have; for if once the natural order and connection of the words is broken, and the idiom of the language violated, the lines appear manufactured, and lose all that character of enthusiasm and inspiration, without which they become cold and insipid, how sublime soever the ideas and the images may be which they express.[15]

This problem, addressed with such solemnity by Johnson and Wordsworth, was touched upon with a lovely brevity and irreverence by Alexander Pope in *The Dunciad*, a sublime mock-epic tribute to the goddess of Dulness, who is "Daughter of Chaos and eternal Night." Pope describes her presiding on her divine heights:

> Here to her Chosen all her works she shews;
> Prose swell'd to verse, verse loit'ring into prose.
> (1.273–74)[16]

The real test of poets may well be the keen sense with which they expose themselves to danger, not merely by approaching the rigidities of form on the one hand, or the flaccidities of prosy formlessness on the other, but instead by the grace, deftness, and agility with which they make us feel that they have found a language that dances above these perils by the sheer artfulness with which it is deployed. We feel this instinctively in, for example, the blank verse of Shakespeare, which can be used to effect the brisk disposition of military forces for battle, with no aim but expediency, and can turn almost immediately to such an observation as "Light thickens, and the crow / Makes wing to the rooky wood" (*Macbeth*, 3.2.50–51). Indeed, it may be claimed that in a poem of any length, such variety of compression and expansion, such oscillation beween the relaxation of spoken discourse and the compactness and delphic intricacy of the complex lyric is virtually essential. Moreover, complexity can parade itself brilliantly under the wonderful guise of simplicity, and there have been many readers who rejoiced in the delusion that the poems of Blake, Emily Dickinson, and Robert Frost were sweet and simple expressions of moral uplift, or benign views of life and nature, when in fact such poems were darkly complex, ambiguous, and frankly alarming.

Poetry's music is involved with its shapeliness, and I would claim that those poets who seek, out of a spirited rebellion against formality of any kind and against all conventions, to dispense with the very concept of "closure" (as do, for example, certain kinds of rock music, that merely fade away through a technological diminution of volume) are not opening new vistas, as they would like to believe, but simply avoiding a poetic responsibility. As Frank Kermode has observed with a delicate shrewdness in *The Genesis of Secrecy*, "it does appear that we are programmed to prefer fulfillment to disappointment, the closed to the open. It may be that this preference arises from our experience of language-learning; a language that lacked syntax and lacked redundancy would be practically unlearnable. We depend on well-formèdness—less so, it must be confessed, in oral than in written language."[17] In an essay called "Making, Knowing, and Judging," W. H. Auden wrote, "A poem is a rite . . . the form of a rite must be beautiful, exhibiting, for example, balance, closure, and aptness to that which it is the form of."[18] And when Frost describes the figure a poem makes he says, "It has denouement."[19] In any case, apart from problems of closure and shapeliness in general, poetry has at its disposal an enormous arsenal of devices, serving as the very structure and armature by which the poem is knit together and kept in shape, devices that may

properly be regarded as part of its musical structure. This would include all the tropes, metaphors, and figures categorized with impressive Greek nomenclature in the rhetoric books. It would include as well the rich and versatile instruments of prosody, which, in these latter days, have been rather too hastily consigned to the dustbin under the impression, on the part of some poets, that if they are strident, or shocking, or emphatic enough, all artifices will be superfluous. Such poets incline to argue, and to believe, that anything in the least contrived, and as seemingly artificial as metrical regularity, would compromise and incriminate their passionate integrity.[20] This is a view I cannot share, in part because I believe that we may gauge the success of a poem by the fact that it reads as effectively the second time as the first, and the third time as the second; and with any real merit it will outlast a lifetime. If this is so, it will have to rely on more than the strength of its convictions. It will have to persuade us that those convictions were arrived at under the pressure of long thought, and were expressed with an artfulness that took into account that almost nothing in this world can be easily simplified into good and bad, right and wrong. And the pressure of long thought, whatever else it may be, is a valuable corrective to those simple bursts of spontaneous emotion that so many people believe poetry to be. John Dryden, certainly a man of his age, declared, "The great easiness of blank verse renders the poet too luxuriant; he is tempted to say many things which might better be omitted or at least shut up into fewer words; but when the difficulty of artful rhyming is interposed, . . . the fancy then gives leisure to the judgment to come in; which, seeing so heavy a tax imposed, is ready to cut off all unnecessary expense."[21] Dryden would certainly have hated Wordsworth; and Byron, who loved the poetry of Pope, and whose temperament was really more attuned to eighteenth-century modes than to the revolutionary styles of his own day, wrote:

> And Wordsworth, in a rather long "Excursion"
> (I think the quarto holds five hundred pages),
> Has given a sample from the vasty version
> Of his new system to perplex the sages;
> 'Tis poetry—at least by his assertion,
> And may appear so when the dog-star rages—
> And he who understands it would be able
> To add a story to the Tower of Babel.[22]

I quote this stanza knowing it is two-edged. Wordsworth is indisputably a greater poet than Byron. And Byron here seems to stand for the dated, if not obsolete, virtues Dryden championed, and those devices to curtail the

aimless prolixity of a poet too full of himself. But Wordsworth was himself the author of two sonnets that praised the constrictions of the sonnet form, one of which begins: "Nuns fret not at their convent's narrow room," while the other begins, "Scorn not the sonnet. . . ." The value of discipline is ambiguously moral *and* artistic; as experienced readers we rejoice in the victory achieved within the arbitrary limits imposed by formal considerations. In this, poems clearly resemble games, and it is no accident that poets as different as Frost, Auden, and Wilbur have likened poetry to athletic contests—not with regard to competitiveness, but out of consideration of a grace achieved by earned practice within formal limitations. The Dutch historian Johan Huizinga, in his work *Homo Ludens*, has given careful expression to this very idea.

> Play is superfluous. . . . It is never imposed by physical necessity or moral duty. . . .
>
> . . . it stands outside the immediate satisfaction of wants and appetites, indeed it interrupts the appetitive process. . . . It thus has its place in a sphere superior to the strictly biological processes of nutrition, reproduction and self-preservation. . .
>
> . . . It contains its own course and meaning.
>
> . . . it at once assumes fixed form as a cultural phenomenon. Once played, it endures as a new-found creation of the mind, a treasure to be retained by the memory. It is transmitted, it becomes tradition. . . .
>
> . . . All play moves and has its being within a play-ground marked off beforehand either materially or ideally, deliberately or as a matter of course. Just as there is no formal difference between play and ritual, so the "consecrated spot" cannot be formally distinguished from the play-ground. The arena, the card-table, the magic circle, the temple, the stage, the screen, the tennis court, the court of justice, etc., are all in form and function play-grounds, i.e. forbidden spots, isolated, hedged round, hallowed, within which special rules obtain. . . .
>
> . . . it creates order, *is* order. Into an imperfect world and into the confusion of life it brings a temporary, a limited perfection. Play demands order absolute and supreme. . . . The profound affinity between play and order is perhaps the reason why play . . . seems to lie to such a large extent in the field of aesthetics. . . . It is invested with the noblest qualities we are capable of perceiving in things: rhythm and harmony.
>
> . . . It is an activity connected with no material interest, and no profit can be gained by it.[23]

We may take that last sentence of Huizinga's to relate, not to the neglected situation of artists in modern society, but to the disinterestedness with which they ought to work, and to which I must return in a later lecture.

There is no satisfactory way by which I can well illustrate all the manifold uses and devices of poetic music—the interweaving of assonance and dissonance, the complications of meter and stanzaic form, the echoic effects of repetitions, as well as allusions to musical effects both within the context of the individual poem and to earlier works. So I shall settle, for better or worse, on a greatly and justly admired poem by Thomas Hardy as a way of representing a small portion of the ways music can be employed in poetry with dramatic effect. The poem I mean to discuss is "During Wind and Rain," and properly to discuss it will mean first saying a few words about its title, which is allusive. It is meant to recall to us the song that is sung by Feste at the end of Shakespeare's *Twelfth Night*, and which, for its relevance and its curious charm, is worth reciting here.

> When that I was and a little tiny boy,
> With a hey-ho, the wind and the rain,
> A foolish thing was but a toy,
> And the rain it raineth every day.
>
> But when I came to man's estate,
> With a hey-ho, the wind and the rain,
> 'Gainst knaves and thieves men shut their gate,
> For the rain it raineth every day.
>
> But when I came, alas, to wive,
> With a hey-ho, the wind and the rain,
> By swaggering could I never thrive,
> For the rain it raineth every day.
>
> But when I came unto my beds,
> With a hey-ho, the wind and the rain,
> With tosspots still had drunken heads,
> For the rain it raineth every day.
>
> A great while ago the world begun,
> With a hey-ho, the wind and the rain;
> But that's all one, our play is done,
> And we'll strive to please you every day.
> (5.1.398–417)

There are genuine puzzles about this little song, some of them grammatical. For example, it has been proposed that there ought to be an apostrophe before the word "had" in the third line of the fourth stanza, by way of indicating the elision of the pronoun "I," and thus rectifying the otherwise ungrammatical mess of the entire stanza. There is much conjecture about the meaning of the line, "But when I came unto my beds," which has been construed variously as meaning "when I came to the end of my life" or "to old age." As for the line, "A foolish thing was but a toy," there seems to be some consensus that it means "a wayward child was looked upon as a mere trifle (and thus, by implication, indulged)." There are other local puzzles in the poem, but these will stand to represent them. But in addition to such local matters, there is the larger puzzle about the design and meaning of the whole, and about this speculation has been rife, as it has been about almost everything Shakespeare ever wrote. One critic, for example, calls it "a song of unfulfilled love," and, eager to reconcile the sour and discordant notes expressed here with the fact that the song concludes a comedy of love, and therefore (it is rashly assumed) must be "upbeat," he goes on to say, "The exaggeration so often operative in the refrains of Elizabethan lyrics emphasizes that the watery as well as the sunny vision can become funny: it doesn't rain every day by a long shot."[24]

This seems to me almost as remote from the spirit and intention of the song as it is possible to get. The question of meteorological caprice is irrelevant to this lyric, which is mordant and amused in its comic pessimism about all things, including love itself, as Feste indicates when he sings, "But when I came, alas, to wive." This is not a happy omen for the lovers of this play. The true tone of Feste's song may best be inferred from his previous speech, which was in prose. Fabian has just publicly revealed the plot by which Malvolio was humiliated, the forged letter that made him think he was beloved, the ridiculous clothing he was urged to wear, the indignity to which he was exposed. When all this is revealed, Olivia says, "Alas, poor fool! How have they baffled thee!" (5.1.377). This is presumably addressed to poor Malvolio, whose plight, while comic, is tainted with the sadness that belongs to one who is made a laughingstock because of misplaced love. But it is not Malvolio who responds—at least not immediately. Perhaps because Olivia begins, "Alas, poor fool!" Feste, who is her jester (and hence a professional fool), responds himself with further taunts, and quotations from the letter that was the instrument of Malvolio's entrapment. He says, "Why, 'Some are born great, some achieve greatness, and some have greatness thrown upon them.' I was

one, sir, in this interlude, one Sir Topas, sir—but that's all one. 'By the Lord, fool, I am not mad!' But do you remember: 'Madam, why laugh you at such a barren rascal, an you smile not, he's gagged'? and thus the whirligig of time brings in his revenges" (5.1.378–385). Feste's little song is, as it were, an improvisation on this theme of the whirligig of time. And what it asserts, with a mordant amusement, is that, in the old saying, things go from bad to worse. In his childhood his folly was tolerated because it was the folly of innocence, but from there on in he encountered mounting hostility, waning comforts in both love and drink, and only the promise of ultimate extinction. After the first, each successive stanza begins with "But," which serves to contrast the early bliss with everything that follows. The final stanza does not begin with a "But"; instead, it states "A great while ago the world begun," and from everything that has gone before we may infer that Feste is about to claim that what he has just said about himself is true of the world and of humanity in general: it is on its way to ruin. In fact, he does not need to say this, so strongly is it implied. And he can enjoy the joke of appearing hastily to change the subject, and invite the audience's applause. And the change of subject not only makes a hasty conclusion, but muffles the implied suggestion that the lovers have before them only a world stained by the old realities.

And so we come at length to Thomas Hardy; here is his poem.

During Wind and Rain

> They sing their dearest songs—
> He, she, all of them—yea,
> Treble and tenor and bass,
> And one to play;
> With candles mooning each face. . . .
> Ah, no; the years O!
> How the sick leaves reel down in throngs!
>
> They clear the creeping moss—
> Elders and juniors—aye,
> Making the pathway neat
> And the garden gay;
> And they build a shady seat. . . .
> Ah, no; the years, the years;
> See, the white storm-birds wing across!

They are blithely breakfasting all—
Men and maidens—yea,
Under the summer tree,
 With a glimpse of the bay,
While pet fowl come to the knee. . . .
 Ah, no; the years O!
And the rotten rose is ript from the wall.

They change to a high new house,
He, she, all of them—aye,
Clocks and carpets, and chairs
 On the lawn all day,
And brightest things that are theirs. . . .
 Ah, no; the years, the years;
Down their carved names the rain-drop ploughs.[25]

There cannot be the least question of Hardy's interest in the musical qualities of poetry. Of all nineteenth-century poets he is almost certainly the most versatile in the invention and deployment of poetic forms, and possibly the most original in his use of actual musical materials, as in such poems as "On the Tune Called the Old Hundred and Fourth," and "Lines to a Movement of Mozart's E-Flat Symphony." Every one of his 947 poems is composed in formal verse, excluding blank verse. Moreover, Hardy began his career as an architect, and I have tried to suggest the close connection between architecture and music.

Let us begin with a simple device employed both in Shakespeare's song and Hardy's poem: the refrain. In the song, the second and fourth lines remain constant throughout, except for the deliberate violation of this pattern in the final stanza, the effect of which is ironic, and a playful avoidance of the general theme of decay, undertaken in the name of comic closure. Generally speaking, a refrain always performs a musical function that enforces an asynchronic form upon the work in which it appears. A part of the poem or song moves forward in a linear progression from beginning to end. But this progression is periodically interrupted by the refrain, which usually remains exactly the same, and therefore speaks of another dimension of time, distinct from the narrative or argument it interrupts. In Shakespeare's song, the claim that the rain raineth every day is simply a metaphor for the ways in which our pleasures or expectations are regularly frustrated, especially since, from the point of view of the child, with which the song begins, a rainy day is a day lost.

But Hardy's refrains in his short lyric are more complicated, and it is worth eyeing the patterned symmetries among his stanzas. We easily notice that each stanza breaks off with a series of dots at the end of the fifth line. We then notice that in the four-stanza poem, the sixth lines become alternating refrains, "Ah, no; the years O!" appearing in the first and third stanzas, while "Ah, no; the years, the years" appears in the second and fourth. We notice a similar alternation in the words that conclude the second lines of each stanza; "yea" for the first and third, "aye" for the second and fourth. We notice furthermore that the entire second line of the first stanza is repeated verbatim in the final one, though "aye" is substituted for "yea," while greater variations appear in the two middle stanzas. And now, on a larger scale, we notice the cheerfulness, the attractiveness, the outright prosperity celebrated in the first five lines of each stanza, up to the break signified by the row of dots. This break is followed by one of the two alternating refrains, followed in turn by the final line of the stanza, which, strangely, seems in each case utterly disconnected from what had gone before, and seems moreover almost a violation of that narrative line, a gratuitous intrusion of an unpleasantly symbolic sort that has something of the feeling of being out of place. The final line of each stanza is also its longest line: a tetrameter line to conclude a series composed of trimeters and dimeters, thereby giving an almost oracular authority to its utterance. Let me give you a brief account of this poem in the words of John Crowe Ransom. He says that it

> pictures a happy family doing very well in the world, but each of the four stanzas has for pendant a refrain of two lines which utters an ironic vision of the ruin to come. We may suppose they are spoken by the poet, who perhaps has been reading a series of gay letters from his friends, but since the weather is bad where he is, inside as well as outside his head, he cannot keep down his own constitutional misgivings. But perhaps the refrain-parts are fabulous, as coming from some Cassandra, singing of doom to come though nobody would believe her. Or are they rendered by a Chorus of Pities and Ironies, commenting in unison a piece of domestic history?[26]

I cannot help regretting this formulation as a sad diminution of the poem. To be sure, Hardy's poem is only a brief lyric, but it has tragic overtones, and it would be surely unfair to characterize, say, *Hamlet* or *Oedipus Rex* as "a piece of domestic history," though both plays are certainly that. It is also curious to find Ransom referring to the final lines of each stanza as part of the "refrain," since each is unique and, except metrically, without parallel.

Hardy's poem (and in this it is different from Shakespeare's song) is decussate in structure, that is, having the form of an X, and expresses something in the nature of the cross-purposes we commonly find in paradox and irony. It is the pattern of *King Lear* and *Macbeth*. Lear only begins to see the truth, and to attain moral grandeur, when he has lost everything else. As his wordly fortunes decline, his spiritual stature grows. Macbeth begins as a man full of caution, while his wife seethes with an almost inhuman ambition. In the course of the play the two change places symbolically, Macbeth becoming increasingly bold as his wife sickens and, eventually, dies. Hardy's poem begins in darkness—or, if you prefer, the comparative darkness of evening, and in the literal harmony of song and accompaniment betokening the felicities of domestic accord; and it progresses from indoors and from darkness to out-of-doors and light. Moreover, in the course of the poem a family rises in fortune and prosperity, and seems serenely free from the sort of taints that bring on the downfall of tragic heroes. But the fate that awaits them is the common fate of humanity, and it is voiced in omens that figure in the last lines of each stanza. These lines are portentous and the more sinister in seeming so thoroughly unprepared for, and alien to the stanzas they conclude. Consider them in naked isolation.

> How the sick leaves reel down in throngs!
> See, the white storm-birds wing across!
> And the rotten rose is ript from the wall.
> Down their carved names the rain-drop ploughs.

Forbidding, dreadful, and ominous as they all are, the last one concludes the poem with the enormous power of the verb "ploughs," which reminds us of how long and patiently water must work to erase the names incised on tombstones. That slow but inexorable process, that particular chronometer, is set in contrast to the upward mobility of the family, its cheerfulness and high hopes. But delphic, surprising, portentous as these final lines may be, they have been cunningly prepared for, and the preparation is musical. Hardy's stanzas are musically quite elaborate and invite attention. The second and fourth lines rhyme, much in the manner of a ballad, and the syntactical flow comes to an easy point of rest at the end of every fourth line, so that we may read these opening units as self-contained. The fifth line is mated by rhyme to the third, which comes as a kind of auditory surprise, since we had prepared ourselves to hear the familiar quatrain rhyme of ABCB, a pattern we have become familiar with in such ballads as, for example, "Sir Patrick Spens":

> The king sits in Dumferline toune,
> Drinking the blude-reid wine:
> "O whar will I get a guid sailor,
> To sail this ship of mine?"[27]

Then comes one of the refrains, rhyming with nothing; but this need not disturb us, since the first line has been left unrhymed, and that practice was common in the ballads. Then at last comes the final line; it is the seventh line in the stanza, and we may be excused for not at first realizing that it chimes perfectly in rhyme with the last word of the first line. Seven lines is a long time to hold in suspense the sound of a word that awaits its mating in rhyme. And not least because Hardy's metrical patterns and rhyme scheme have induced in us expectations that they have proceeded to disappoint, like the failure of the first and third lines to rhyme with one another, and the sixth lines of every stanza that have no rhyming mates within the limits of their own stanzaic units. But those opening lines of each stanza are prophetic in terms of rhyme. They come before as anticipations of a sound that will be fulfilled when their stanza concludes. They announce what is to come, and whatever that is has nothing to do with bad weather in the neighborhood of the recipient of some cheerful letters, nor even with that recipient's constitutional misgivings. There is no Cassandra, no Chorus of Pities and Ironies (though Hardy was not above employing them elsewhere in his work). Instead, the concluding lines of each stanza are firmly bound to their beginnings by the rhyme scheme, and are therefore uttered by the same voice and intelligence—just as Feste's lines all belong to him. The poem's very music, from the serene and hopeful beginnings of every stanza, initiates a preordained ending by virtue of its rhyme scheme, and leads to that inevitable finality that is the closure of all our lives. It is the cold, varied, but reiterated note of mortality itself. It bears the same weight of prophecy and fulfillment as the inscription Beethoven placed at the beginning of his String Quartet no. 16 in F Major: "Muss es sein? Es muss sein! Es muss sein!" (Must it be thus? It must be thus! It must be thus!).

III

Paradise and Wilderness

The desert in the garden the garden in the desert
T. S. ELIOT
"Ash Wednesday"

I am sometimes so very sceptical as to think Poetry itself a mere Jack a lanthern to amuse whoever may chance to be struck with its brilliance—As Tradesmen say every thing is worth what it will fetch, so probably every mental pursuit takes its reality and worth from the ardour of the pursuer—being in itself a nothing—Ethereal thing[s] may at least be thus real, divided under three heads—Things real—things semireal—and no things—Things real—such as existences of Sun Moon & Stars and passages of Shakespeare.
JOHN KEATS
letter to Benjamin Bailey, March 13, 1818

Unsre Hoffnung ist zu neu und zu alt—
Ich weiss nicht, was uns verliebe,
Wäre Liebe nicht verklärte Gewald
Und Gewald nicht irrende Liebe.

(Too old or new, our hopes; I can't think of
Anything of ours that would abide
Were love itself not power glorified
And power some wayward deviant of love.)
MARTIN BUBER
"Gewald und Liebe"

IF WE ARE ASKED to imagine a perfect or ideal state, we may find ourselves shifting back and forth between some notion of governmental regulation or lack of regulation on the one hand, and a putative condition of personal bliss, based, let us say, on love or drugs or heaven itself on the other. And there will be, as there always have been, those who affirm that one of these conditions is a prerequisite to the other: that we can have no harmonious community without the religious foundation that contents the soul of every individual—or that no individual can possibly be happy outside the perimeter of the social contract that binds people to an interdependent humanity. These singular and plural considerations have long governed our views of such images as we cherish of both mortal and immortal happiness. In medieval thought the most common image of such a state, both in writing and in graphic art, was the garden, and the very word "paradise" derives from the Persian for a walled garden, while one of the most popular early Muslim legends explains that the rose was born from the sweat of Mohammed's brow. For medieval Europe, the *hortus conclusus*, or enclosed garden, firmly distinguishing the cultivated plants and flowers from the wilderness and disorder beyond its walls, was a clear analogue to Eden itself; and all the garden's plants and flowers were duly assimilated into allegorical terms that turned the locus of quiet retreat into a figurative commentary on the Bible. The rose, for example, regarded as the supreme flower, was said to represent the Virgin on several grounds. It was claimed of the rose that it opened and shed its blossoms in a single day, and thus expressed the Virgin's modesty; its thorns were symbolic of the unregenerate Jews from whom Mary sprung, and among whom she was raised, though maintaining her inviolable perfection. The iris, emblem of the kings of France, under the name of fleur-de-lys recalled Christ's descent from the royal house of David, while the three-leaved strawberry plant evoked the Trinity. In this manner a whole garden might serve as a surrogate for the Bible, and even the straight, raked paths might reflect the conduct to be expected of the pious. In a poem describing why Sunday is to be preferred to any other day of the week, George Herbert wrote in the fourth stanza of a nine-stanza poem,

> Sundaies the pillars are,
> On which heav'ns palace arched lies:
> The other dayes fill up the spare
> And hollow room with vanities.
> They [i.e., Sundays] are the fruitfull beds and borders
> In God's rich garden: that is bare,
> Which parts their ranks and orders. [1]

This garden iconography, bolstered as it was by many biblical references to gardens (including, besides Eden, the site of Christ's agony, and the locus of the Song of Songs) exfoliated richly, and produced a *hortus deliciarum* (or garden of delights), a *hortulus animae* (or little garden of the soul), and the popular *rosarium* (or rose garden), from which the word "rosary" derives. All these were predicated on the idea of a sanctuary from the hostilities of disorder or danger beyond the garden's limits.[2]

But there was another received tradition, no less biblical, but opposed to this one. It envisioned the wilderness into which humanity was exiled from Eden not simply in terms of horror and repulsion, but as a ground for testing, as Christ himself was tested by the forty days in the wilderness, which, as a time span, was an analogue to the forty years of wandering in the wilderness experienced by the children of Israel after their escape from Egyptian bondage. The wilderness was, to be sure, no garden, but it was there that God fed his people by his providence, made a covenant with them (which declared them "chosen" in the obligatory sense that they were henceforth required to be exemplary), and gave them the Law. "*Exodus*," as John Prest says in *The Garden of Eden*, "is the record of a whole people being educated through tribulation and privation to obedience."[3] And the latter part of Hebrew Scripture presents many instances of the prophets withdrawing to the wilderness. Elijah and Elisha were but two of these, and the theme reappears in Jeremiah, Ezekiel, Hosea, and Amos. The later Christian glossing of the phrase of Isaiah regarding the "voice of him that cryeth in the wilderness," and his injunction to "make straight in the desert a highway for our God," asserted that they referred to the life of John the Baptist. This New Testament prophet and ascetic made his diet, according to Scripture, of honey and "locusts," which are not insects, as many suppose who have been influenced by the modern knowledge that in Asia grasshoppers are thought a delicacy. They are instead the fruit of the carob tree, the names of both, fruit and insect, being the same in Greek, possibly because it was thought that the insect resembled the pod of the fruit. In any case, John the Baptist's diet was spare, and a virtue was imputed to it that could not be found in all the luxurious abundance of Oriental gardens. It was affirmed that God could be found most surely through the simple life, and, in the ascetic manner of the desert saints, through self-deprivation and mortification of the flesh.

This twofold view of the site of the "great good place" created a huge variety of contrasts as well as similarities between gardens and wilderness. The notion of making a garden within a wilderness made the gardener into a pioneer as well as a colonist, an intrepid exporter of civilization to

the untamed wilds. The notion of the wilderness as itself a place to be preferred above all others honored it precisely because it was unsophisticated by mankind's corrupt ambitions and desires, their guilty wealth acquired at the expense of the misery of others, their idle and selfish luxury and garden-variety wickedness. And thus, since each is thought most desirable, gardens and wilderness can be regarded as equivalents, or as substitutes for one another. "The garden, or Paradise, with its softness, ease and lack of exertion [it now can be argued] saps the fibre and becomes a moral wilderness, while the desert, with its hardships, [becomes] the right road to religious experience, and is itself Paradise,"[4] as Prest declares. The biblical wilderness of the Jews had no likeness in Europe, where it was conveniently transmuted to forests, which were abundant, as Sir Philip Sidney does in his double sestina when he writes, "Long since my thoughts more desert be then forrests," and, again, "Turning to desarts our best pastur'de mountaines."[5] It is from this ascetic line of thought that the tradition comes of saints, hermits, and monks living at peace among wild animals, though the tradition goes back to Daniel in the lion's den, and includes Androcles, Saint Francis, and Saint Jerome.

As if these interwoven traditions were not complex enough, there is yet another, this one of classical origin, which concerns the region called Arcadia. This is a real place, a rather forbidding stretch of ground in the Peloponnesus, the southern part of Greece, where the legend developed of the lovely songs of shepherds. As the pastoral tradition grew it was believed that these shepherds sang because, like the saints and hermits, theirs were lives free from the taints and corruptions of society, though Polybius describes the place as rough and unproductive, and any singing was likely to be an activity cultivated to distract from the bleakness of ordinary existence. Arcadia was the mythic birthplace of Pan, god of shepherds, and whether they sang to divert themselves from an uncongenial landscape and occupation, or because the simplicity of their lives was the seal of their innocence and happiness, the name Arcadia became equated with a world of unspoiled perfection—primitive, elemental, something approaching a terrestrial paradise. It was in precisely this spirit that Giovanni da Verrazano, the navigator who, in 1524, was probably the first to discover New York Bay and the mouth of the Hudson River, gave the name of "Archadia" to the portion of the Atlantic coast that he sighted, the luxuriance of its trees reminding him of the Arcadia of Virgil's tenth eclogue, a place that is a solace to a shepherd who has been disappointed in love.

These traditions, blended in spite of their seeming contradictions, re-

ceived what seemed to the entire civilized world an astonishing confirmation by the discovery of a "brave new world" in the Western Hemisphere. The European discoverers were often ruthless and barbaric exploiters, their motives greed, power, and fame; but they were not without awe at the majesty of what they found, and their greatest hopes were expressed in the names of the towns and villages they eventually established along the Atlantic seaboard, and the communities they settled further inland: Salem (an abbreviation for Jerusalem), Providence, New Hope and New Haven, Concord, Philadelphia (the city of brotherly love), Bethlehem, Lebanon, and New Canaan. These almost millennial expectations were expressed as well in the poetry of the era. Encouraging his fellow Englishmen to colonize the new continent for what amounted to three reasons: glory and honor, the crude acquisition of wealth, and the fact that the New World is nothing less than paradisal, Michael Drayton wrote "To the Virginian Voyage," though evincing no disposition to go abroad himself.

> You brave heroic minds
> Worthy your country's name,
> That honor still pursue,
> Go, and subdue,
> Whilst loit'ring hinds
> Lurk here at home, with shame.
>
>
>
> And cheerfully at sea,
> Success you still entice,
> To get the pearl and gold,
> And ours to hold,
> Virginia,
> Earth's only paradise,
>
> Where nature hath in store
> Fowl, venison, and fish,
> And the fruitful'st soil
> Without your toil
> Three harvests more,
> All greater than your wish.
>
> And the ambitious vine
> Crowns with his purple mass,
> The cedar reaching high
> To kiss the sky,

The cypress, pine,
And useful sassafras.

To whose the golden age
Still nature's laws doth give,
No other cares that tend,
But them to defend
From winter's age,
That long there doth not live.[6]

The Pennsylvania Quaker Edward Hicks, a man of unquestioned piety
and austere temperament, painted perhaps as many as a hundred versions
of a symbolic scene called *The Peaceable Kingdom* (fig. 20). It is based on
the presumed fulfillment of the prophecy of Isaiah: "For behold, I create
new heavens, and a new earth: and the former shall not be remembered,
nor come into mind. . . . The wolf and the lamb shall feed together, and
the lion shall eat straw like the bullock: and dust shall be the serpent's

20. Edward Hicks, *The Peaceable Kingdom*

meat. They shall not hurt nor destroy in all my holy mountain, saith the Lord" (65:17). Off to one side of Hicks's painting there is an image of William Penn's treaty with the Indians, representing the actual coming to pass of the biblical prophecy in the New World. The loitering hinds who lurked at home in Europe were assailed by testimonies of all kinds about the paradisal aspects of the newly discovered regions—so much so that John Donne, addressing his beloved in an excess of sexual ecstasy, as he explores her body, calls her "O my America, my new-found-land."[7] Bartolomé de Las Casas wrote a history of the Indies, making full use of all the journals and papers of Columbus, on the basis of which he reports that Columbus believed he had found the terrestrial Paradise "because all men say that it's at the end of the Orient, and that's where we are." Expecting to encounter either the Grand Khan and other Oriental potentates, or the natives of a paradisal and perfect land, Columbus brought with him a converted Jew named Luis de Torres, who knew Hebrew, Aramaic, and some Arabic, to serve as interpreter, on the ground that Arabic was then thought to be the mother tongue of all languages, and if the edenic shores were reached Hebrew and Aramaic would clearly be indispensable.

The equivocal character of the New World—fearsome, savage, alien, on the one hand, yet paradisal, fruitful, edenic on the other—appears in some of the earliest accounts of explorers, and the works of the poets who read their reports. And the ambiguities of the landscape were matched by what was reported of the natives. (See fig. 21.) Montaigne writes that he had as a guest in his house a man who lived for some ten years among the natives of Brazil. (See fig. 22.) These people were cannibals; they executed their prisoners of war, then cooked and devoured them. This was a ritual practice connected with their idea of valor and triumph. It is, as Montaigne certainly felt, initially repellent. But he goes on to say:

> I am not so much concerned that we should remark on the horrible barbarity of such acts, as that, whilst rightly judging their errors we should be so blind to our own. I think there is more barbarity in eating a live than a dead man, in tearing on the rack and torturing the body of a man still full of feeling, in roasting him piecemeal and giving him to be bitten and mangled by dogs and swine (as we have not only read, but seen within fresh memory, not between old enemies, but between neighbors and fellow citizens, and, what is worse, under the cloak of piety and religion), than in roasting and eating him after he is dead.

Montaigne wishes wistfully that the ancient philosophers, including Plato, could have met and learned from these cannibals, saying:

21. Charles Le Brun, *The Peoples of America*. In contrast to representations of Native Americans as barbarous, a nearly Michelangelesque nobility infuses this painting, aligning it with ideas of the "noble savage" such as appeared in Montaigne, as well, Hugh Honour tells us in *The New Golden Land*, as in Bishop Bramhall's retort to Hobbes's *Leviathan*, wherein the bishop denies that there was ever a place "where mankind was altogether without laws and without governors," even "amongst the most barbarous Americans who (except some few criminal habits which these poor degenerate people, deceived by national custom, do hold for noble) have more principles of naturall piety and honesty and morality than are readily to be found in [Hobbes's] writing" (18–19), a view not unlike that of Theodor De Bry.

it seems to me that what we have learned by contact with [them] surpasses not only all the beautiful colours in which the poets have depicted the golden age, and all their ingenuity in inventing a happy state of man, but also the conceptions and desires of Philosophy herself. They were incapable of imagining so pure and native a simplicity, as that which we see by experience. . . . This is a nation, I should say to Plato, which has no manner of traffic; no knowledge of letters; no science of numbers; no name of magistrate or statesman; no use for slaves; neither wealth nor poverty; no contracts; no successions; no partitions; no occupation but that of idleness; only general

22. Edward Eckhout, A *Tapuya Brazilian*. Hugh Honour, in *The New Golden Land*, comments, "Accuracy was [Eckhout's] aim and he depicted the Tapuya in exactly the same painstaking way as he did the strange exotic plants among which they stand and the various indigenous animals and reptiles which appear in the foregrounds. . . . Cannibalism, relegated to its proper place, is indicated by Eckhout almost casually, as a mere incident in Brazilian life" (80–81).

respect for parents; no clothing; no agriculture; no metals; no use of wine or corn. The very words denoting falsehood, treachery, dissimulation, avarice, envy, detraction, pardon, unheard of. How far removed from this perfection would he find the ideal republic he imagined![8]

This passage was famously incorporated into a speech in Shakespeare's *The Tempest*, toward which I am pointing. Montaigne refers to Plato in one other important respect in the same essay. He writes, "'All things' (saith Plato) 'are produced, either by nature, by fortune, or by art. The greatest and fairest by one or other of the two first, the least and imperfect by the last.'"[9] This may have some bearing on Prospero's abdication at the end of the play.

If we turn from an account of the people to those two astonishing reports, also sources of *The Tempest*, about the settings in which these people dwelt, we encounter the same mixture of qualities long identified with wilderness and with gardens, eliciting dread, horror, and loathing on the one hand, and on the other awe, reverence, and gratitude. The accounts are those of William Strachey and Sylvester Jourdain, and they report the tribulations of a ship and crew, wrecked on the coast of Bermuda in 1609. Their accounts are dated 1610. *The Tempest* was first performed in 1611, and it is difficult to imagine that anyone who has read the reports of Strachey and Jourdain could doubt that Shakespeare had read them and made use of them. The dates nevertheless utterly failed to discourage the advocates of Edward de Vere, earl of Oxford, for the authorship of Shakespeare's plays, even though this very limited lyric poet incontestably died in 1604. His candidacy was first promoted by the felicitously named J. Thomas Looney, and won the remarkable approval of that master of the dreamworld Sigmund Freud. Both Strachey and Jourdain give vivid accounts of the terror of a storm in the region known to this day as the Bermuda Triangle, "an area of the sea . . . credited with a high number of unexplained disappearances of boats and aircraft," according to the Supplement of the Oxford English Dictionary. Strachey reports that the shipwrecked mariners found themselves cast ashore on "the dangerous and dreaded Iland . . . of the Bermuda . . . so terrible to all that ever touched on them, and such tempests, thunders, and other fearefull objects are seene and heard about them, that they be called commonly, The Devil Ilands, and are feared and avoyded of all sea travellers alive, above any other place in the world."[10] Yet having established a settlement there, the mariners soon came to regard it as very little short of paradisal, where large, plump, web-footed fowl that were tasty to eat came flocking to the

call of any human voice, and obediently perched on the summoner's arms, offering themselves as provender, in a manner that recalled the feeding in the wilderness of the Israelites with quail and with manna, as well as the provision of Elijah by ravens. Jourdain seconds this revisionist view that changes from revulsion to gratitude toward an island "that whereas it hath beene, and is still accounted, the most dangerous infortunate, and most forlorne place of the world, it is in truth the richest, healthfullest, and pleasing land . . . as ever man set foot upon."[11]

Of all Shakespeare's plays, *The Tempest* is the one that most resembles a masque, that elaborate and highly artificed entertainment compounded of spectacle, music, dance, and that is usually symbolic or allegorical in its design. (See fig. 23.) Of the masques initiated by King James's Queen Anne, Sir John Summerson writes:

> These early masques were, for England, a wonderful innovation. They introduced something resembling the *intermezzo*, which at the Medici court had developed from small beginnings as an entr'acte

SECONDO INTERMEDIO DOVE SI VIDE ARMARSI L'INFERNO PER FAR VENDETTA DI CIRCE CONTRO TIRRENO

23. Jacques Callot, *Second Intermezzo*

into a dramatic species of its own—a species in which poetry, movement and scenic devices combined to set intensely in relief a theme rooted in classical mythology but conveying sentiments appropriate to contemporary occasions. In Ben Jonson's hands there was nothing trivial about these masques. They were short, but highly wrought in every dimension. The texts were distillations of immense learning and models of literary craftsmanship; they were long in preparation and extremely expensive, often costing as much as it would take to build a fair-sized country house; and the costumes, lighting and contrivances may, at their best . . . have begotten true theatrical magic.[12]

Masques often celebrated specific events, including nuptials; they were, moreover, often moralistic and didactic in character, as we know not only from Milton's *Comus* but from the very titles of two of Ben Jonson's masques: *Love Freed from Ignorance and Folly* and *Pleasure Reconciled to Virtue. The Tempest* contains within itself a betrothal masque, presented by Prospero to his daughter, Miranda, and her suitor, Ferdinand, the prince of Naples. It contains, in the familiar manner of masques, a cast of goddesses and nymphs and reapers. But there are three other minimasques as well. There is the elaborate banquet presented to the castaways, and withdrawn as soon as they are tempted by it; there is the apparition of hounds and the sound of hunters that drive out Caliban, Stephano, and Trinculo at the crucial point of their planned coup d'état. And, most movingly of all, there is the moment in the final act when Prospero, drawing back the curtain to his cell, reveals the actual living presence of Ferdinand and Miranda to an assemblage so overcome with incredulity that it accords perfectly with our reaction to Juno, Iris, and Ceres in Prospero's more conventional masque.

The conventions of masques, their allegorical and didactic trappings, usually result in the presentation of moral dilemmas in greatly simplified and categorical ways. The necessarily lofty tone that belongs to such dramatizations of rectitude and high-mindedness were sometimes balanced by the inclusion of antimasques, which performed a function not unlike that of the satyr plays with which tragic trilogies of classical drama formally concluded. The distinguished classical scholar Bernard Knox has persuasively suggested that Shakespeare's play owes a good deal—more than anyone had ever suspected—to the Roman comedy of Plautus, Terence, and Menander, a debt exhibited principally though not exclusively in the ways the Romans and their Jacobean heir dealt with the relations between the enslaved and the free. Knox's brilliant essay should be read as

a valuable corrective to any speculative excesses of my own. For example, Knox finds in Roman comedy a sound precedent for the Shakespearean double plot in which the characters of a lower social order mimic, mock, or otherwise parallel the actions of their betters.[13] For my present purposes, I think an explanation can be found in the highly stylized relationship of masque and antimasque. We may plausibly claim that in *The Tempest* the comic level of the double plot (the insurrection of the drunken and discontented rabble) is an equivalent of the antimasque incorporated into the body of the play—as Shakespeare had long been used to doing in earlier plays. The subsidiary plot is a parody of and commentary on the sinister plots in the main action. But the main action is by no means as shapely, lucid, and simplified as is usual in a masque, and if we are to think of *The Tempest* as exhibiting a masquelike character we must admit that it equivocates between the smooth formalities, neat resolutions, and moral tidiness common to masques and the more equivocal, uncertain, ambiguous character of familiar Shakespearean drama.

Consider these parallel complexities. Prospero is cast out of his dukedom and supplanted by his wicked brother. But Prospero in turn usurps the island that belongs to Caliban by inheritance from his mother. Antonio, having succeeded in obtaining a dukedom by contrivance, encourages Sebastian to murder his brother Alonso, and thus to acquire the kingdom of Naples. Ferdinand, believing his father Alonso to be dead, speaks of himself as king of Naples, thus unconsciously behaving like a usurper. Given these parallels, it is not easy to claim that all the Europeans in this play are better than the uncivilized Caliban, though Caliban surely represents something unformed and barbarous. Yet we would do well to restrain our too easy contempt for him. He has not enjoyed the benefits of civilization, as Antonio has. And Prospero's frequent assertions of Caliban's incapacity to learn notwithstanding, we are assured that this is the exaggeration of impatience. In one of Caliban's first speeches, he says:

> This island's mine by Sycorax my mother,
> Which thou tak'st from me. When thou cam'st first,
> Thou strok'st me and made much of me; wouldst give me
> Water with berries in't; and teach me how
> To name the bigger light, and how the less,
> That burn by day and night. And then I loved thee
> And showed thee all the qualities o' th' isle,
> The fresh springs, brine pits, barren place and fertile.
>
> (1.2.331–38)

Two things about this speech deserve special notice. The first is the emphatic echo of Genesis 1:16, "And God made two great lights; the greater light to rule the day, and the lesser to rule the night: he made the stars also." Prospero has clearly begun Caliban's religious education and potential conversion, and Caliban expresses pleasure in this and gratitude for it. The second matter concerns the line descriptive of the island: "The fresh springs, brine pits, barren place and fertile." These carefully balanced contrasts are too neat and tidy to be accidental. The island itself is ambiguously hospitable and inhospitable, it contains barren and fertile places, fresh springs and brine pits, much like the equivocal characters of gardens and wildernesses of which I spoke earlier. This equivocal character is powerfully and wittily clarified in the first scene of the second act, where Adrian and Gonzalo, examining their surroundings, find them attractive, admirable, and sustaining, while Antonio and Sebastian, in mocking asides, make fun of the praisers and excoriate the island. They speak, as it were, antiphonally, the praisers and dispraisers, and it is easy to fall into the moral categories of the masque, and claim that the men who are good see the island as good, whereas the wicked see it as foul. But surely what is important is the equivocal character of the place itself. Adrian begins (and I omit the cynical commentary of his adversaries) "Though this island seem to be desert . . . Uninhabitable and almost inaccessible— . . . Yet— . . . The air breathes upon us here most sweetly." At this point Gonzalo takes up the theme: "Here is everything advantageous to life. . . . How lush and lusty the grass looks! How green! . . . But the rarity of it is—which is indeed almost beyond credit— . . . that our garments, being, as they were, drenched in the sea, hold, notwithstanding, their freshness and glosses, being rather new-dyed than stained with salt water" (2.1.37–67). It is true that the castaways have experienced a symbolic baptism during the storm that shipwrecked them; yet that immersion failed of its beneficent effect on Antonio and Sebastian, who to the very end seem obstinately unrepentant —in marked contrast, it may be argued, to Caliban himself. But the point about the island is not that, like a Rorschach test, it reveals a great deal about its beholders and nothing about itself. The astonishment expressed by Adrian and Gonzalo is a virtual echo of the surprise recounted by Strachey and Jourdain in first surviving an impossibly destructive storm, and then finding themselves beached in a place they believed to be hostile and savage, but which they found little less than paradisal. Their awe and gratitude were also expressed in a poem by Andrew Marvell, called "Bermudas."

Where the remote Bermudas ride
In the ocean's bosom unespied,
From a small boat, that rowed along,
The listening winds received this song.
 "What should we do but sing his praise
That led us through the watery maze
Unto an isle so long unknown,
And yet far kinder than our own?
Where he the huge sea-monsters wracks,
That lift the deep upon their backs,
He lands us on a grassy stage,
Safe from the storms, and prelate's rage.
He gave us this eternal spring,
Which here enamels everything,
And sends the fowls to us in care,
On daily visits through the air.
He hangs in shades the orange bright,
Like golden lamps in a green night,
And does in the pom'granates close
Jewels more rich than Ormus shows.
He makes the figs our mouths to meet,
And throws the melons at our feet,
But apples plants of such a price
No tree could ever bear them twice.
With cedars, chosen by his hand,
From Lebanon, he stores the land,
And makes the hollow seas, that roar,
Proclaim the ambergris on shore.
He cast (of which we rather boast)
The gospel's pearl upon our coast,
And in these rocks for us did frame
A temple, where to sound his name.
Oh let our voice his praise exalt,
Till it arrive at heaven's vault:
Which thence (perhaps) rebounding, may
Echo beyond the Mexique Bay."
 Thus sung they, in the English boat,
A holy and a cheerful note,
And all the way, to guide their chime,
With falling oars they kept the time.[14]

The commentators have had much to gloss about this poem, but I will confine myself to one observation. When Marvell writes of God that "He cast [in the past tense] (of which we rather boast) / The gospel's pearl upon our coast," the pearl referred to is the one in Matthew 13:45, where a pearl of great price is likened to the kingdom of heaven, so that we can entertain no doubt of the perfection that this "desert" isle represents.

Of all Shakespeare's plays, *The Tempest* is certainly the one that comes nearest to observing the classical unities of time and place. If we allow that its double plot, or antimasque, excuses it from unity of action, and that some freedom is exercised in moving the site of events to different parts of Prospero's island, we are nevertheless not allowed to forget the meticulously exact timetable of the play. Its action is strictly limited to the events of a few hours. This cannot be explained purely on the premise of the play's "magic." Time is the inexorable, fateful dimension of the play, which presents, among its many transformations, the supplanting, not only of duke for duke, but ultimately of one generation by another, so that there should be no surprise at the play's end (when much of the play's havoc has been resolved) that in almost his last words, Prospero says,

> and so to Naples,
> Where I have hope to see the nuptial
> Of these our dear-beloved solemnizèd;
> And thence retire me to my Milan, where
> Every third thought shall be my grave.
> (5.1.308–12)

The island where all this happens is the simultaneously paradisal and desolate setting for a drama about the no-less-ambiguous forces of love and of power, each of which is subject to its own particular form of corruption; and in the course of the play, each enjoys its own symbolic coronation, in language that cannot be accidental. Antonio fiendishly tempts Sebastian to murder Alonso (speaking, as it were, like Sebastian's own subconscious, and therefore sounding much like Sebastian's dream life), thereby to make himself king of Naples, in emulation and admiration of the usurpation Antonio himself had performed to become duke of Milan. He says,

> My strong imagination sees a crown
> Dropping upon thy head.
> (2.1.212–13)

When, at the play's end, harmony reconciles almost all the loose ends of the play, and Miranda is freely given in betrothal to Ferdinand, Gonzalo prays,

> Look down, you gods,
> And on this couple drop a blessèd crown!
> For it is you that have chalked forth the way
> Which brought us hither.
> (5.1.201–4)

Art, both Prospero's and Shakespeare's, and therefore poetry itself, is power governed by love. Ferdinand and Miranda are carefully instructed in such government, which should prepare them to assume the roles of rulership. But so are almost all the others instructed, including Prospero, Caliban, and Ariel. The play presents us with two kinds of power, and two kinds of love. (If in my account I sound forbiddingly schematic, this is in part encouraged by the genre of the masque.) The power that is most dangerous and corrupt expresses itself as much in the yearning for it as in its use. In this it resembles sexual lust as Shakespeare had described it in one of his sonnets:

> Th'expense of spirit in a waste of shame
> Is lust in action; and, till action, lust
> Is perjured, murd'rous, bloody, full of blame,
> Savage, extreme, rude, cruel, not to trust;
> Enjoyed no sooner but despisèd straight;
> Past reason hunted, and no sooner had,
> Past reason hated as a swallowed bait
> On purpose laid to make the taker mad:
> Mad in pursuit, and in possession so;
> Had, having, and in quest to have, extreme;
> A bliss in proof, and proved, a very woe;
> Before, a joy proposed; behind a dream.
> All this the world well knows; yet none knows well
> To shun the heaven that leads men to this hell.

The correspondingly corrupt form of love is, accordingly, lust itself, as represented by Caliban's boast that, had he not been restrained, he "had peopled else / This isle with Calibans."

The love that maintains its purity and freedom from corruption is the love between Ferdinand and Miranda, the one celebrated in the mini-masque of Juno, Iris, and Ceres, and, supremely, the love of parent for

child. The power that remains uncorrupted is throughout represented by Prospero's art—which is the art of language, and language, joined with patience, is the means to self-knowledge, and self-knowledge in turn is the only pure channel by which external, political power can be exercised.[15] Our first view of Prospero is that of an educator, first of his daughter ("who / Art ignorant of what thou art . . . 'tis time / I should inform thee farther"), then, in deliberate sequence, of Ariel, and of Caliban. There is a speech that the First Folio gives to Miranda, but which editors from Dryden to Kittredge assign instead to Prospero. Stephen Orgel, one of the most astute modern editors of the play, claims the reassignment is due to the heated terms of the speech, which earlier editors thought unsuitable to one of Miranda's delicacy and innocence.[16] I find myself disposed to agree with those who claim the speech for Prospero, not on grounds that it is too "energetic" (to use Orgel's word) for Miranda, but because it exhibits the emphatic character of the schoolmaster (the word Prospero uses to describe himself) that permeates the second scene of the play, which accords with the generally didactic character of masques. The speech is addressed to Caliban:

> Abhorrèd slave,
> Which any print of goodness will not take,
> Being capable of all ill! I pitied thee,
> Took pains to make thee speak, taught thee each hour
> One thing or other: when thou didst not, savage,
> Know thine own meaning, but wouldst gabble like
> A thing most brutish, I endowed thy purposes
> With words that made them known.
> (1.2.351–58)

Now, for all the intemperate anger of these lines, we already know they are greatly overstated, for Caliban has already exhibited a "print of goodness" in his account of his biblical training, and he is to offer more evidence of his potentially regenerate state in one of the most eloquent and lovely speeches in the play, and one of the most important.

> Be not afeard: the isle is full of noises,
> Sounds and sweet airs that give delight and hurt not.
> Sometimes a thousand twangling instruments
> Will hum about mine ears; and sometimes voices
> That, if I then had waked after long sleep,
> Will make me sleep again; and then, in dreaming,

> The clouds methought would open and show riches
> Ready to drop upon me, that, when I waked,
> I cried to dream again.
>
> (3.2.140–48)

This dropping of riches upon him of which Caliban dreams is an innocent analogue (innocent because in this play, as in *Macbeth*, the guilty cannot sleep) of the crown Antonio sees dropping on Sebastian's head, and the crown Gonzalo prays may be dropped from heaven upon the heads of Ferdinand and Miranda. It is a vision expressed as musical harmony, in a play in which musical metaphors abound and signify a harmony of the body and spirit, the citizen and the state. Caliban's capacity to sleep, and dream of a revelation beheld through a parting of the clouds (which surely argues a heavenly vision), ought to persuade us that he represents more than "dull earth," or some unformed primordial life. For if Prospero's island is both desert and paradise, Caliban is both savage and the kind of at least potentially noble figure described by Montaigne, and imagined by the writers of pastoral poetry. Indeed, at the end of the play, as conspicuously distinguished from the highly civilized Antonio and Sebastian, Caliban says, "I'll be wise hereafter, / And seek for grace" (5.1.295–96). Nor is it unimportant that he speaks of dreaming in a play so filled with dreams and the sort of illusions that occur in dreams. Within the narrow confines of this speech Caliban alternates between waking and sleeping not once but twice, and finds the alternatives almost equally alluring.

Is it quite suitable that "civilized" Europeans should undertake to impart their civilization to a native of that New World of which Isaiah spoke? (See fig. 24.) Alas, the American Indians were exploited as the sort of curiosities suitable for exhibit in a sideshow, as freaks, and Frank Kermode, one of this play's best editors, tells us that "such exhibitions were profitable investments, and were a regular feature of colonial policy under James I. The exhibits rarely survived the experience."[17] This is offered by way of commentary on Trinculo's discovery of the stinking and half-concealed Caliban.

> What have we here? a man or a fish? dead or alive? A fish: he smells like a fish; a very ancient and fish-like smell; a kind of, not of the newest Poor-John [dried hake]. A strange fish! Were I in England now, as once I was, and had but this fish painted, not a holiday fool there but would give a piece of silver: there would this monster make a man [that is, be the making of a man]; any strange beast there makes a man: when they will not give a doit to relieve a lame beggar, they will lay out ten to see a dead Indian. (2.2.25–34)

24. John White, *Pictish Man*. This illustration was appended by Theodor De Bry to the first volume of his *America* (1590), included "for to showe how the Inhabitants of the great Bretannie haue bin in times past as sauuage as those of Virginia." Quoted in Hugh Honour, *The New Golden Land: European Images of America from the Discoveries to the Present Time* (New York: Random House, 1975), 77.

Trinculo, terrified by the violence of the storm, takes shelter under the same gaberdine with Caliban, at which point the drunken butler, Stephano, discovers what he deems to be a monster with four legs. He vows to himself, "If I can recover [i.e., restore] him, and keep him tame, and get to Naples with him, he's a present for any emperor that ever trod on neat's-leather. . . . If I can recover him, and keep him tame, I will not take too much for him; he shall pay for him that hath him and that soundly" (2.2.69–80).

What is involved in the exploitation of a native people? Who is qualified to civilize whom? By what means and to what end is such an education undertaken? Since this is a play in which everyone including Prospero himself is instructed, these questions are worth asking in general

25. Portrait of Wild Boy of Aveyron

terms. And it is not wrong to discuss them in the light of the numerous experiments in the education of so-called wild men. I call to your attention an eloquent account of one that was conducted in France around 1800, and is described in *The Forbidden Experiment: The Story of the Wild Boy of Aveyron,* by Roger Shattuck.[18] (See fig. 25.) This boy, like certain others who gave rise to the myth of Tarzan, was brought up outside human society entirely by beasts, though in his case the beasts not of the jungle but of the forests of southern France. He eventually was captured and put under the (all things considered) relatively humane care of Dr. Jean-Marc Gaspard Itard, a physician and therapist who ran a school for the deaf. The process of education was dramatic and often painful, as Shattuck, and through him Itard, tells it. I offer here only two small fragments, and must explain that the boy was dubbed Victor by his educator.

One day when he was working with Victor in his study [Itard] decided to lock the door so that Victor could not go to his own room, where all the objects had been put that he was usually sent to fetch. Instead, he could find the same items (book, key, knife) in Itard's study. But though there were scores of books staring him in the face, he would not settle for any of them. He wanted to get the usual one locked in

his room. Itard could not persuade him to link the words on the cards with any of the objects in the room. Itard describes himself as losing all patience.

"'Unhappy boy,' I burst out as if he could understand me, 'since all this work has been in vain, go back to your woods. Or since you're now a ward of society, face up to your own uselessness and go live out your time in Bicêtre in misery and boredom!' If I hadn't known the limits of my pupil's intelligence, I might have believed that he understood every word I uttered. For I had barely finished when I saw, as happens in such moments of sorrow, his chest begin to heave with sobs, his eyes close, and tears stream out of his lids."[19]

Itard was clearly sensitive to some of the most insoluble and paradoxical aspects of his task, and when, on another occasion, poor Victor had been reduced to tears, the instructor records, "Oh! at that moment as at many others when I was ready to give up the task I had imposed upon myself and when I looked upon all my time as wasted, how deeply I regretted ever having known this child, and how I condemned the barren and inhuman curiosity of those men who first uprooted him from an innocent and happy life!"[20] It may easily be imagined, and is powerfully recorded by Shattuck and Itard, how agonizing was the advent of puberty for Victor when he found himself in the company of provincial French young ladies. The comparable plight of Caliban is obvious, as well as insoluble; when Miranda, beholding a new assemblage of mortals for the first time, breaks out enthusiastically, "O brave new world / That has such people in't," her father is right to say "'Tis new to thee" (5.1.183–84), just as the sight of any woman other than his mother was new and wonderful to Caliban.

It has been conjectured, given the formal and masquelike character of this play, that Caliban represents the body and Ariel the spirit; and this is not altogether mistaken.[21] Prospero undertakes to tame and order them both, and each one is duly educated. Moreover, it is finally Ariel, the spirit, who offers spiritual instruction to Prospero, recommending clemency for all of Prospero's antagonists. When Prospero frees both of his pupils they are duly separated from him, and his only course then is to "retire . . . to [his] Milan, where / Every third thought shall be [his] grave." If Ariel is his spirit, of Caliban he declares, "This thing of darkness I acknowledge mine." (See fig. 26.)

Yet if Caliban is a thing of darkness, he has seen the light more than once in the course of the play. He has seen the greater and the lesser lights, he has dreamed of heaven itself opening to him and showering its

riches upon his head, he has vowed to be wise and seek grace. And no small part of his hope for that grace is based on his capacity to dream.

I turn, accordingly, to the most famous passage in the play, not because it is an old chestnut, but because, in its reference to dreaming, it embodies some of the richest ambiguities of the play. It follows almost immediately after the masque Prospero has fashioned to entertain and (no less importantly) to edify Ferdinand and Miranda in the laws of restraint and self-government.

> Our revels now are ended. These our actors
> (As I foretold you) were all spirits, and
> Are melted into air, into thin air,
> And like the baseless fabric of this vision,
> The cloud-capp'd tow'rs, the gorgeous palaces,
> The solemn temples, the great globe itself,
> Yea, all which it inherit, shall dissolve,
> And like this insubstantial pageant faded
> Leave not a rack behind. We are such stuff
> As dreams are made on; and our little life
> Is rounded with a sleep.
> (4.1.148–58)

Some have asserted that the fame of the passage rests on its familiarity as a literary topos, on how all the grandeurs of life prove evanescent and illusory, citing the twentieth chapter of Job, and such a passage as the following from a play of 1603 (i.e., before *The Tempest*) called *The Tragedy of Darius*, by William Alexander.

> . . . let this worldly pomp our wits enchant,
> All fades, and scarcely leaves behind a token.
> Those golden palaces, those gorgeous halls
> With furnishings superfluously fair:
> Those stately courts, those sky-encount'ring walls
> Evanish all like vapours in the air. [22]

The commentary on Shakespeare's lines is understandably vast, for they are deeply resonant, touching as they do upon a dramatic performance (the "revels," or betrothal masque) within Shakespeare's play, but also on that play itself as a dramatic illusion, and on the illusory character of our own brief lives, which become more illusory the older we get. Yet so resonant indeed are Prospero's lines that I think I hear them echoed in Wordsworth as he gazes one early morning at the city of London from the ramparts of Westminster Bridge, and observes where "ships, towers,

26. Charles A. Buchel, Charcoal drawing of Herbert Beerbohm
Tree as Caliban

domes, theatres and temples lie / Open unto the fields, and to the sky."[23]
To be sure, Shakespeare makes no mention of ships, but a ship is central
to the beginning and end of his play. He makes no mention of domes, but
their shape is distantly suggested by the globe. He makes no mention of
theaters, but we recall that the Globe was itself Shakespeare's theater, and
the entire speech, and indeed the entire play, is about nothing less. Still
more to the point, Wordsworth's sonnet presents us with an enchanting
view in which the urban and rural are almost transcendentally assimilated
into a whole, harmonious unity and living presence. Moreover, Shelley
seems to echo the same lines when, in his "Julian and Maddalo," he
writes, of Venice, "Its temples and its palaces did seem / Like fabrics of
enchantment piled to Heaven."[24] In Prospero's speech we are presented

with the elaborate pomps and architectural extravaganzas of the masque—those artificial towers, palaces, and temples Inigo Jones earned such great fame by constructing (fig. 27)—and they are all the emblems and signs of a civilized metropolis. But we must recall that they have been conjured up within the precincts of a desert island, so that Shakespeare has suggested the same double world as Wordsworth, and linked both parts in a common bond.

Consider a further matter that seems, at least initially, disturbing. The speech contains two lines so nearly the equivalent of one another as to make us think for a moment that in his haste of composition Shakespeare forgot what he had just written, and inadvertently repeated himself. Only three lines separate the two, which go

> And like the baseless fabric of this vision
>
> And like this insubstantial pageant faded

This parallelism points to another in the speech, and requires of me that, like Prospero, I become for the moment an irritable pedagogue, and worry the passage's syntax and grammar. I have reproduced it according to the edition of Hallett Smith, which, allowing itself the minimal modernizations and pointings required by a modern reader, is the nearest I have found to that of the First Folio in which the play was first published. And it seems to me that we are required to ask of ourselves what is the subject of the verbal phrase "shall dissolve." This is not a matter as easy of solution as one might at first suppose; and it has been complicated by some modern editors, who have added punctuation in the name of greater clarity. They have, for example, put a comma after the "And" that begins the two parallel lines I have just cited. By doing this, they suggest that the skeletal outlines of the grammatical structure would run something like this: These our actors are melted into air, and, like the following catalogue of things, shall dissolve and leave not a rack behind. But this patently makes no sense, since, if the actors have already faded into air in the first three lines of the speech, they cannot linger about to prepare themselves, in the seventh, to dissolve at some point in the future.

It is more plausible, I think, to presume that the speech is composed of two parallel statements that are the independent clauses of a compound sentence, the first clause concerning the actors, the second the stage set, so that we may postulate a major stop after the words "into thin air." What we are left with, however, still presents a puzzle, since it offers us a simile, and deliberately employs the word "like." Something is to be compared with something else, and both parts of the equation "shall dissolve." If we

27. Inigo Jones, *Oberon's Palace*. This stage set of "Oberon's Palace" by Inigo Jones perfectly integrates architectural formalities and symmetries with an uncouth and forbidding natural landscape, in a manner that resembles the masquelike ingredients of Prospero's famous speech, momentarily "erected" in a wild island setting.

were to formalize the simile in mere schematic terms, it would state: like A, just so B, C, D, and E shall dissolve. What Shakespeare does is ingeniously to eliminate the "just so," thereby allowing, or demanding, that we insert it ourselves at whatever we deem the desired point. But what is being likened to what? Shall we begin by supposing that the long catalogue of things to be compared is divided into "the baseless fabric of this vision" on the one hand, and everything that follows on the other? Should we instead assume that "The cloud-capp'd tow'rs, the gorgeous palaces, / The solemn temples" are merely instances of the "baseless fabric," purely appurtenances of the masque, to be both likened to and, more carefully, distinguished from "the great globe itself," which is simul-

taneously the world we inhabit and Shakespeare's Globe Theatre? What I
suggest is that we have been given the liberty to insert the requisite "just
so," the grammatical and logical fulcrum balancing the two parts of the
simile, between any of the phrasal nouns in this speech. And in so doing
we would be asserting that whatever came before our inserted "just so" is
to be compared with whatever comes after it. By simple reckoning that
allows four possibilities. And surely the point of the speech is the illusory
character of all experience, which the very grammar of the speech enacts,
since there is no way firmly to distinguish between what is patently illu-
sory ("the baseless fabric of this vision") and what we habitually think of as
reality. The worlds of the real and imaginary are blended seamlessly to-
gether because grammar itself refuses to tell them apart. They are, accord-
ingly, simply the materials of dream and sleep to which, like Caliban in
life, like Prospero in his anticipated death, we shall in due course return.

The dream to which we so yearningly return is of paradise, ambigu-
ously either a garden or a wilderness: but also possibly a city of human and
civic habitation as represented by the elaborate architectural elements of
the masque. These are created, as is much else in this play, by art, which,
as I earlier declared, is power chastened and restrained by love. And love
itself is both the exalted passion and also the taking of infinite pains. Such
pains are evidenced in the ordeals, the deprivations and mortifications,
voluntarily undertaken by Ferdinand and Miranda, or imposed as pen-
ance upon others. The disciplines of art are a just analogue for the chas-
tening powers of love, and the self-discipline required of those who,
having learned to govern themselves, are proved suitable to govern others.
The dream to which we so eagerly return is that of a world untainted by
human or natural imperfection, as promised by the goddess Ceres toward
the end of the masque:

> Earth's increase, foison plenty
> Barns and garners never empty,
> Vines with clust'ring bunches growing,
> Plants with goodly burden bowing;
> Spring come to you at the farthest,
> In the very end of harvest!
> (4.1.110–15)

This world, from which winter and all its depletions have been elimi-
nated, was more than a dream. It was a reality that in Shakespeare's time
had taken its name from the virgin queen, Elizabeth, and saluted by Mi-
chael Drayton as "Virginia, / Earth's only paradise."

IV

Public and Private Art

Song, I think they will be few indeed
Who well and rightly understand your sense.
DANTE
Convivio, dissertation 2, canzone 1
(TRANSLATED BY HOWARD NEMEROV)

CERTAIN ARTS seem to be, by necessity and of their natures, more public than others. Though we may read a play or, if we have that skill, a piece of music, it is always envisioned by its composer as something performed, ideally before an attentive and literate audience.[1] Architecture, serving as it does a manifest social function, might seem to be the most public of all the arts. And yet I would urge upon you the notion that all the arts participate, each in its own way, in equivocal and curious balances between private and public modes of discourse. They withhold something; they operate by implication; they engage our capacities for inference. Sometimes they withhold a great deal, and reserve a part of their meaning for a select initiate. Edward Elgar's *Enigma Variations*, for example, are said to be musical portraits of certain personal friends whose identities were unknown to all but the composer at the time of composition, and were apparently not always recognized by the friends themselves. As for that supremely public art of architecture, there are at least two ways in which it can be exclusive and private—and these two ways have nothing to do with a third: those ostentations of wealth and power exhibited in the palaces and villas that are calculated to excite our envy and emulation but from which we are firmly denied access by posted signs saying "Private Property." Such buildings, though they may arouse populist indignation at their unashamed extravagance, are undeniably attractive. Yet some great buildings are meant to look forbidding. The rusticated stonework exteriors of the lower stories of the Pitti and Medici-Riccardi Palaces in Florence are meant to make them look impregnable and fortresslike. This effect can only be achieved by being actually seen, just as the most exclusive cottages at Newport or villas on the Brenta are meant to generate the admiration of even the most distant and debarred of passersby.

Despite this, there are, as I said, at least two ways architecture may be conceived of as private. One is represented by the underground bunker reserved for so-called heads of state—so exclusive that almost no one knows of its existence or location, and certainly not open for inspection. The second kind may be illustrated by two examples, one speculative, the other actual. The speculative one is furnished by the once fashionable legend that affirmed that since the Cathedral of Notre Dame de Paris was constructed by masons, and since the Masonic Order in modern times has earned the reputation of being firmly anticlerical, it followed "as the night the day" that the building must incorporate within the details of its design some central cryptogrammatic mockeries of religion in general and of Catholic Christianity in particular.[2] The beauty of this logic is somewhat

marred by the fact that, among other things, Mozart found it perfectly comfortable to be a member of the Masonic Order and a devout Catholic at the same time; as well as the fact that the medieval masons who built the cathedral, though certainly members of a professional guild, were only by time-warped imputation thought to be members of what we modernly think of as a "lodge"—even though an eighteenth-century historian of the Masonic Order, the Reverend James Anderson, generously bestowed retrospective membership on Moses, declared Solomon a "Grand Master of the Lodge at Jerusalem," and pronounced the Masonic Grand Mastership of Nebuchadnezzar.

I must leave it to others to decode the esoteric iconography of the Paris cathedral, if such an iconography exists. But there is a small building in England that can serve our purposes very well. It is a real—that is to say, an architectural—lodge, and was built in 1597 by Sir Thomas Tresham (fig. 28). It is not only triangular in its ground plan but it is composed of three stories with three gables on each side, and trefoil embellishments in groups of three running around the bottom and the top, a total of nine gargoyles, and a multitude of triangular windows. Sir Thomas could affirm, if questioned, that this insistence on reiterated threes was an expression of his personal signature, and a visual pun on the first three letters of his surname, Tresham. But he happened also to be an ardent Roman Catholic in an age when that faith was not well tolerated in England, and in 1581 he had been arrested and imprisoned for having given aid, comfort, and secret shelter to the Jesuit Edmund Campion, who was later executed as a traitor because it was believed that, being a Roman Catholic, he could not be loyal to Queen Elizabeth, who was the offspring of the marriage between Henry VIII and Anne Boleyn, which the Vatican regarded as illegitimate. It is believed that during Tresham's seven years of imprisonment he worked out the design of the lodge, every last detail of which was meant to figure in a visual cipher his Trinitarian faith. As a literary analogue for this small building, one need only think of the role of the number three in the *Vita Nuova* and the *Commedia* of Dante, in both of which it plays an indispensable part.

As for graphic art, Albrecht Dürer's celebrated engraving *Melencholia I* (fig. 29) is obscure and secretive not alone because of its atmosphere of darkness, or its depiction of silent meditation, but because even such gifted interpreters of iconography as Dame Frances Yates, Erwin Panofsky, and Jay Levenson hold completely opposed and irreconcilable interpretations of the meaning both of individual details and of the whole work.[3] Or take another, and perhaps more curious, example: *The Rest on the Flight*

28. Sir Thomas Tresham, Rushton Hall/Triangular Lodge

into Egypt, with the Ass Grazing, by Rodolphe Bresdin, a nineteenth-century Belgian engraver (figs. 30–32). The title of this work is his, and he was a man who enjoyed a private joke; this one in part has to do with the ass, which is nowhere visible. Bresdin's explanation for this is that in pursuit of fodder the ass has wandered outside the frame of the picture. But

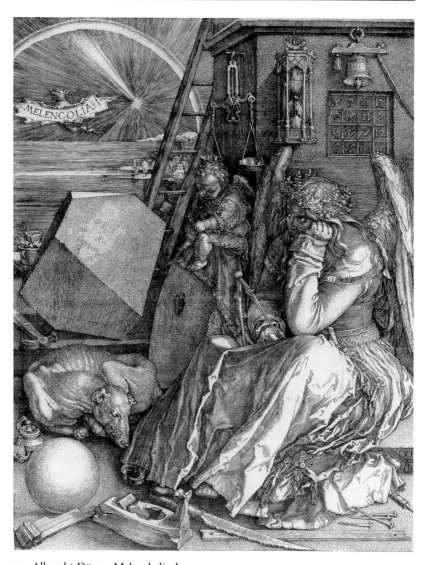

29. Albrecht Dürer, *Melencholia I*

there are still other covert meanings. The picture seems, like some others of the same subject, serenely tranquil, for all its umbrageous darkness; and the Holy Family is hedged about with its own numinous diffusion of light, as if by Providence itself. But loitering in the shadows are to be seen positively demonic figures and faces of which the three sacred persons take

no notice. These satanic presences are fairly well concealed, and it is up to us to discover them. The artist is making his demands upon our attention. Once we pay him that attention,* and discover the hidden diabolism figured in the picture, we are immediately reminded of the Herodian wrath and reign of terror that drove these three refugees into exile, and of the terrible doom and agonizing death that, at this apparently serene moment, lies in the obscure darkness of the future.

But I must turn my attention now more narrowly to poetry. It has been justly said that poetry is a kind of code, and this cannot fail to be true if, as some modern philosophers emphatically maintain, all writing, all language, is code. Even if this larger proposition is true, it can be stated that poetry is a code within a code, and this fixes upon it the imputation of elitism and exclusivity. It may be claimed that all the arts are ultimately elitist, and in the most elementary way, being as they are addressed to a privileged group. For simply to be able to say that something is beautiful means to enjoy, howsoever briefly, the favored position of luxurious serenity, freedom from acute pain, excessive anxiety, overwhelming internal and external pressures. People in extremis—and there are multitudes of these at any given moment—are not connoisseurs of anything but their own plight. As for poetry in particular, it demands of its readers a greater diligence of attention, and it calls upon more concentrated powers of inference, drawn from a wider range of reference, than ordinary expository prose; for that reason many general readers of, say, cheap fiction find it impenetrable, and unworthy of their effort. Robert Frost, who used to be thought one of the most accessible of poets, in an excess of enthusiasm (which he never troubled to recant or modify later, though there was plenty of time to do so), wrote in 1931, "Poetry provides the one permissible way of saying one thing and meaning another."[4] Almost as soon as he wrote that, Frost must have known it was not true—that there are many other "nonpoetical" ways of doing this, for it is the central mechanism of all irony and much satire, to say nothing of certain kinds of hypocrisy. "Good satire," writes Hoyt Hudson, "is an intrigue among honest men, a conspiracy of the candid. But intriguing and conspiring, with a little change of scale, become statesmanship."[5] Hudson was thinking of that copious and ample work, Erasmus's *Praise of Folly*, when he wrote this, but he could just as well have had in mind Swift's *Modest Proposal* and a lot of modern comedy. As for his claim about "statesmanship," it applies to all the "newspeak" Orwellian euphemisms with which governments and diplomats seek to say something that cannot be called an outright lie, but which aim to misguide the unwary—as, for example, when our own

30. Rodolphe Bresdin, *The Rest on the Flight into Egypt with Ass Grazing*

31. *Rest on the Flight into Egypt*, detail of devil

32. *Rest on the Flight into Egypt*, detail of squirrel

Defense Department referred, in its Gulf War bulletins, to "hard" and "soft" targets, meaning by "hard" military buildings, weapons, vehicles, or other installations, and by "soft" human bodies.[6] The name of the department itself ought to be worth a moment's thought. It is usually converted from the "Defense" to the "War Department" when we are engaged in warfare with an enemy. But that is only when such a war is actually declared, and the declaration must be made by Congress. So although we have sent troops, and lost lives, in many serious and prolonged wars since World War II, none was declared, and the "Defense Department" was not constrained to change its name. Presidential candidates and their speechwriters are wholly given over to the business of saying one thing and meaning another—so the technique is by no means purely a poetic one.

But apart from the more common poetic modes of indirection, there are other ways that poetry undertakes to conceal things, and in a more sober and confidential frame of mind Frost once wrote privately to his friend Sidney Cox, "I have written to keep the over curious out of the secret places of my mind both in my verse and in my letters to such as you."[7] This may be thought of as either a strategy of decent reticence, a belligerent snobbery, or a timid lack of candor, depending on your view. The problem presents itself in template form in what we may regard as the mixed, and possibly contradictory, motives at play in a love poem. In one sense it is conceived as the most private and intimate kind of communication, intended only for the eyes of the beloved. But insofar as it has been exposed to the general readership by publication, if it is to keep any note of emotional integrity it must succeed in conveying a sense that whatever the casual reader may think he or she divines, the poem contains that which only a few initiates, and perhaps only the beloved alone, can understand. And sometimes, as with Dante, Petrarch, and Spenser, the secret is cryptogrammatized in cunning ways. This means that such poems can be read on at least two, possibly mutually exclusive, but at least independent, levels.

Male poets have contrived from very early times to protect the identity of the beloved by many devices, the most familiar of which is to assign to her a fictitious and conventional name, generally classical in character. This preserves her personal reputation, and is the more prudent if she happens to be married, so the wronged husband may cheerfully continue to enjoy the bliss of ignorance. Hence the multitude of sonnets addressed to Celia, Delia, Stella, Chloris, and other anonymous beauties.[8] The device was employed by Robert Herrick, who was accordingly blamed by one rather stuffy critic for the shamelessly sexual relish with which he

wrote of intimacies with his Latinate "mistresses," a lapse of taste the more to be deplored, according to this view, because Herrick was an Anglican clergyman. As the editors of the *Norton Anthology* remark, "The Puritans would have been scandalized had they realized that this minister of the holy gospel was at least half a pagan, and didn't even have the grace to be ashamed of the fact."⁹ This reproach is doubtless based on poems with such titles as "Upon the Nipples of Julia's Breasts," or the epigram "Upon Julia's Breasts," which in its entirety goes:

> Display thy breasts, my *Julia*, there let me
> Behold that circummortall purity:
> Betweene whose glories, there my lips Ile lay,
> Ravisht, in that faire *Via Lactea*.¹⁰

But the trouble with such a literalist and condemnatory view lies not merely in its sanctimoniousness, but in its belittlement of Herrick's imagination. For it is not only possible to invent a Latin name for a beloved, but to invent the lady herself. And a careful perusal of all of Herrick's poems can leave little doubt that his Julias, Electras, Corinnas, and other amorous and well-endowed ladies were the daughters of the classical conventions, the creations of his Greek and Roman predecessors, so much admired by Ben Jonson, to whose learning and poetic skill Herrick was devoted, and of whom he counted himself, in unambiguous terms, a disciple.

> When I a Verse shall make,
> Know I have praid thee,
> For old *Religions* sake,
> Saint *Ben* to aide me.
>
> Make the way smooth for me,
> When I, thy *Herrick*,
> Honouring thee, on my knee
> Offer my *Lyrick*.
>
> Candles Ile give to thee,
> And a new Altar;
> And thou Saint *Ben*, shalt be
> Writ in my *Psalter*.¹¹

The "old religion" appealed to in the first stanza is entirely a classical and literary one, celebrated by Herrick over and over, and according to all the classical conventions. A poem called "To Live Merrily, and to Trust to

Good Verses" is a lovely series of toasts to all the great classical poets, toward the end of which homage Herrick has gotten exceedingly drunk. But reflect for a moment; drunks do not write poetry, or at least not Herrick's extremely careful and disciplined kind.

There are certainly many strategies of concealment and privacy, and some of the most celebrated of these are riddle poems, acrostics, and various kinds of cipher. These poems are most successful at maintaining their secret meanings when they can parade themselves as utterly innocent, as in, for example, *Mother Goose* rhymes. These have long been suspected of meanings that were likely to be lost on the children for whom they were ostensibly written. Take this one, for example.

> Little Jack Horner
> Sat in a corner,
> Eating his Christmas Pie;
> He put in his thumb,
> And pulled out a plum,
> And said, What a good boy am I.

The commentary on this little verse is enormous, and I offer here only two of many examples. First, Robert Graves gives the following account:

> Francis Horner, Scottish economist and member of Parliament during the Napoleonic Wars, was one of the few honest statesmen of his day; he even refused a Treasury secretaryship in 1811 because he could not afford to live on the salary. In 1810 he had been secretary to the Parliamentary Committee which investigated inflation and persuaded the House to check the issue of paper currency unsupported by bullion. Horner exercised a moral as well as an intellectual influence on his fellow members, which galled the Whig opposition. A "plum" in the slang of the time was £100,000; it appeared even in such sober reports as: "The revenue is about £90 plum, to be increased by funding." But here critical caution is needed. Though the Whigs may have mischievously applied the rhyme to Horner, as an accusation that he had secretly enriched himself by bribes from the City, while protesting his incorruptibility, it was already at least a century old. Henry Carey quotes it in his *Namby Pamby* satire on Ambrose Phillips in 1724. The Wiltshire Horners were a rich family who profited from Henry VIII's dissolution of the monasteries, and seem to have been notorious for their self-righteousness. [12]

The Oxford English Dictionary confirms Graves in his slang definition of "plum." To that account should be added the following by William and

Ceil Baring-Gould. "A persistent legend states," they tell us, "that the original *Jack Horner* was *Thomas* Horner, steward to Richard Whiting, last of the abbots of Glastonbury Cathedral. At the time of the Dissolution, when Henry VIII was taking over all the church property he could get his royal hands on, the abbot is said to have sent his steward to London with a Christmas gift intended to appease the king: a pie in which were hidden the deeds to twelve manorial estates. On the journey, Thomas Horner is alleged to have opened the pie and extracted one deed—that to the fine manor of Mells (a plum indeed!). There his descendents live to this day. As for Abbot Whiting, he was tried (with Thomas Horner sitting on the jury!), found guilty of having secreted gold sacramental cups from the profane touch of the king, and consequently hanged, beheaded, and quartered."[13]

There are a variety of ways in which poems can be private, as well as a few ways of being public.[14] If it is conceded that all poetry is a code, and that there can be all kinds of codes, it ought to be clear that however exclusively addressed to some tiny band of the elect a poem may wish to be, if it haughtily eliminates everyone but its own author from the realm of comprehension, it is no longer poetry but the irresponsible gibberish of a lunatic, who feels no obligation to communicate with anyone. This obvious fact, however, should not be used as a weapon for simpleminded philistines to belabor anything beyond the limits of a meager intelligence. Byron declared that the poetry of Wordsworth was unintelligible; much the same thing was once said of the music of Beethoven, and the premiere of Stravinsky's *Sacre du printemps* ended in a riot; Eliot's early poetry from *Prufrock* to *The Waste Land* was regarded as indistinguishable from the "barbaric yawp" that had been heard in America in the nineteenth century. All poetry, therefore, no matter how encoded, envisions an audience that will, perhaps at first laboriously, but in time with increasing skill, discover the key to the cipher, and, furthermore, find that cipher to be in the end a style of thought and feeling, a unique mode of apprehending and articulating whatever it is we try to know about ourselves and one another and the world we inhabit.

At the opposite pole from the too-exclusive private gibberish of the lunatic who does not trouble about being understood is what I have loosely called "public poetry." It, too, comes in a number of varieties, of which two require special notice. One is the kind that W. H. Auden, in one of his poems, calls "official art."[15] It is the blameless, innocuous, derivative, tepid work that will always satisfy government bureaucracy and congressional committees by dint of its negative virtues of being safely inoffensive. Robert Penn Warren, the first Poet Laureate of the United States, recalls a

characteristic instance of the sort of artistic cowardice commonly practiced by politicians.

> After the victory [of the Union forces in the Civil War], the completion of a new iron dome for the Capitol, and the publication of [Herman Melville's] *Battle-Pieces*, William Vanderbilt (son of the old Commodore) rose to explain to a congressional committee that nobody could now stop the new men who ran the country. Naturally, Melville, who had long since written of that "iron dome" and who had dreamed of a kind of peace far different from what had actually happened, was not the man invited to write the cantata to be presented at the great Centennial celebration of the founding of the United States. The cantata was done by Sidney Lanier, a safe choice who ruffled no feathers; his work was vapid, harmless and unmemorable.[16]

It may be too much to demand of politicians that they should have an aesthetic sensibility. Auden wrote, "We are all of us average men outside our particular fields. If we are not politicians we fail to understand politics that lie outside personal relations, if we are not artists we fail to understand art that does not reflect our own private phantasies, if we are not scientists we are bewildered by science that is not obviously based on common-sense experience."[17] Nevertheless, all of us in our capacity as citizens are called upon at regularly stated intervals to behave as if we knew something about politics, by going to the polls and voting. And indeed we almost all behave as if we were unusually shrewd and canny politicians.

Santayana allows himself the luxury of some imaginary conversations with Socrates on the subject of modern American democracy, in the course of which the ancient philosopher says to him:

> The man with a hole in his shoe is not forthwith a cobbler; much less does a landsman become a pilot whenever he is seasick. Imagine yourself (who I suspect are no sailor) appointed to command a trireme in a storm or in a fog or in the thick of the battle of Salamis, not knowing the draught of your vessel, or the position of the rocks, or the tactics of the enemy, or even the words of command or with which hand to steer but asking yourself what death to expect, while all hands waited upon you for direction; and I think your anxiety and suspense in such a nightmare, and the confusion and agony with which you would implore every god, or the most humble fellow-creature, to relieve you of that task, though the fate of only one trireme was at stake, would be as nothing to the anguish that must assail

the heart of an ignorant man voting in a moment of danger upon the government of his country.

Santayana's rather lame response to this is to say that somehow or other we muddle through.[18]

I am fortunate these days in having an especially discreet and close-mouthed barber, but he is uncharacteristic of his tribe, who seem professionally devoted to expressing firm political views on any occasion. As for politicians themselves, in a nation convulsed by populist seizures from time to time, it is a matter of the most elementary political prudence even for highly cultivated elected officials to seem to share the taste of what may be called "the lowest common denominator of the voting public," and experts abound to indicate what that taste is. Franklin Delano Roosevelt, detested as an aristocratic snob by his enemies, responded to a question from the press about his favorite music by saying that it was "Home on the Range." This may, of course, have been an ironic reply, for John Barbirolli, sometime conductor of the New York Philharmonic, when asked the same question on another occasion, replied "Tea for Two," of the popular songs of all time perhaps the most tediously unimaginative and repetitive. In any case, with a few happy exceptions, when the government undertakes to commission works of art it is likely to be conspicuous for its hopeless conventionality—thus "public" in the most deplorable sense of the word.

Another form of "public" art may be the kind that stands ideologically and aesthetically at the opposite end of the spectrum from the kind that is "politically correct." It also wishes to appeal to a special audience, though a different one. Its tone is often hortatory, sometimes indignant, occasionally accusatory, and it courts the artistic danger of lapsing into propaganda—which is to say that its end is nothing less than the immediate response of public action. To say this is to call it "revolutionary," and it rejoices in that label. But the revolution it seeks to effect is almost always in the social and political arena, seldom or never in the artistic one. The poetry of politics and moral indignation is a perilous undertaking, not least because it takes easy comfort in the Manichaean device of dividing the universe with surgical neatness into the good and the bad, and locating itself without any complex reflection on the side of the good, and in fierce opposition to the bad. Rarely, however, does the world of public events divide itself as conveniently as this, and the consequence is that a lot of angry, self-righteous poetry of no staying power gets written, to be read aloud at rallies of like-minded people. No one thinks, or is invited to think; only

visceral reactions are meant to be aroused. This is not poetry; it is mere evangelism. And the proof is that once the initiating political cause is past, the durability of the poem vanishes.

The evidence for this assessment is overwhelming, but I will furnish only two poignant instances. When John F. Kennedy was assassinated, a couple of literary entrepreneurs thought they had found a suitably lamentable occasion to commission a whole flock of elegies from some inglorious but noisy Miltons, presumably on the supposition that if they invited enough poets to contribute to the collection they projected, at the very least another "When Lilacs Last in the Dooryard Bloom'd" would eventuate. They threw their net of invitation very wide, including English as well as American poets in their ecumenical embrace, and invited a total of two hundred eight poets, of which a not inconsiderable seventy-eight produced something or other in the way of elegy. These poems are gathered and published in a book called *Of Poetry and Power*, and though among its contributors it includes the work of such celebrated poets as John Berryman, Auden, Reed Whittemore, Gwendolyn Brooks, Allen Ginsberg, and May Swenson, there is not a good poem in the book, and the whole volume is nothing more than deplorable literary opportunism.[19] To say this is not to say that the poets who contributed were indifferent to the occasion, but only that their largely casual efforts produced pitiable results. Berryman and Auden present themselves at their worst; Ginsberg is perfunctory; the rest are, generally speaking, embarrassing. There was not a Whitman among them. Something of the same kind of literary disappointment eventuated in the poetry that was written, largely in protest, about the war in Vietnam. It was a long war, the longest war in American history. It was a war that we failed to win, that probably should never have been fought, that was not only deeply and painfully contested thoughout its long length and long afterward, but, never having been sanctioned or declared by a cautious and uncertain Congress, was, in effect, a campaign directed wholly by the executive branch of the government. In addition, it was badly conducted, excessively cruel both to our own troops and to those (often helpless civilians) we called "the enemy," when we did not call them something else. There was, in consequence, an enormous amount of bad poetry written—and not only written, but read aloud at protest rallies. It changed no one's mind, of course, and had no effect whatever on public events. It managed to give some short-term celebrity to a number of very untalented poets who have never been heard of since.

Apart from love poetry, there are two other kinds of poems that fall

under the general heading of "private" art. These are devotional poetry and the poetry of the mad. Both of them come in many varieties, and it is difficult to be formally neat in discussing them. Our devotions, for example, have in their nature something both public and private about them. Publicly they are formalized in ritual ceremonies and formulaic liturgy; privately they involve our most intimate relations with divinity, our personal prayers, hopes, and faith. Religious poetry accordingly can lie anywhere within the spectrum from the most formal and liturgical to the most intensely private utterance, and it is this second kind that I am concerned with. As an instance of it, I offer this small and poignant poem by George Herbert, titled "Bitter-Sweet."

> Ah my deare angrie Lord,
> Since thou dost love, yet strike;
> Cast down, yet help afford;
> Sure I will do the like.
>
> I will complain, yet praise;
> I will bewail, approve:
> And all my sowre-sweet dayes
> I will lament, and love. [20]

Herbert regarded his poems as deeply confessional, and in his dying hours told a friend that they were "a picture of the many spiritual Conflicts that have passed betwixt God and my Soul."[21] The tone and feeling of this little poem of two quatrains is remarkably complex. Viewed in one way it might be thought an audacious, and possibly insolent, as well as truculent, statement that could be paraphrased approximately as: "Well, if you're going to be capricious, so will I!" Read in this spirit, it bears a spiritual resemblance to a couplet by Robert Frost that goes

> Forgive, O Lord, my little jokes on Thee
> And I'll forgive Thy great big one on me. [22]

Clearly the tone of Frost's lines borders on the irreverent, while nothing of that sort taints the Herbert poem. Brief as it is, it confronts two great mysteries: the inscrutable purposes of God, and the instability—and thus more or less parallel mystery—of the poet's own temperament. But while human instability may be attributed to our universal imperfection, God is by definition perfect, so the inexplicable changes in the way he deals with us cannot be laid to anything so trivial as caprice. We are presented here with profound questions posed by the notion of theodicy: the ultimate

meaning of God's purposes, veiled though they be from us. The poem in this respect resembles those debates conducted by the patriarch Abraham with God about the fate of the cities of Sodom and Gomorrah, as well as those more extended human debates about the inexplicable suffering of the innocent that constitutes the whole of the Book of Job. In Herbert there is no demand for explanation, nor indeed any quid pro quo effrontery at all. The mystery of God's ways is matched by the feebleness of the human response, and we are invited to infer the deeply incommensurate nature of what is presented as a superficial parallelism. Herbert confesses his human incapacity to understand God's ways, and confesses his faith in God at the same time, in both cases with a deep and touching honesty.

The lunatics also come in many varieties. There were, for example, at one time what may be called professional lunatics. When Henry VIII appropriated the church properties of England, it meant the closing of many hospitals run by religious orders that had cared for the mad. So a lot of handicapped and demented men and women were driven out upon the roads to beg for alms and care for themselves—a situation that has found a hideous modern parallel in our country under recent administrations. These Tudor lunatics were known as Bedlamites (having once been cared for at the Hospital of Saint Mary's of Bethlehem, which name was colloquially contracted to Bedlam) and they wandered the roads much as our own homeless do today. Such people were desperate in their plight, as they still are. But their very existence led to the evolution of a professional class of mendicants who pretended to be mad, and acted accordingly as a way of taking advantage of the general sympathy for these outcasts. They produced not only a corpus of poetry about madness, of which "Tom O'Bedlam's Song" is perhaps the best known, but a number of characters in Elizabethan literature, including Diccon, the Bedlam, in *Gammer Gurton's Needle*, a character in Dekker's pamphlet *Bellman of London*, and the role Edgar adopts as a disguise in *King Lear*.

But let us turn instead to some of the learned and deeply private obscurities of a poet who was certifiably mad. Christopher Smart had been a student and Fellow of Pembroke College, Cambridge University, where he had been well known for his Latin verses; but in the course of time debt and mental troubles so crippled him that he was forcibly confined in Saint Luke's Hospital, where he wrote, among other extraordinary works, one called *Jubilate Agno*, from which I want to quote a number of remarkable verses.

Let Sarah rejoice with the Redwing, whose harvest is in the frost and
 snow.

For the hour of my felicity, like the womb of Sarah, shall come at the
latter end.

.

Let Ehud rejoice with Onocrotalus [that is, the Pelican], whose braying
is for the glory of God, because he makes the best music in his
power.
For I bless God that I am of the same seed as Ehud, Mutius Scaevola,
and Colonel Draper.

.

Let Achsah rejoice with the Pigeon who is an antidote to malignity and
will carry a letter.
For I bless God for the Postmaster general and all conveyancers of letters
under his special care especially Allen and Shelvock.

.

Let Eli rejoice with Leucon—he is an honest fellow, which is a rarity.
For I have seen the White Raven and Thomas Hall of Willingham and
am myself a greater curiosity than both.[23]

The long and difficult poem from which these lines are taken is mod-
eled in part on the canticle sung at matins in the Church of England,
Benedicite omnia opera: "O all ye works of the Lord, bless ye the Lord:
praise him, and magnify him forever." The poem is filled with biblical
names (Sarah, Ehud, Achsah, Eli). We also encounter Mutius Scaevola,
a Roman of the sixth century B.C., who made his way into the enemy
camp of Lars Porsena and attempted to kill him. Captured before he could
accomplish his purpose, he was sentenced to death, and to show his indif-
ference to this fate, he thrust his right hand into a fire. The king was so
impressed that he released Mutius, who then acquired the cognomen
Scaevola, which means "left-handed." Far more obscure is Colonel
Draper, who was a Cambridge friend of the poet. Smart's capacity to iden-
tify with the Pelican, a creature that was believed to pierce its own breast
with its beak, and by shedding its blood and dying, to nourish thereby its
own young, and thus exemplify Christ's sacrifice, and whose unlovely
song is nevertheless "the best music in his power," and his identification
with the stoic and resigned Mutius, are both affecting enough. But it is the
final line quoted above that seems to me most moving. The "White Ra-
ven," an albino bird, is obviously a curiosity and a freak. So was poor
Thomas Hall of Willingham, a "gigantic boy" who lived to be six years
old. And Smart felt himself to be a freak not only because he was aware of

his own madness, or because it was certified by authorities, but because, according to the custom of the times, one of the social diversions of ladies and gentlemen was to visit lunatic asylums in much the same way that we visit zoos, and William Hogarth represented some such fashionable visitors to a madhouse in one of the paintings of *The Rake's Progress* (fig. 33). As Michel Foucault observes in *Madness and Civilization*:

> It was doubtless a very old custom of the Middle Ages to display the insane. In certain of the Narrtürmer [places of detention reserved for the insane] in Germany, barred windows had been installed which permitted those outside to observe the madmen chained within. Thus they constituted a spectacle at the city gates. . . . As late as 1815, if a report presented in the House of Commons is to be believed, the hospital of Bethlehem exhibited lunatics for a penny, every Sunday. Now the annual revenue from these exhibitions amounted to almost four hundred pounds; which suggests the astonishingly high number of 96,000 visits a year. In France, the

33. William Hogarth, Plate VIII (second state) from A *Rake's Progress*

excursion to Bicêtre and the display of the insane remained until the Revolution one of the Sunday distractions for the Left Bank bourgeoisie.[24]

This curious mixture of pride, self-consciousness, and vulnerability, evidenced in the lines by Smart, is also to be found in a poem by the American poet Anne Sexton, which exhibits a distinct kind of emotional disjunction.

Her Kind

I have gone out, a possessed witch,
haunting the black air, braver at night;
dreaming evil, I have done my hitch
over the plain houses, light by light:
lonely thing, twelve-fingered, out of mind.
A woman like that is not a woman, quite.
I have been her kind.

I have found the warm caves in the woods,
filled them with skillets, carvings, shelves,
closets, silks, innumerable goods;
fixed the suppers for the worms and the elves:
whining, rearranging the disaligned.
A woman like that is misunderstood.
I have been her kind.

I have ridden in your cart, driver,
waved my nude arms at villages going by,
learning the last bright routes, survivor
where your flames still bite my thigh
and my ribs crack where your wheels wind.
A woman like that is not ashamed to die.
I have been her kind.[25]

The disjunction of which I spoke is most easily to be detected in the not easily reconcilable shifts of tone from one stanza to the next. The first of these stanzas seems to be indebted not only to the figures of the Weird Sisters in *Macbeth*, but to the general witches' lore of common superstition that lay behind them and that was a part of Elizabethan folklore. It found a characteristic expression in *The Discoverie of Witchcraft* (1584) by Reginald Scot.

Then he (the Devil) teacheth them to make ointments of the bowels and members of children, whereby they ride in the air, and accomplish all their desires. So as, if there be any children unbaptized, or not guarded with the sign of the cross or orisons; then the witches may and do catch them from their mothers' sides in the night, or out of their cradles, or otherwise kill them with their ceremonies; and after burial steal them out of their graves, and seethe them in a cauldron, until their flesh be made potable. Of the thickest whereof they make ointments, whereby they ride in the air. . . . It shall not be amiss here in this place to repeat an ointment greatly to this purpose. . . . The receipt is as followeth. R. the fat of young children, and seethe it with water in a brazen vessel, reserving the thickest of that which remaineth boiled in the bottom, which they lay up and keep until occasion serveth to use it. They put hereunto *eleoselinum, aconitum, frondes, populeas,* and soot. Another recipe to the same purpose [contains] blood of a flittermouse [i.e., a bat]. They stamp all these together, and then they rub all parts of their bodies exceedingly, till they look red, and be very hot, so as the pores may be opened, and their flesh soluble and loose. . . . By this means in a moonlight night they seem to be carried in the air, to feasting, singing, dancing, kissing, culling and other acts of venery, with such youths as they love and desire most: for the force of their imagination is so vehement, that almost all that part of the brain, wherein the memory consisteth, is full of such conceits.[26]

If the first stanza partakes of all the macabre, hallucinatory, and dimly supernatural airs of Elizabethan witchcraft and its lore, the second is quite different, and has about it the odd nursery-tale anthropomorphism and animal domesticity of Arthur Rackham drawings (fig. 34). It presents something whose unnaturalness is sanitized by elements bordering dangerously on cuteness. The fussy housewifery performed on behalf of "the worms and the elves" comes out of a child's world of safety and delight in the unsuspected world of which adults know nothing. But this in turn gives way in the third stanza to something even more inconsistent with what preceded it. The materials of the final stanza are neither folklorish like the first, nor childlike as in the second, but come instead from the terrible annals of the Salem witch trials. A woman is here being sent to an excruciating death, in the name of religious zeal and fanaticism that took real lives in our country, in England, and elsewhere. It is also made more immediate, personal, and direct by addressing a specific, if nameless,

34. Arthur Rackham, Illustration from *Peter Pan in Kensington Gardens* by J. M. Barrie

"driver," who is delivering the witch to her execution—and who stands, accordingly, for persecutors generally, and for the society that finds madness a punishable crime. What is troubling about these shifts in tone and background is that we have difficulty grasping the identity of the speaker or figuring out how she feels about herself. There is certainly a keen sense of martyrdom and self-pity in the final stanza, half justified by the undeniable fact that women were once treated in this way for any deviation from socially accepted behavior. But we nevertheless remember that the speaker is not literally going to be executed, and there is something like a plea for pity in the last stanza that, in its witch-trial context, makes no sense, and makes even less sense when it is aligned with the two previous stanzas. Behind this pronounced inconsistency is psychic conflict that may have

been so private as to have been unresolved by, and possibly even unknown to, the poet herself.

I must turn finally to a poem that represents a different kind of privacy. There is a celebrated sonnet by Sir Thomas Wyatt that may be cited here, not alone for its relevance but for its beauty and power as well.

> Who so list to hount, I knowe where is an hynde,
>> But as for me, helas, I may no more:
>> The vayne travaill hath weried me so sore.
>> I ame of theim that farthest commeth behinde;
> Yet may I by no meanes my weried mynde
>> Drawe from the Diere: but as she fleeth afore,
>> Faynting I folowe. I leve of therefore,
>> Sins in a nett I seke to hold the wynde.
> Who list her hount, I put him owte of dowbte,
>> As well as I may spend his tyme in vain:
>> And, graven with Diamonds, in letters plain
> There is written her faier neck rounde abowte:
>> *Noli me tangere*, for Cesars I ame;
>> And wylde for to hold, though I seme tame. [27]

This remarkable poem was for a long time construed to be redolent of the most intimate kind of scandal, which has been summarized in the account by Kenneth Muir in his excellent Muses Library edition of Wyatt's poems. As a young man of seventeen, Muir tells us, Wyatt married Elizabeth, the daughter of Lord Cobham. She bore him two children but later proved unfaithful, and Wyatt refused to live with her. He was then appointed to various posts at court, and sent on some embassies abroad, but it was in the court at home that he became acquainted with Anne Boleyn. According to Nicholas Sanders, a contemporary, Anne, then merely a lady-in-waiting, became Wyatt's mistress. A good deal of speculation has naturally gone into debating this allegation, most of it an ex post facto assessment of Anne's moral and sexual character, which was to be far more severely calumniated later in her brief life. Suffice it to say that when Henry VIII let it be known that he intended to marry Anne (having put away and divorced his first wife, Catherine of Aragon, on what he claimed were theological grounds, but which were much more probably her incapacity to produce a male heir that Henry desperately wanted) Sir Thomas Wyatt came forward and informed the Privy Council that his former mistress "was not a suitable wife for the King." It was a very courageous thing to have done, and it may in the end have saved Wyatt's life. In

any case, Henry was not to be deflected from the object of his desires, and regally decided to overlook Anne's early indiscretion.

The topic of Anne's character is considered with painstaking care in James Anthony Froude's enormous *History of England from the Fall of Wolsey to the Death of Elizabeth,* an admittedly partisan and Protestant account, the objectivity of which has been called into question by a number of later, chiefly Catholic, historians. Some facts, however, are virtually indisputable. Anne understandably regarded Henry's first wife, though now divorced by the king, and sequestered under a kind of house arrest, as an affront to her own claim to be both queen of England and wife of Henry, for the Vatican did not recognize Henry's divorce. Consequently, nothing could have been more liberating and legitimating to Anne than the death, when it came to pass, of Catherine of Aragon. Henry may have divorced her (probably for dynastic reasons, as I said), but he respected her, and he must in some ways have liked her, or at least wished to give that appearance, for he ordered the court into mourning, "a command which," in the words of Froude, "Anne Boleyn distinguished herself by imperfectly obeying."[28] She wore yellow. Her hour of triumph, however, was very little more than a literal hour. She had borne Henry a daughter, who would one day become the great Queen Elizabeth, but she then produced a stillborn son, and by this time Henry had wearied of her, and had already fixed his attention on the young Jane Seymour, who was to be his next queen. But before he could wed Jane, Anne had to be disposed of, and charges of adultery and incest were brought against her. She was accused of "following her frail and carnal lust" with her own brother, George, Lord Rochfort, as well as with Henry Norris, William Brereton, Sir Francis Weston, and Mark Smeaton. Froude suspects that there must have been at least some truth in these allegations, for if Henry had merely desired to free himself by framing Anne with a false charge he need not have gone to the trouble of indicting so many men, when a single one would have done. Moreover, there were many rumors about Anne's sirenlike capacity to bewitch men. She was not particularly beautiful, and indeed according to one account she was actually deformed, having six fingers on one hand. It may be that her sexual charm was developed precisely to compensate for this unconcealable handicap. Whatever the case may be, Anne herself and all the indicted men were found guilty, and her execution, together with theirs, freed Henry to marry again almost immediately. But in the brief period of her disgrace, Wyatt was remembered as one who had warned the Privy Council with regard to her, and though he was detained in prison, he was exonerated.

This, in brief, is the background that for many years served as a literal and historical gloss on Wyatt's sonnet. The poem was read as an allegorical account of the taunting behavior of a sexual tease, a flirt who encouraged the pursuit of men, whose admiration and desire she deliberately provoked, only to turn at the last minute and claim the privilege and the quarantine of royal protection. The poem seems poignantly to express, under the traditional figure of the hunt, not only the pursuit but the magnetic attractiveness of the quarry, the exhaustion and ultimate hopelessness of the undertaking, and the smug, almost sadistic pleasure with which men are led on, only to be, as it were, summarily and regally disappointed. It was an assumption that scarcely needed to be stated that by "Caesar" King Henry was intended.

But after this sense of the poem had enjoyed its widespread acceptance, a new school was heard from, announcing that there was nothing personal whatever in Wyatt's poem, which was in fact a lively and imaginative translation of one of the sonnets of Petrarch—a sonnet, moreover, that wholly lacked the notes of bitterness and reproach that seem such strong elements in Wyatt. I offer here an English version somewhat nearer to the original Italian, which itself is a darkly obscure and difficult poem.

> CXC: *Una candida cerva*. . . .
> A pure-white doe in an emerald glade
> Appeared to me, with two antlers of gold,
> Between two streams, under a laurel's shade,
> At sunrise, in the season's bitter cold.
>
> Her sight was so suavely merciless
> That I left work to follow her at leisure,
> Like the miser who looking for his treasure
> Sweetens with that delight his bitterness.
>
> Around her lovely neck "Do not touch me"
> Was written with topaz and diamond stone,
> "My Caesar's will has been to make me free."
>
> Already toward noon had climbed the sun,
> My weary eyes were not sated to see,
> When I fell in the stream and she was gone.[29]

As compared with Wyatt's superb poem (not everyone agrees; John Berdan finds the Wyatt blighted by "its lack of either art or feeling") this one by a

modern translator is clumsy, awkward, and deficient in grammar, as well as being obscure where the original is clear. For example, where this translation offers "the season's bitter cold," which leaves us free to imagine winter, the Italian has *la stagione acerba*, which refers to April and the onset of spring. This detail, in a heavily allegorized poem, is important to Petrarch, since the entire poem is about his beloved Laura, whom he beheld for the first time when he was twenty-three, on April 6, 1327, at the Church of Saint Clare in Avignon, which is, as the translation indicates, located between two streams, the Sorga and the Durenza. More serious still, what the modern version translates as "suavely merciless" in the original is *dolce superba*, or "gently proud." Nevertheless, despite these inadequacies and some others as well, the modern version allows us to see some things denied us in Wyatt's poem. There is general critical agreement among Petrarch scholars that the "doe" or "hynde" of the poem represents Laura; the doe is sacred to Diana, goddess of both chastity and the hunt, and is thus a symbol of purity. Its whiteness also symbolizes chastity. Pliny the Elder mentions a white fawn that was the constant companion of Quintus Sertorius, the Roman general and statesman, so much beloved by the tribes in Spain he was assigned to govern that they gave him the tame creature for a pet, and he allowed it to accompany him everywhere, and treated it with great respect. The two golden horns are said to represent Laura's blonde hair. The poem is not only set in the month of April, but at *levando 'l sole*, which literally means the rising of the sun, and figuratively the onset of adolescence. And now we come to the extraordinary collar and its motto. The collar is composed of diamonds and topazes, which refer respectively to virtue in general and to modesty in particular. It is universally acknowledged by Italian commentators that Caesar is to be understood as God, and that the poem is a conflation of Petrarch's first encounter with Laura and his later anguished premonition that she had been chosen by God for an early death. There was a legend that three hundred years after the death of Caesar a fawn was discovered with a collar that was inscribed *Noli me tangere, Caesaris sum*. The Latin phrase explicitly recalls the words of Christ to Mary Magdalene, spoken after his resurrection, and reported in the Gospel of John, "Jesus saith unto her, Touch me not; for I have not yet ascended to my Father." What is implied by this is Christ's perfect purity, which, though he had taken upon himself the sins of the world, was achieved or renewed by his sacrifice—a purity not now to be defiled before his ascent into heaven. But behind this there lies as well the more or less common practice of tagging or otherwise identifying the deer allowed to roam on royal

preserves, which are therefore explicitly protected from common hunters or poachers under threat of the most severe penalties. The terrible premonition of Laura's death accounts for the swoon into which the poet falls at the end of the poem, an ending that is set at *mezzo giorno*, which is to say, at noon, even though the sonnet begins at dawn. This dramatic change of time is not to be explained, according to the commentators, by the fact that the pursuit has occupied the entire morning, but instead we are to understand that by "noon" is meant the midpoint of life, and Petrarch was already just past that point at the time he wrote this poem.

So we have two seemingly irreconcilable ways of regarding the Wyatt poem: as an embittered, if somewhat guarded, personal complaint, or as a very free and cavalier translation, lacking a good deal in the way of fidelity to the original. But it seems to me mistaken to assume that a choice must be made between alternatives, decisively opposed though these two seem to be in tone and significance. Wyatt would not have been the first, nor was he to be the last, to express his feelings in the innocuous guise of translation; nor the first or last to adopt the voice of a departed predecessor to serve as mouthpiece for sentiments it might have been injudicious to utter in his own person. The differences between his version and the Italian original could always be explained by those liberties and interpretations that are the invariable right of translators, and unquestionably Petrarch's sonnet, in its allegorical complexity, allows for a variety of renderings, and resonates with a multitude of implications.

V

The Contrariety of Impulses

The excellence of every Art is its intensity, capable of making all disagreeables evaporate, from their being in close relationship with Beauty & Truth—Examine King Lear & you will find this examplified [sic] throughout.

JOHN KEATS
letter to George and Tom Keats, December 21–27, 1817

Poetry is a disinterested use of words.

NORTHROP FRYE
Anatomy of Criticism

[Haydn's] quartets attempt to unify the most diverse materials against great odds.

GEORGE EDWARDS
"The Nonsense of an Ending: Closure in Haydn's String Quartets"

I BEGAN the first of these essays with a brisk and fleeting reference to Schopenhauer's description of architecture as an art revealing itself in what he called "discord"—by which he did not mean its complicated and possibly compromising negotiating of aesthetic and practical motives, but something intrinsic to the art itself. He says:

> properly speaking the conflict between gravity and rigidity is the sole aesthetic material of architecture; its problem is to make this conflict appear with perfect distinctness in a multitude of different ways. It solves [the conflict] in depriving these indestructible forces of the shortest way to their satisfaction, and conducting them to it by a circuitous route, so that the conflict is lengthened and the inexhaustible effort of both forces becomes visible in many different ways. [1]

This characteristic of dialectical forces, delayed resolutions, balanced oppositions, reckoned as essential to many of the most memorable works of art, is the topic I want to pursue today. And I find that the dramatic plays of force I wish to speak about were not, even in architectural discourse, confined to Schopenhauer's philosophy; they appear in the very title of Robert Venturi's book *Complexity and Contradiction in Architecture*. That book opens with the following bold declaration:

> I like complexity and contradiction in architecture. I do not like the incoherence or arbitrariness of incompetent architecture nor the precious intricacies of picturesqueness or expressionism. Instead, I speak of a complex and contradictory architecture based on the richness and ambiguity of modern experience, including the experience which is inherent in every art. Everywhere, except in architecture, complexity and contradiction have been acknowledged, from Gödel's proof of the ultimate inconsistency in mathematics to T. S. Eliot's analysis of "difficult" poetry and Joseph Albers' definition of the pardoxical quality of painting. [2]

It is possible that Mr. Venturi's book, written from the perspective of a 1962 view of modern architecture, was framed to some degree as a polemic; he has himself provided an antidote to the kinds of sterility he deplored. But I want to turn from his eloquent description of his own art to Dr. I. A. Richards's description of *his*. Richards was a poet-critic (probably better known for his criticism than for his poetry, not unlike some others of the same double profession, like Dr. Johnson), and he approached the problem of defining the experience of poetry from the point of view of one trained in psychology, linguistics, and philosophy. In a

work called *Science and Poetry* he offers this almost mechanistic description of what happens to us when we read a poem.

> To understand what an interest is we should picture the mind as a system of very delicately poised balances, a system which so long as we are in health is constantly *growing*. Every situation we come into disturbs some of these balances to some degree. The ways in which they swing back to a new equipoise are the impulses with which we respond to the situation. And the chief balances in the system are our chief interests.
>
> Suppose we carry a magnetic compass about in the neighbourhood of powerful magnets. The needle waggles as we move and comes to rest pointing in a new direction whenever we stand still in a new position. Suppose that instead of a single compass we carry an arrangement of many magnetic needles, large and small, swung so that they influence one another, some able only to swing horizontally, others vertically, others hung freely. As we move, the perturbations in this system will be very complicated. But for every position in which we place it there will be a final position of rest for all the needles into which they will in the end settle down, a general poise for the whole system. But even a slight displacement may set the whole assemblage of needles busily readjusting themselves.
>
> One further complication. Suppose that while all the needles influence one another, some of them respond only to some of the outer magnets among which the system is moving. . . .
>
> The mind is not unlike such a system if we imagine it to be incredibly complex. . . .
>
> We must picture then the stream of the poetic experience as the swinging back into equilibrium of these disturbed interests.[3]

Dr. Richards, who gave as much thought to these matters as any man of modern times, reformulated this notion two years later in his book of 1928, *Principles of Literary Criticism*, from which I beg to be allowed to quote selectively and at modest length.

> The primitive and in a sense natural outcome of stimulus is action; the more simple the situation with which the mind is engaged, the closer is the connection between the stimulus and some overt response in action, and in general the less rich and full is the consciousness attendant. . . . Most behavior is a reconciliation between the various acts which would satisfy the different impulses which

combine to produce it; and the richness and interest of the feel of it in consciousness depends upon the variety of the impulses engaged. . . . To take [an] obvious example, the description or theatrical presentation of a murder has a different effect upon us from that which would be produced by most actual murders if they took place before us. These considerations, of vast importance in the discussion of artistic form, will occupy us later. Here it is sufficient to point out that these differences between ordinary experience and those due to works of art are only special cases of the general difference between experience made up of a less and a greater number of impulses which have to be brought into co-ordination with one another.

At this point in the course of his description, Richards makes a singular and very important point.

> The result of the co-ordination of a great number of impulses of different kinds is very often that no *overt* action takes place. There is a danger here of supposing that there is something incomplete or imperfect about such a state of affairs. But imaginal action and incipient action which does not go so far as actual muscular movement are more important than overt action in the well-developed human being. Indeed the difference between the intelligent and refined, and the stupid or crass person is the difference in the extent to which overt action can be replaced by incipient and imaginal action. An intelligent man can "see how a thing works" when a less intelligent man has to "find out by trying" . . . it is in terms of attitudes, the resolution, inter-inanimation, and balancing of impulses—Aristotle's definition of Tragedy is an instance—that all the most valuable effects of poetry must be described.[4]

In a review (which Richards himself wryly approved) of the book from which I have just quoted, Conrad Aiken characterized the aesthetic doctrine here expounded in these words: "An experience, [Richards] says, is valuable in accordance as it organizes and uses without waste 'conflicting impulses.' The poet's experiences 'represent conciliations of impulses which in most minds are still confused, intertrammelled and conflicting.'"[5]

For all his long and productive life Dr. Richards was a devoted admirer of Coleridge (who was also a poet-critic), and so it should not perhaps surprise us to find that his scientific-mechanistic description of impulses as the oscillating needles in a hierarchy of compasses, resembling the control panels of a science-fiction spaceship, is in fact a modernist metaphor for

something Coleridge famously formulated in the fourteenth chapter of the *Biographia Literaria* in 1817.

> The poet, described in *ideal* perfection, brings the whole soul of man into activity, with the subordination of its faculties to each other, according to their relative worth and dignity. He diffuses a tone and spirit of unity, that blends, and (as it were) *fuses*, each to each, by that synthetic and magical power, to which we have exclusively appropriated the name of imagination. This power, first put in action by the will and understanding, and retained under their irremissive, though gentle and unnoticed, controul . . . reveals itself in the balance or reconciliation of opposite or discordant qualities: of sameness, with difference; of the general, with the concrete; the idea, with the image; the individual, with the representative; the sense of novelty and freshness, with old and familiar objects; a more than usual state of emotion, with more than usual order; judgement ever awake and steady self-possession with enthusiasm and feeling profound or vehement; and while it blends and harmonizes the natural and the artificial, still subordinates art to nature; the manner to the matter; and our admiration of the poet to our sympathy with the poetry.[6]

What my critical authorities have been asserting in their different ways is, it seems to me, very much what Yeats stated in *Per amica silentia lunae* when he declared: "We make out of the quarrel with others rhetoric, but of the quarrel with ourselves, poetry." Not content to leave that thought in prose, he incorporated it, or something akin to it, though deeper still in meaning, in the poem *Ego Dominus Tuus*, which is a poem of colloquy between two voices, called Hic and Ille, meaning "this" and "that." I break into their conversation at a point of contention in which the topic of art is addressed by Hic.

> *Hic.* Yet surely there are men who have made their art
> Out of no tragic war, lovers of life,
> Impulsive men that look for happiness
> And sing when they have found it.
> *Ille.* No, not sing,
> For those that love the world serve it in action,
> Grow rich, popular and full of influence,
> And should they paint or write, still it is action:
> The struggle of the fly in marmalade.
> The rhetorician would deceive his neighbours,

> The sentimentalist himself; while art
> Is but a vision of reality.[7]

We may gloss that challenging, oracular final line defining art as "a vision of reality" as a claim that insofar as the imagination is capable, it will take into account all factors, however conflicting, without fear or favor, without recourse to suppression of truth for polemical advantage (as rhetoric would do), and without falsification in behalf of some self-serving or self-gratifying agenda (as sentimentality is inclined to do). I shall return to Yeats, whose poetic imagination was particularly dialectical in character, before I have done. But I want to pause over these important declarations, or invite you to give them a moment's serious thought, for like Dr. Richards's statement that poetry does not lead us into direct action, they bear upon a famous and often misunderstood line of W. H. Auden's—written, it may be added, in an eloquent tribute to Yeats. Auden wrote: "Poetry makes nothing happen." He further claimed—this time in a prose passage —that "poetry may be defined as the clear expression of mixed feelings."[8] Such views as these tend to inhibit any instinct toward sanctimoniousness, indignation, or that dangerous urge to eliminate the leaven of self-doubt or humor from the poet's purview. Indeed, it has been said by Benjamin de Casseres that "All seriousness is a defect of vision . . . there is no form of seriousness, even in art, that has not in it the germ of disaster for the mind that is slave to it."

Humor, as Freud and others tell us, is itself a kind of balance, hence dialectical in nature—and thus also implicitly dramatic. As Robert Frost observed, "Everything written is as good as it is dramatic. It need not declare itself in form, but it is drama or nothing."[9] And whatever else drama may be, it is of necessity dialectical. In this it transcends the partial and polemical, as Eliot claims in an essay called "The Social Function of Poetry," and claims, moreover, that poetry manages to bring about this transcendence almost, as it were, in spite of itself, and, if the poet is good enough, against the poet's own superficial intentions. Eliot writes:

> I should say that the question of whether a poet is using his poetry to advocate or attack a social attitude does not matter. Bad verse may have a transient vogue when the poet is reflecting a popular attitude of the moment; but real poetry survives not only a change of popular opinion but the complete extinction of interest in the issues with which the poet was passionately concerned. Lucretius' poem remains a great poem, though his notions of physics and astronomy are dis-

credited; Dryden's, though the political quarrels of the seventeenth century no longer concern us; just as a great poem of the past may still give great pleasure, though its subject matter is one which we should now treat in prose. [10]

Defending himself in the controversy raised about his line "Poetry makes nothing happen," Auden would later declare, "By all means let a poet, if he wants to, write *engagé* poems, protesting against this or that political evil or social injustice. But let him remember this. The only person who will benefit from them is himself; they will enhance his literary reputation among those who feel as he does. The evil or injustice, however, will remain exactly what it would have been if he had kept his mouth shut."[11]

I have attempted here to make the claim that the richest, most eloquent and durable of the arts in general, and poetry in particular, is always multivalenced, and implicitly when not explicitly dialectical. And this dialectical, self-critical discordance performs two functions simultaneously. It allows the poet to achieve a certain healthy impersonality, serving as a device by which to inhibit any limp tendency to narcissistic solipsism, on the one hand; and on the other, it lends to the poetry itself the rich complexity of actuality—the unsimplified plenitude of the objective world. This quality of what Venturi called "complexity and contradiction" is intrinsic not only to the art of poetry itself, to its created artifacts, but to the experience of poetry as a psychological event on the part of the reader. In an early essay called "The Perfect Critic," T. S. Eliot puts this case as unequivocally as I have found it stated anywhere. "The end of the enjoyment of poetry," he declares, "is a pure contemplation from which the accidents of personal emotion are removed; thus we aim to see the object as it really is . . . and without a labour which is largely a labour of the intelligence, we are unable to attain that state of vision *amor intellectualis Dei.*"[12] Such a labor of the intelligence, we may logically infer, would almost certainly serve to inhibit any instantaneous, visceral response that could eventuate in practical action.[13] (It needs also to be noted, at least parenthetically, that those final words in which Eliot lapses into Latin are appropriated from Baruch Spinoza, who came to identify the "highest" knowledge with that "intellectual love of God" in which the individual realizes himself as part of the living universe. And it must also further be remarked that such respect for the views of Spinoza, expressed here in a volume of 1920 called *The Sacred Wood*, does not chime harmoniously with Eliot's later deprecation, expressed in the 1933 volume *After Strange Gods*, of what he calls "excessive tolerance" toward "free-thinking Jews.")

35. Anonymous, *February*, prefixed to the second eclogue of *Shepherd's Calendar* by Edmund Spenser. The "argument" runs, in part: "This Aeglogue . . . specially conteyneth a discourse of old age, in the persone of *Thenot* an olde Shepheard, who for his crookednesse and unlustinesse, is scorned by Cuddie an vnhappy Heardsmans boye." Their views of age and youth are diametrically opposed throughout. Edmund Spenser, *Spenser's Minor Poems*, edited Ernest de Sélincourt (Oxford: Oxford University Press, 1910), 18

There are certain varieties of poetry in which the elements of discord and contrariety are overt and clear. Some of the eclogues of Virgil and idylls of Theocritus present us with explicit debates between two parties, or contentions in artistic or rhetorical endeavor, to be judged by a third party. Such poems as these (which some conjecture may have derived from the debates among the Olympian gods in Homer) were reverently imitated, and served as models for a good many poets of the English Renaissance, including Sidney, Spenser, Barnabe Googe, George Turbervile, Alexander Barclay, and Mary, Countess of Pembroke. The classical models have even been claimed as the origin of the debate among the fallen angels in Milton's *Paradise Lost*. There was, moreover, another strain of debate poems that may have found their origin, not in classical exempla, but in scriptural sources, and specifically in the verse of Saint Paul's Epistle to the Galatians that reads: "For the flesh lusteth against the spirit, and

the spirit against the flesh: and these are contrary the one to the other"
(5:17). It would take no great ingenuity to find in that verse the *fons et
origo* of a good number of celebrated debate poems, including Samuel
Daniel's "Ulysses and the Siren," the poems by Andrew Marvell called "A
Dialogue between the Soul and Body" and "A Dialogue, between the
Resolved Soul and Created Pleasure," and continuing into our own cen-
tury in the form of Yeats's "Dialogue of Self and Soul." But debate poems
were virtually a genre of their own in the Middle Ages. These would
include "The Dialogue of the Body and Soul" by Jacapone da Todi, the
anonymous poem "The Owl and the Nightingale," the *Psychomachia*
("The Battle of the Soul") by the Latin poet Prudentius, and a consider-
able body of French and Provençal poetry composed as colloquy, an-
tiphon, and contention. One of the minor lyric prizes in this category is
the lovely Elizabethan poem in fourteeners by Richard Edwards, which
embraces both discord and reconciliation in its very title, *Amantium irae
amoris redintegratio est*, and its refrain, which turns into English the Latin
title: "The falling out of faithful friends, renewing is of love." This line,
repeated at the end of every stanza, is a translation of some words of Ter-
ence, and quite obviously borders closely on paradox. But it should not
surprise us that paradox, irony, and ambiguity should be counted as
among the most powerful and revealing instruments at a poet's disposal.

Let me turn from this by no means exhaustive list of debate poems and
their kin to a set of poems in which the controversy is more subtly and
covertly represented. I have in mind that diptych of poems, Milton's
"L'Allegro" and "Il Penseroso." The poems are artfully paired, as their
paralleled language makes clear, and they seem to offer either alternate
moods that might possess a person, susceptible of changing from one day
to the next, or else alternative attitudes toward life itself, to which a person
might be said to be condemned or consigned by fate or temperament.
"L'Allegro" presents a largely sensual, "Il Penseroso" a largely moral or
intellectual, view of the world. But these alternatives are only two among
many that these complex poems present. One would have to add: the
active versus the contemplative (a favorite medieval theme); the secular
versus the religious; the gregarious versus the solitary; and the opposed
values of immediate versus delayed gratification. What Milton does with
remarkable skill (the more remarkable because he wrote these poems
when he was about twenty-two) is to make out an equally attractive and
plausible case for both sides, in the manner that any young university
debater, trained in the art of forensics, might be expected to be able to do.
(In something of the same virtuoso spirit, an earlier Cambridge graduate,
Christopher Marlowe, allowed his young protagonist, Leander, to con-

36. Donato Bramante, *Heraclitus and Democritus*

duct his courtship not in amorous but in forensic terms, by offering the beautiful young lady with whom he had fallen in love at first sight a syllogistic demonstration that chastity is not a virtue because it is not earned by merit or exertion, and that it does not exist because it cannot be seen— among other arguments, which enlist the authority of Aristotle, and which turn out to have a wonderfully persuasive effect upon the lady to whom they are addressed.)

Behind Milton's paired poems appear to lie an archetypal pair of philosophers. The Renaissance humanist Marsilio Ficino had a painting of "the smiling Democritus, defying the tears of Heraclitus," decorating his study, to remind himself and his visitors, in the words of Edgar Wind, that "cheerfulness was a quality becoming to a philosopher."[14] (See fig. 36.) Montaigne would have agreed, having written, "The most evident sign of wisdom is a constant cheerfulness."[15] But this view was by no means universally shared, and, as Milton's paired poems make clear, neither attitude

(all modern prejudices to the contrary notwithstanding) is intrinsically better or wiser than the other. In fact, a strong and important tradition associated philosophy not with cheerfulness but with melancholy. Edgar Wind, upon whose ample and admirable learning I have greatly relied in my account of these matters, reminds us: "Like the Florentine academicians, those in Milan cherished the image of Democritus and Heraclitus, but without giving the palm to Democritus. Bramante's painting in the Brera should be compared with a long poem in *terza rima* by Antonio Fregoso, *Riso de Democrito et pianto de Heraclito*, where Heraclitus has the last word."[16] Ficino, favoring the smiling philosopher, and basing his views on a discourse by Aristotle, had nevertheless himself asserted in his treatise *De vita triplici* that all truly outstanding men were melancholics. The Florentine Neoplatonists linked the idea of melancholy to Plato's theory of "divine frenzy," and discovered that Plotinus and his followers, rather than disparaging Saturn, the tutelary god of melancholy, considered him the highest of the planets, representing the mind of the world, and consequently superior to Jupiter, who symbolized the soul. This "priority" of Saturn may also have been due to the combined facts that (a) Saturn was the father of Jupiter, and (b) Saturn was the reigning divinity of the legendary and taintless Age of Gold, before the decline in human fortunes had set in. In his *Occulta philosophia*, Cornelius Agrippa of Nettesheim follows Ficino's hierarchy of mental faculties. They both place mind (*mens*) first, followed by reason (*ratio*), which in turn is followed by imagination (*imaginatio*). But whereas Ficino thought only the highest order, mind, was "susceptible to the inspiring influence of Saturn," Agrippa asserted that the *furor melancholicus* could produce genius at all these levels. Dame Frances Yates conjectures that the title of Dürer's engraving *Melencholia I* signifies that he intended two more depictions of melancholy, corresponding to the two additional faculties in Ficino's and Cornelius Agrippa's Neoplatonic hierarchy. Do not, incidentally, be misled into the easy supposition that by melancholy is meant anything so simple as a disposition to morbidity or surliness. Cornelius Agrippa wrote, "The *humor melancholicus*, when it takes fire and glows, generates the frenzy (*furor*) which leads us to wisdom and revelation, especially when it is combined with heavenly influence, above all with that of Saturn."[17] And Robert Burton's *Anatomy of Melancholy* (see fig. 37), an immensely long and complicated disquisition on the very condition of being learned, composed by a very learned man, opens with an introduction by a putative "Democritus Junior" whose laughter at the follies of the world is almost as sad as, and is nearly the equivalent of, the tears of Heraclitus.[18]

That familiar pairing of laughter and tears was iconically expressed by the ancient Greek masks of comedy and tragedy; it is our habit of mind to regard these two dramatic forms as not only distinct from but opposed to one another. As perhaps they are. But it may also be that like "L'Allegro" and "Il Penseroso," they are merely two ways of regarding the one and only world. This seems to have been the view of Socrates early one morning after a night of carousing and speculation on the topic of love. Almost everyone one had had too much to drink, and, as Plato (or, more properly, his narrator, Apollodorus) tells it,

> there remained only Socrates, Aristophanes, and Agathon, who were drinking out of a large goblet which they passed round, and Socrates was discoursing to them. Aristodemus was only half awake, and he did not hear the beginning of the discourse; the chief thing which he remembers was Socrates compelling the other two to acknowledge that the genius of comedy was the same as that of tragedy, and that the true artist in tragedy was an artist in comedy also. To this they were constrained to assent, being drowsy, and not quite following the argument. And first of all Aristophanes dropped off, then, when the day was already dawning, Agathon. Socrates, having laid them to sleep, rose to depart; Aristodemus, as his manner was, following him. At the Lyceum he took a bath, and passed the day as usual. In the evening he retired to rest in his own home.[19]

Plato's dialogue is, of course, an exercise in dialectics, but the *Symposium* (from which I have quoted) is still more. All the views it presents on the topic of love are composed of a linkage of binary forces, of matched and neatly mated pairs, sometimes in opposition, sometimes in conciliation. Love itself, in the famous description of Diotima, is, in a marvelous paradox, the child of Poverty and Plenty, and so when we encounter the last topers, groggy with drink as the cocks crow at the earliest light of dawn, we should not be surprised—though it goes against our common experience—to find Socrates maintaining the kinship of comedy and tragedy. When he affirms that the true artist in one of these genres ought to be equally competent in the other, we cast about in our minds and can rarely think of anyone besides Shakespeare who exhibits that versatility. And it may be added that Shakespeare's skill extends beyond his capacity, praised by Ben Jonson, to adorn himself, as the occasion warranted, with either the buskin of tragedy or the sock of comedy. For in each of his tragedies, no matter how terrible, we are granted some perspective by the sympathetic presence of a comic voice, an alternate and even parodic vision of

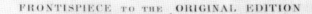

Zelotypa

Democritus Abderites

Solitudo

THE
ANATOMY OF MELANCHOLY

What it is, with all the kinds, causes,
symptoms, prognostics & several cures of it.

In three Partitions, with their several
Sections, numbers & subsections.
Philosophically, Medicinally,
Historically opened & cut up.

BY

Democritus Junior.

With a Satyrical Preface conducing
to the following Discourse.
The Sixth Edition, corrected and
augmented by the Author.
Omne tulit punctum, qui miscuit utile dulci.

Inamorato

Hypocondriacus

Superstitiosus

Democritus Junior

Maniacus

London,
Printed & are to be sold by
Hen. Cryps & Lodo. Lloyd at
their shop in Popes-head Alley
1652

Borage

Hellebor

all the terror and pain at the heart of the tragic events. All the great Shake-spearean tragedies are the richer, the more persuasive, for providing this double vision. But it is also there in even so seemingly taintless a comedy as *A Midsummer Night's Dream*, where a possible sentence of death may be imposed upon Hermia if she disobeys her father regarding the choice of her husband. And this is only the beginning of fearful omens. The marital hostilities of Oberon and Titania are anything but a cheerful portent for newlyweds. Mention is made in the course of the play of venereal disease and women's death in childbirth, and the play ends with a play within a play, the hilarious performance of what is amazingly called "very tragic mirth," the double suicide of Pyramus and Thisby, which is nothing less than a grotesque parody of the plot of *Romeo and Juliet* that Shakespeare would treat with tragic respect only a year later. And the complications of comedy and tragedy not only end but begin the play. Shakespeare's origi-nal audience, encountering Theseus and Hippolyta just before their wed-ding, would have been less likely to have thought of these majestic figures as derived from classical mythology than to recall them from their pres-ence in one of the *Canterbury Tales*. There, in the Knight's Tale, Theseus and Hippolyta are interrupted at their wedding festivities by mourning queens whose husbands were slain in the seige against Thebes, and their corpses condemned by Creon to be left unburied. On this tragic note do the wedding festivities begin, with Eros and Thanatos brought into terrible and eloquent conjunction. Shakespeare is likely to have depended upon his audience's familiarity with this uncomfortable collocation, so that any modern critic who blithely assures us that "the play is a comedy, and . . .

37. (facing) Frontispiece to *The Anatomy of Melancholy* by Robert Burton. Burton wrote a poem to gloss the panels of this title page. *Upper left* is "*Zelotipia* or sexual jealousy, including two fighting cocks. In the *centre* is Democritus of Adbera medi-tating, surrounded by the skins of animals which he has anatomized to find 'the seat of black choler': in the sky is the sign of Saturn, 'Lord of Melancholy'. On the *right* is *Solitudo*, the symbolic animals including a sleeping dog [see Dürer's en-graving], a hare (timorous and melancholy) in the 'desert', and owls hovering over 'shady bowers' in 'melancholy darkness'. *Centre left* a lovesick melancholic, with traditional folded arms and hat pulled over his eyes, the 'lute and books' as 'symp-toms of his vanity'; *centre right* the hypochondriac melancholic, chin resting on his hand (sign of inactivity), pots and glasses from the apothecary all around him. *Lower left* is a superstitious and idolatrous monk telling his beads; *lower right* a mad-man in rags shackled to the floor. Below them are the herbs borage and hellebore, 'sovereign plants to purge the veins . . . and chear the heart' of its black fumes. The portrait is of the author as Democritus Junior, intending to revive and com-plete the work of his great predecessor." Brian Vickers, "The Seventeenth Century," in *The Oxford Illustrated History of English Literature*, edited by Pat Rogers (New York: Oxford University Press, 1987), 192.

38. Titian, *Cupid with the Wheel of Fortune*

nothing fatal, irreparable, or unforgivable will occur to disturb our plea-
sure and our laughter"[20] has missed all the anxious notes of contingency
and conditionality that hedge the play about. And pure aleatory, random
fortuitousness is what Puck, like blind Cupid, though perhaps more mis-
chievously, represents in this play. Love was traditionally represented as
associated with fate and uncontrollable destiny that could eventuate in
grief as easily as in joy. He is depicted, "setting the wheel of Chance in
motion," in a painting by Titian in the National Gallery (fig. 38). And

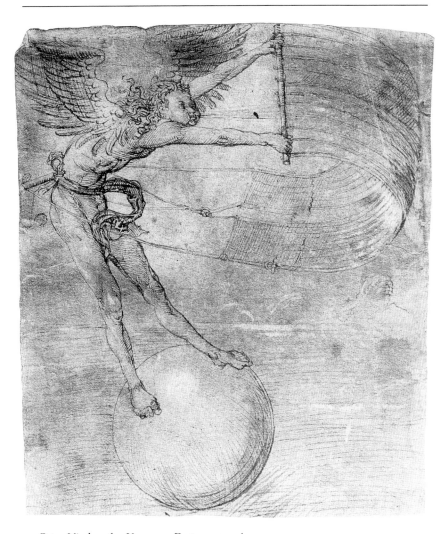

39. Peter Vischer the Younger, *Fortuna amoris*

Wind also directs our attention to the image of *Fortuna amoris* (fig. 39), the depiction of self-sustained fatuity, a divinity that has appropriated the sphere and sail belonging to Fortuna herself.

But I must turn from these large works, so easily susceptible to a welcome variety of effects, to the examples of dialectical forces within the framework of the lyric poem. And I want to offer as my first example a poem by William Carlos Williams, who has always been revered by his admirers as the poet who is supremely straightforward, antiacademic,

guileless, plain, and a militant foe of affectation. In the words of Randall Jarrell, one of the most astute of his devotees, "He has the honesty that consists in writing down the way things seem to you yourself, not the way that they really must be, that they *are*, that everybody but a misguided idealist or shallow optimist or bourgeois sentimentalist *knows* they are."[21] In other words, Williams is unequivocally opposed to sham and falsity under whatever banner such falsity may wish to advance itself. Here, then, is one of his better-known, and much admired, poems.

<div style="text-align:center">Tract</div>

I will teach you my townspeople
how to perform a funeral
for you have it over a troop
of artists—
unless one should scour the world—
you have the ground sense necessary.

See! the hearse leads.
I begin with a design for a hearse.
For Christ's sake not black—
nor white either—and not polished!
Let it be weathered—like a farm wagon—
with gilt wheels (this could be
applied fresh at small expense)
or no wheels at all:
a rough dray to drag over the ground.

Knock the glass out!
My God—glass, my townspeople!
For what purpose? Is it for the dead
to look out or for us to see
how well he is housed or to see
the flowers or the lack of them—
or what?
To keep the rain and snow from him?
He will have a heavier rain soon:
pebbles and dirt and what not.
Let there be no glass—
and no upholstery, phew!
and no little brass rollers

and small easy wheels on the bottom—
my townspeople what are you thinking of?

A rough plain hearse then
with gilt wheels and no top at all.
On this the coffin lies
by its own weight.

 No wreaths please—
especially no hot house flowers.
Some common memento is better,
something he prized and is known by:
his old clothes—a few books perhaps—
God knows what! You realize
how we are about these things
my townspeople—
something will be found—anything
even flowers if he had come to that.
So much for the hearse.

For heaven's sake though see to the driver!
Take off the silk hat! In fact
that's no place at all for him—
up there unceremoniously
dragging our friend out to his own dignity!
Bring him down—bring him down!
Low and inconspicuous! I'd not have him ride
on the wagon at all—damn him—
the undertaker's understrapper!
Let him hold the reins
and walk at the side
and inconspicuously too!

Then briefly as to yourselves:
Walk behind—as they do in France,
seventh class, or if you ride
Hell take curtains! Go with some show
of inconvenience; sit openly—
to the weather as to grief.
Or do you think you can shut grief in?
What—from us? We who have perhaps
nothing to lose? Share with us

share with us—it will be money
in your pockets.
 Go now
I think you are ready.[22]

Let us begin with the title. Though there are a number of neutral and comparatively dispassionate definitions of the word, I think the meaning demanded here is the one from the *Oxford English Dictionary* which reads: "A short pamphlet on some religious, political, or other topic, suitable for distribution or for purposes of propaganda." For the poem gives all the outward appearances of being hortatory, embattled, and polemical, by turns instructive, cajoling, reprimanding, contemptuous, but invariably doctrinaire and pedagogical. It contains no fewer than fourteen exclamation marks, as well as seven rhetorical questions, implying their own answers, and is nothing if not emphatic, almost to the point of being dogmatic.

Nominally it is about how a funeral ought to be conducted; but we know at once that this is merely the pretext for discourse of a wholly different sort (and we recall Frost's dictum about poetry being the only way of saying one thing and meaning another). The poem begins, "I will teach you my townspeople / how to perform a funeral / for you have it over a troop / of artists—" and we are entitled immediately to wonder why the poet did not present us with the more predictable words "morticians," "undertakers," or "funeral-parlor directors," instead of "artists." It will not take long for us to realize that the poem is about a revolution in the arts in which Williams himself played a major and active role. He was a member of the American avant-garde, a friend of such artists as Charles Demuth and Alfred Stieglitz; they were engaged in a campaign to produce a native and indigenous art that not only would pay no debts and make no obeisance to English forerunners, but would conscientiously eliminate all the superfluous frills and artificial ornamentations that had cluttered, when they had not in fact corrupted, the art of the past. And in this poem, which is composed of four hundred and two words, three hundred and forty-three of them are monosyllables. Dr. Williams has an agenda here, and it has very little to do with death.

The very fact that the speaker addresses his "townspeople"—not his "countrymen" or even his "fellow citizens"—insists on the deliberately parochial, homemade concerns at the heart of this defiantly hectoring poem. And there is much more here (such as the words "it will be money / in your pockets") to convince us that this poem is not offered as a manual about interments.

What Williams is actually writing about is the relationship of the symbol to the thing symbolized; and the relationship is often highly complicated, especially when the thing symbolized is charged with emotion, as funerals are, and as poems often intend to be. What both poems and funerals do is to give formality—even a ceremonious and traditional formality—to what otherwise would be unmediated feeling: in the case of funerals the lamentations of raw grief, and the perfunctory dumping of a body in the ground. Raw grief is a terrible and undeniable emotion; it lies beyond criticism. But it also lies beyond art. And to the degree that a poem wishes to express grief, it must make some concessions to formality. In his book *The Waning of the Middle Ages*, Johan Huizinga observes, "The cultural value of mourning is that it gives grief its form and rhythm. It transfers actual life to the sphere of drama. It shoes it with the cothurnus [that is, the tragic buskin, and makes of it] a sort of acted elegy."[23] And there is evidence in Dr. Williams's poem that, embattled though he seems to be, he has made some important concessions to tradition and convention. He will allow the wheels of his wagon to be painted with gilt; he will allow flowers, if the deceased had strong feelings about them; he specifies that there shall indeed be a procession. And he requires that all be done "with some show / of inconvenience." Now the expression of raw grief has nothing to do with either convenience or inconvenience. It is spontaneous, inarguable, and immitigable. A show of inconvenience, however, attends the making of a work of art, for it is something calculated and ordained;[24] and this is in fact the subject of Dr. Williams's poem, as it is in part the subject of the poem with which I want to close my remarks, a poem by William Butler Yeats.

Adam's Curse

We sat together at one summer's end,
That beautiful mild woman, your close friend,
And you and I, and talked of poetry.
I said: 'A line will take us hours maybe;
Yet if it does not seem a moment's thought,
Our stitching and unstitching has been naught.
Better go down upon your marrow-bones
And scrub a kitchen pavement, or break stones
Like an old pauper, in all kinds of weather;
For to articulate sweet sounds together
Is to work harder than all these, and yet
Be thought an idler by the noisy set

Of bankers, schoolmasters, and clergymen
The martyrs call the world.'

And thereupon
That beautiful mild woman for whose sake
There's many a one shall find out all heartache
On finding that her voice is sweet and low
Replied: 'To be born woman is to know—
Although they do not talk of it at school—
That we must labour to be beautiful.'

I said: 'It's certain there is no fine thing
Since Adam's fall but needs much labouring.
There have been lovers who thought love should be
So much compounded of high courtesy
That they would sigh and quote with learned looks
Precedents out of beautiful old books;
Yet now it seems an idle trade enough.'

We sat grown quiet at the name of love;
We saw the last embers of daylight die,
And in the trembling blue-green of the sky
A moon, worn as if it had been a shell
Washed by time's waters as they rose and fell
About the stars and broke in days and years.

I had a thought for no one's but your ears:
That you were beautiful, and that I strove
To love you in the old high way of love;
That it had all seemed happy, and yet we'd grown
As weary-hearted as that hollow moon.[25]

Let us begin our consideration by taking note of two historical facts, furnished by the splendid scholar-critic Richard Ellmann. He tells us: "Although Yeats deliberately does not name the two women in this poem, they are modeled on Maude Gonne [with whom Yeats was in love from the time he first met her on January 30, 1889, to the end of his life] and her sister Kathleen."[26] We may set it down to some strategy of discretion, a means of preserving what I earlier referred to as the "private" dimensions of the poem, that the poet chose to refer to Kathleen as his beloved's "close friend" rather than her sister. Ellmann also tells us that "Kathleen's re-

mark that it was hard work being beautiful is recorded in Maud Gonne's autobiography, *A Servant of the Queen*."[27]

There are three figures in this poem: the poet-speaker, the woman he addresses and whom he obviously loves, and a third (close friend or sister, as you prefer) whose particular beauty and loveliness of voice is remarked upon. Nothing, it may be noted, is said of the beauty or voice of the beloved, though we may take it that a compliment is offered to her by the clear inference that she is preferred even above a woman whose beauty and voice (and their foreseeable effect upon many) is explicitly praised.

The speaker recalls a discussion that began on the topic of poetry, and we must notice that the entire poem is composed, in the most artful way, of rhymed pentameter couplets. These have been formed in accordance with a fluid syntax and grammatical flow that, for the most part, consciously disregards the formal patterning of the rhymes, so that every major break but one in the poem divides rather than unites a couplet, thereby giving the entire poem what we may call the "audible" air of freedom from the constraints of form, and boldly distinguishes it from the effects of the couplet in Dryden or Pope. Indeed, a skillful reader might be able to keep the rhymes from anything but an almost subliminal effect.

The speaker begins by remarking on the sheer difficulty of writing poems, and this difficulty is compounded by the effort required to make the art appear easy. There is a good deal in the way of aesthetic doctrine embedded in these lines. It may have originated in the Latin proverb *Ars est celara artem* (true art lies in concealing art). This point has, from time to time, been hotly debated, especially by those who maintain that if art is not supposed to look difficult, why not let it be made easily, and thereby give the desired effect without effort and duplicity—a view warmly embraced by no inconsiderable number of modern poets. In any case, the idea of art as a difficult task for the artist, who must contrive to make the difficulties look easy, not only dates from antiquity but is precisely exemplified by Yeats's handling of his couplets. Indeed, his doctrine leads to a further paradox, which is that his audience of inexperienced laymen, the bankers, schoolmasters, and clergymen he speaks of, cherishing their worldly and practical values, and mistaking his art for something easy, dismisses it as frivolous and nothing more than the diversions of an idler. He is secretly, when not overtly, despised by the very people he is laboring with such difficulty to please.

The appeal to antiquity, to authority, to echoes and assurances from the past may present itself in the description of the voice of "that beautiful

mild woman" who is either friend or sister of the poet's beloved. When it is said that her voice is "sweet and low," we recognize the words of a song in Tennyson's *The Princess*. In their original context the words belong to a lullaby, and it is that quality of soothing gentleness, as well as a Tennysonian mellifluousness, that Yeats wished to associate with this woman. As for her statement, confirmed in Maud Gonne's autobiography, that women must labor to be beautiful, we may understand this in several ways. The most obvious, and by no means trivial from the poet's point of view, concerns cosmetics, and the pains that a woman will take to make herself attractive, and make herself appear, moreover, to be "naturally" attractive, the pains that correspond to the poet's attempt to make his words appear completely natural and unforced. There lies behind this the classical dictum (which is also a paradox) that art imitates nature. There is secondly the sense that woman's labor is literally the labor of childbirth, to which she was condemned in Genesis, just as Adam was condemned to labor of a different sort, the getting of his bread by the sweat of his face. There is, however, a third sense in which it may be said that women must labor to be beautiful; and we are entitled to believe that this is a sense Yeats may well have had in mind, since he mentions it in another, though admittedly much later, poem called "A Prayer for My Daughter." In the course of that poem, cataloguing in his own mind the blessings he should like to confer upon his newborn child, he writes:

> In courtesy I'd have her chiefly learned;
> Hearts are not had as a gift but hearts are earned
> By those that are not entirely beautiful;
> Yet many, that have played the fool
> For beauty's very self, has charm made wise,
> And many a poor man that has roved,
> Loved and thought himself beloved,
> From a glad kindness cannot take his eyes.[28]

It is this beauty, whose slight imperfections, whatever they may be, are compensated for by the effort of courtesy and kindness in which the labor of women consists. And indeed we may suspect that this third sense was intended by Yeats even though a gap of seventeen years intervened between the writing of the poem under discussion and the one I have quoted as a gloss upon it. For the speaker, after a perfunctory glance at Adam's fall, and all the labor entailed thereby, goes on to speak not only of "high courtesy" but of quoting "with learned looks / Precedents out of beautiful old books" on the topic of love.

It is to this "learned" topic of love that we must now attend. Yeats must have had in mind Giovanni della Casa's *Galateo of Manners and Behavior*, as well as Stefano Guazzo's *La'civile conversazione*, but chiefly Baldassare Castilione's *Il libro del cortegiano*, or *The Book of the Courtier*, to which he makes reference elsewhere in his work. Their relevance has to do with their common theme of love conceived as an art, as something at once vital and governed by great discipline, and even, at times, by austerity. This Renaissance ideal had its sources in the late Middle Ages, and so it is helpful to call once again on the assistance of Johan Huizinga. He tells us, apropos of the disciplines of love, that "the poets in the circle of Charles D'Orléans compared their amorous sadness to the sufferings of the ascetic and the martyr. They called themselves 'les amoureux de l'observance,' alluding to the severe reform which the Franciscan order had just undergone." But this was, understandably, only one attitude toward the complex matter of love. Huizinga also reports: "Side by side with the courtly style, . . . the primitive forms of erotic life kept all their force; for a complicated civilization like that of the closing Middle Ages could not but be heir to a crowd of conceptions, motives, erotic forms, which now collided and now blended." Of these carefully twinned yet contradictory attitudes, Huizinga shrewdly remarks:

> French authors like to oppose "l'esprit gaulois" to the conventions of courtly love, as the natural conception and expression opposed to the artificial. Now the former is no less a fiction than the latter. Erotic thought never acquires literary value save by some process of transfiguration of complex and painful reality into illusionary forms. The whole genre of *Les Cent Nouvelles Nouvelles* and the loose song, with its wilful neglect of all the natural and social complications of love, with its indulgence towards the lies and egotism of sexual life, and its vision of a never-ending lust, implies, no less than the screwed-up system of courtly love, an attempt to substitute for reality the dream of a happier life. It is once more the aspiration towards the life sublime, but this time viewed from the animal side. It is an ideal all the same, even though it be that of unchastity. Reality at all times has been worse and more brutal than the refined aestheticism of courtesy would have it be, but also more chaste than it is represented to be by the vulgar genre which is wrongly regarded as realism.[29]

Yeats in his poem has linked love and poetry, not because one is a favorite topic of the other, but because both must negotiate between paradoxically opposed and conflicting forces in the hope of arriving at a recon-

ciliation for which there is no formula. The attempt, both in love and in poetry, is long and exhausting, in danger of lapsing either into a spontaneous barbarity of ungoverned vigor or into the sterility of suppressed feelings and rehearsed responses, for which the image of the cold, chaste moon, washed by the tides of immeasurable time, serves as a chilling symbol. And so for Yeats, the curse laid upon Adam and his progeny was not confined merely to the labors imposed in Genesis, but was further embodied in the seemingly irreconcilable conflicts that, in the name of love and art, we must ceaselessly struggle to reconcile; and our successes must always, and at best, be called "mixed."

VI

Art and Morality

Even the little material assembled . . . will have made evident the difficulty of defining what obscene art really is. It can safely be said that works intended as obscene could be looked upon as inoffensive and virtuous and, more often, that works intended as sincere or light-hearted, cheerful and amusing, may be interpreted as obscene. Such interpretations depend to a large extent on the conception of morality prevalent at any given period. Few in fifteenth century Florence saw obscenity in contemporary art, nor were nude figures objected to until a prudish age judged differently. When Savonarola had opened the eyes of his fellow citizens some women confessed that the beautiful body of Fra Bartolomeo's St. Sebastian in S. Marco, the work of a painter beyond moral reproach, awaked lascivious thoughts in them. For that reason the picture was first transferred from the church to the monastery and was later sold. . . .

The question as to what extent moral conduct and artistic integrity are connected was scarcely raised before the Counter-Reformation. For the Middle Ages and the Early Renaissance the problem hardly existed. Despite the frank sensuality and sexuality of many medieval works their creators may well have been God-fearing and pious men, just as Fra Filippo's sterling religious paintings came from an artist with questionable moral standards. Yet once the artists became conscious of the problem, the situation changed. When their works reflected their principled life, sentimentality or even hypocrisy raised its head and stamped the products of many masters. . . . When the debonair Charles de Brosses, *président des parlements* of Dijon, wrote the memoirs of his Italian journey of 1739–40, he observed of Bernini's S. Teresa, considered the epitome of divine rapture, "If this is divine love, I know it well."

RUDOLF AND MARGOT WITTKOWER
Born under Saturn

We know of no spectacle so ridiculous as the British public in one of its periodic fits of morality.

THOMAS BABINGTON MACAULAY

Art hath an enemy called Ignorance.

BEN JONSON
Every Man out of His Humour

Submission to morality can be slavish or vain or selfish or resigned or obtusely enthusiastic or thoughtless or an act of desperation like submission to a prince: in itself it is nothing moral.

FRIEDRICH WILHELM NIETZSCHE
The Dawn

M Y DISTINGUISHED PREDECESSOR in the series of Mellon lecturers, Kenneth Clark, opens his study *The Nude* with a consideration of Velázquez's *The Rokeby Venus*, painted in 1651 (fig. 40). Beginning under the influence of Caravaggio, Velázquez had by this time assimilated the style and manner of Titian, whose *Venus with a Mirror* (fig. 41) at the National Gallery is likely to have had a considerable impact on him.

In the words of E. H. Gombrich, Velázquez "devoted his art to the dispassionate observation of nature regardless of conventions."[1] And presumably he expected his viewers to recognize this. *The Rokeby Venus* in consequence takes on a special and witty delicacy, and what may be called an "erotic tact." Velázquez was unusually adept in the employment of mirrors in his paintings, as his celebrated and majestic *Maids in Waiting* (in which the king and queen appear in cameo distance, reflected in a background mirror) makes amply clear. But in the *Venus* the reflected image is unreal: held at such an angle, the mirror would not reflect the face of Venus, or if it did, it would show us much more than her head.

Velázquez, *The Rokeby Venus*

41. Titian, *Venus with a Mirror*

I must ask you, in any case, to think of her in association with her Titian counterpart, and commit her, if you will, to at least your short-term memory, for we are to see her again before I have done. She serves my purposes today as a means of addressing the complicated and perhaps insoluble topic of art and morality, and if I think she does so with elegance, subtlety, and distinction, my view has been disputed—as shall appear.

I cannot hope to do justice in the course of a brief talk to so complex a topic, but it is worth remembering that while it has, alas, attained particular attention during this election year of 1992, the controversy is a long-standing one that, as history demonstrates, for the cause of morality, sanity, and justice, is a curiously mixed record of triumphs and defeats. And it may be worth attending, however briefly, to some of the contentions of the past.

We may begin with a celebrated High Renaissance debate on the question of obscenity, the first part of which is delightfully reported by Vasari. Of Michelangelo's huge mural *The Last Judgment* he writes:

> I do not propose to describe this work. . . . It will be enough to say that the purpose of the master was to render the human form in the absolute perfection of proportion and the greatest variety of attitude and to express the passions with force and truth. . . .
>
> When it was three quarters done, Pope Paul [III] went to see it. Messer Biagio da Cesena, the master of ceremonies, when asked to give his opinion, said that he thought it very improper to have so many nude forms, shameless in their nakedness, in that sacred place [the Sistine Chapel]. He added that such pictures were suited to a bath or a wineshop. Messer Biagio had no sooner left than our artist drew his portrait from memory, with a serpent wound around him surrounded by devils in hell. Nor could Messer Biagio persuade the Pope to have the portrait removed. [2]

In a footnote Vasari supplies this response of the pope to Biagio's plea to have his portrait removed from among the damned: "If the painter had put thee in purgatory, I would have done my utmost, but since he hath sent thee to hell, it is useless for thee to come to me, since thence, as thou knowest, *nulla est redemtio*." It would be gratifying to report that the wit and liberal views of Pope Paul had settled the matter for good; but, alas, this was not to be. The Wittkowers provide the lamentable sequel:

> Long before the Council of Trent the objections to nudity were raised with a vengeance against Michelangelo's *Last Judgment*. The work was finished in 1541. Fours years later Pietro Aretino . . . himself one of the most lascivious writers of the sixteenth century, addressed his notorious accusing and abusive letter to Michelangelo. . . . Aretino lashed out against Michelangelo for having represented "things from which one would avert one's eyes in a brothel." . . . The letter contains the filthiest innuendoes and even hints at Michelangelo's improper relations with young men. . . . finally, in 1555, ten years

42. Giorgione, *Concert Champêtre*

after Aretino had sounded the charge, Pope Paul IV ordered Michel-
angelo's pupil, Daniele da Volterra, to drape the offending figures.[3]

This was only one of the many successes of Grundyism, which must have
enjoyed its greatest triumphs during the Victorian era, when it was
thought judicious to put decorous stockings on the otherwise dangerously
exposed legs of pianos. But a more serious and costly success for that
militant party was the Puritan interregnum that closed the theaters of En-
gland. In September 1642, an ordinance was published that commanded
that "while these sad causes and set-times of humiliation [i.e., the Civil
War] do continue, the public stage plays shall cease and be forborne." It
was to be twenty years before plays were once again legally performed, and
the consequences of this protracted curtailment upon English dramatic
literature were irreparable, and virtually the end of great tragedy on the

43. Éduoard Manet, *Déjeuner sur l'Herbe*

English stage. The Restoration did produce comedies, some of them of very high caliber, though sadly diminished in range from their Shake-spearean predecessors. Hazlitt wrote of the comedies of Sir Richard Steele (remembered in our time only as the author of polite essays) that they "were the first that were written expressly with a view not to imitate the manners but to reform the morals of the age." The consequence of this laudable missionary zeal is that nobody reads Steele's comedies, and any modern director who proposed to stage one would be suspected of lunacy.

Let us return once again to Renaissance painting, this time to a cele-brated work attributed alternately to Giorgione and to Titian, a richly sensuous painting called *Concert Champêtre* (fig. 42). The body of distin-guished commentary on this painting (which for the sake of brevity I shall designate as Giorgione's) is enormous, touching not only on the quality and effects of the painting itself, but on paintings that may be said to be its

progeny or descendants as well. Many of the most important details are conveniently summarized by Kenneth Clark:

> As Pater pointed out, in some of the finest pages of English criticism, the aim of the *Concert Champêtre* is to create a mood through the medium of color, form, and association. . . . Although it tells no story, and the most determined iconologists have been unable to saddle it with a subject, its theme is not altogether new, for artists had enjoyed painting picnics since the fourteenth century. But the *Concert Champêtre* has this peculiarity, that the ladies have undressed; and we may speculate how Giorgione has persuaded us to accept as natural this unusual freedom. Several memories, no doubt, pictorial and literary, had helped to strengthen and clarify his imagination. There was the memory of Bacchic sarcophagi, with their naked bacchantes seated in the corner, of whom Titian was later to make so superb a use; and there was the antique habit of personification by which the essence of every pleasant thing in nature—springs, flowers, rivers, trees, even the elusive echo—could be thought of as having the shape of a beautiful girl. This, the imaginative legacy of Ovid, became fused with the imaginative legacy of Virgil, the myth of the Golden Age. So naked figures could be introduced into a landscape partly because they could be thought of as embodying some of its elements, and partly because, in the youth of the world, human beings did not need to cut themselves off from nature by the artificial integuments of dress. These are the ingredients of Arcadian poetry; and Giorgione could be represented as part of the same movement that produced Sannazaro and Tebaldeo. But the poets were encumbered with learned allusions. Their more exact equivalent is Raphael's *Judgment of Paris,* known through Marcantonio's engraving, which was to inspire a long line of academic compositions, ending, most surprisingly, with Manet's *Déjeuner sur l'herbe.* [Yet in contrast to these derivative paintings] Giorgione's *Concert Champêtre* is as simple, sensuous, and passionate as the poetry of Keats; and the nude figures, which sound artificial in description, seem, when apprehended through the eye, to embody . . . all the fruitful elements of nature that surround them. The two women, although they have been painted from the same model, differ greatly from one another in conception. She who is seated on the ground is painted with an unprejudiced sensuality, as if she were a peach or a pear. In this she is

the forerunner of Courbet, Etty, Renoir, and those life studies which were the chief product of art schools throughout the nineteenth century.[4]

To these comments I take the liberty of adding one or two of my own. The setting is late afternoon or early evening, golden in its fading glamour, shadows already modeling the contours of the land and darkening the features of the lutanist. (Despite Clark's scoffing at the iconologists, it is worth pointing out that the lute was a highly symbolic instrument during the sixteenth century. It is an attribute of music personified; of Polyhymnia, one of the sacred Muses; of the sense of hearing; and emphatically of the lover.) Perhaps an incipient storm has dramatized the light. On the right a shepherd and his flock certify the pastoral innocence of the setting, as does the fact that the two young men, completely clothed, seem engrossed in a musical performance to the exclusion of any apparent notice of their women companions. But music, upon which their attention is so firmly fixed, is preeminently an art enmeshed in the dimension and flux of time, an art measured precisely by the escapement mechanism of the clock or the metronome, measured out by the composer's and performer's "measure" and tempo. Thus the drama of the light, the late time of day, the pastoral setting, all speak of the brevity of life, the evanescence of this lovely and innocent moment, the ripeness that will not last, and which is therefore as sweet and poignant as that sense of fleetingness and mortality expressed in Tennyson's lyric "Tears, idle tears," and in Yeats's words,

> Man is in love and loves what vanishes,
> What more is there to say?[5]

But not everyone agrees that this painting evokes such a complex of mixed but innocent feelings about our mutability. Anne Hollander, for example, offers this imperious and dogmatic generalization.

Sexual messages are always delivered by the image of an unclothed body; and even more intense ones must then necessarily be conveyed by a bare body shown in the company of a covered one, even in the most abstract arrangement. [This premise is wholly fallacious, as Raphael's Vatican mural *The Great Fire in the Borgo*, Titian's *Sacred and Profane Love*, and other paintings make clear.] This is true simply because the dressed figure is usually perceived as aware of the undressed one or vice versa—or else the spectator is the *voyeur*, and that produces the eroticism by itself.[6]

There is something strikingly disingenuous about this oracular pronouncement, because only a page later Hollander proceeds to make an exception to this manifestly universal rule in behalf of Giorgione's *Concert Champêtre*. Her "law" had been formulated in the course of a description of one of the paintings Clark lists as an offspring of Giorgione's: Manet's *Déjeuner sur l'herbe*, which undeniably created a scandal when it was first exhibited (fig. 43). As distinct from the Renaissance painting, Manet's is indisputably a picnic. Or at least so it appeared to the outraged public that first viewed it. Here were, so it seemed, four representatives of that dissolute, Bohemian segment of society, artists and their models, who had settled in a glade somewhere in the suburbs of Paris, where, after a perfunctory repast, they were up to no good. The naked woman in the foreground has somewhat hastily set aside her everyday clothing, and there is no mistaking her for some chance naiad or dryad. The remains of the picnic are overturned upon her clothes in a manner that seems not to disturb her in the least, and a man's hand, very close to her, peeps out from beside her buttocks. But most shockingly of all to those early viewers was what seemed her brazen stare right at their faces. She was looking straight at Manet, as if confirming what people had always suspected about artists and their models.

But this is, as usual, only a small part of the story. One modern critic has stoutly maintained that the foreground nude was painted in a studio, and simply superimposed upon a pastoral background.[7] Gombrich, on the other hand, though acknowledging the "artificiality" of this presumably "naturalistic" painting, has this to say:

> Critical of accepted life-class routines and eager to guide the student towards "the immense field, almost unexplored, of living action, of changing, fugitive effects," [Lecoq de Boisbaudran, an ardent reformer] obtained permission to let models pose in the open air and made them move freely, as Rodin was to do. . . . Does not the experience of Lecoq . . . suggest the revolutionary work of a much greater innovator, Manet's *Déjeuner sur l'herbe*? It is well known that this daring exploit of naturalism was based, not on an incident in the environs of Paris as the scandalized public believed, but on a print from Raphael's circle [i.e., Marcantonio's version of Raphael's *Judgment of Paris* (fig. 44)].[8]

Manet's debt to Raphael now seems indisputable, but his debt to Giorgione has only lately been confirmed by the polymath writer Wayne Andersen, who reports that

44. Marcantonio Raimondi, *The Judgment of Paris (after Raphael)*

according to Manet's companion, Antonin Proust, [the *Concert Champêtre*] became a source for *Le Déjeuner.* . . . In his memoirs Proust recalls a summer day when he and Manet were relaxing on the bank of the Seine at Argenteuil and chanced to see women bathing. Manet remarked that the two clothed men (themselves) and the undraped women reminded him of the *Concert Champêtre* in the Louvre. He said that he had once copied Giorgione's painting and would like to do so again, but as a contemporary picture, relieved of the heavy weight of chiaroscuro and allegory and rendered as a scene from modern life.[9]

Mark, if you please, the delicious ironies of fate. It is not every man who, upon seeing unclad women, thinks first of a painting in the Louvre; but it was just such a man who provoked outrage at the putatively lubricious character of his work. It is enough to make one flee to the arms, or at least to the words, of Saint Paul in his Epistle to Titus: "Unto the

45. Juxtaposition of "degenerate" art by Karl Schmidt-Rottluff and Amadeo Mod-
igliani (above) and photographs of facial deformities (facing), from Paul Schultz-
Naumburg, *Kunst und Rasse*, as reproduced in *Degenerate Art*, published by Los
Angeles County Museum of Art, 1991

pure all things are pure; but unto them that are defiled and unbelieving is
nothing pure, but even their mind and conscience is defiled" (1:15).

Noel Annan observes that "in the fifties elderly respectable publishers
found themselves to their horror in the dock at the Old Bailey under laws
that made Britain the laughing stock of Europe as the works of authors
ranging from Tolstoy and Ibsen to Joyce and Lawrence were prosecuted."[10]
The chagrin was not only English. Much the same scandal attached to

Lawrence, Joyce, Nabokov, and Edmund Wilson in this country. Jane Heap, the editor of the *Little Review*, which published an extract from Joyce's *Ulysses*, defended herself thus: "Mr. Joyce was not teaching early Egyptian perversions nor inventing new ones. Girls lean back everywhere, showing lace and silk stockings; wearing low-cut sleeveless blouses, breathless bathing suits; men think thoughts and have emotions about these things everywhere—seldom as delicately and imaginatively as Mr. Bloom—and no one is corrupted."[11] Heap's defense is twofold: first, that Joyce is describing normal, natural, perennial behavior; and second, that he is doing so with exceptional artistic skill. The skill is always what the censors take no account of. Style to them is of no consequence; they are the most unimaginative literalists. For this reason the censorious Nazis

branded as "degenerate" any art that deviated from the most pedestrian kind of literalism (except when it deviated into conventional, and rather suspect, heroics). In the celebrated exhibition called "Degenerate Art" held in Munich in 1937, and brilliantly reconstructed at the Los Angeles County Museum in 1991, a set of portraits by Karl Schmidt-Rottluff and Modigliani (those by the first stylized in the manner of Gauguin and Cézanne, the others in the Italian's familiar signature style) was juxtaposed with photographs of deformed human beings, implying that the artists were trying literally to present and glorify deformity, or else were perversely unable to distinguish between deformity and conventional notions of beauty (fig. 45). Branded with the label "Degenerate Art," and either displayed under that stigma or put up for auction as undesirable, were works by the following artists: Franz Marc, Lyonel Feininger, Oskar Kokoschka, Marc Chagall, Wassily Kandinski, Modigliani, Henri Matisse, van Gogh, Picasso, Cézanne, Paul Klee, George Grosz, Max Ernst, and Ernest Barlach. The Nazis were also to condemn with the same label the music of Mahler, Schoenberg, Alban Berg, Ernst Krenek, Hindemith, Stravinsky, and Webern. This species of censorship was not confined to Germany; in Japan during World War II, Joseph Rosenstock, the German conductor of the Tokyo Symphony Orchestra, was told on the day of a scheduled concert that he would have to eliminate from the program Smetana's overture to *The Bartered Bride* on the impeccably high-minded ground that it is immoral to barter a bride.

At the same time we must consider what sort of art it was that won the approval of these repressive regimes. As Peter Adams reports in *Art of the Third Reich*, a greatly admired painting was Adolph Wissel's *Farm Family from Kahlenberg* (fig. 46), a painting that represents what in certain conservative quarters it is popular to call "family values," and which looks for all the world like the work of a well-known illustrator of the covers of the *Saturday Evening Post*. Art of this sort always enjoys a wide popular approval, based almost entirely on its literalness, as well as its anecdotal character. But, as I said, there was one other variety of approved Nazi art, the pseudoheroic, which can be represented by Arno Breker's sculpture *Bereitschaft* (Readiness) (fig. 47). What is chiefly striking about this work is its wonderful resemblance to the kind of sculpture admired by Mussolini—no doubt for much the same reasons, having to do with a narrow nationalism, an appeal to ideals of fitness for implicit military reasons, and a glorification of youth in all its instinctual and heedless vitality. The Fascist examples are to be seen at La Stadio dei Marmi in the Campo della Farnesina on the outskirts of Rome (figs. 48 and 49). This

uniformity of taste, to be observed not only in the painting, sculpture, and music of these totalitarian regimes but in their architecture as well, ought to speak volumes to thoughtful men and women.

If it seems evident that considerations other than aesthetic ones determined the choice of what was approved, the same can be said in large part about what was disapproved of by the Nazis; it should surprise no one that the lists of rejected artists and composers contain an unusually high proportion of Jews. This "ideological" factor enormously complicates the moral dilemmas in any study of the arts, but for my immediate purposes, let the problems be divided into two kinds: those in which the ideology is incontestably an ingredient of the work of art itself (making it a vessel of propaganda or of protest), and those in which the ideology is largely or wholly a censorious attitude of the critic, the viewer, or the government. To be sure, most censorious critics are completely unwilling to admit they have any unarticulated, nonaesthetic agenda; they speak in the name of what they believe to be spontaneous, visceral promptings, and they most commonly like to regard themselves as representative of the taste of the vast majority of people. When they encounter art they find repulsive, their reaction is little short of physiological, and they are rarely in doubt. Such perfect certainty accords with our experience of demagogues and fanatics, and so it is all the more extraordinary to encounter it among the most thoughtful pronouncements of that unusually measured and meditative man, T. S. Eliot, and to find it, moreover, in his eminently "judicious" Charles Eliot Norton Lectures at Harvard. There he writes:

> Mr. I. A. Richards deserves the credit of having done the pioneer work in the problem of Belief in the enjoyment of poetry; and any methodical pursuit of the problem I must leave to him and to those who are qualified after him. But Shelley raises the question in another form than that in which it presented itself to me in a note on the subject which I appended to an essay on Dante. There, I was concerned with two hypothetical readers, one of whom accepts the philosophy of the poet, and the other who rejects it; and so long as the poets in question were such as Dante and Lucretius, this seemed to cover the matter. I am not a Buddhist, but some of the early Buddhist scriptures affect me as parts of the Old Testament do; I can still enjoy Fitzgerald's *Omar*, though I do not hold that rather smart and shallow view of life. But some of Shelley's views I positively dislike, and that hampers my enjoyment of the poems in which they occur; and others seem to me so puerile that I cannot enjoy the poems in

46. Adolf Wissel, *Farm Family from Kahlenberg*

which they occur. And I do not find it possible to skip these passages and satisfy myself with the poetry in which no proposition pushes itself forward to claim assent. . . . And the bad part of a poem can contaminate the whole.[12]

That seems a strong and unequivocal statement; and one riven with ideological pitfalls. It is difficult to resist the temptation to apply Eliot's strictures to anti-Semitic elements in Eliot's own poetry as well as to the work of his admired contemporary, Ezra Pound. It is not easy to assess such matters in a way that will be both manifestly just and also persuasive. The Pound case, for example, was almost from the first prejudiced by the cries and denunciations of self-serving politicians. Jacob Javits, who never before or after evinced any interest whatever in poetry, and who at the time was a member of Congress from New York, attracted considerable attention to himself by denouncing a jury of fourteen distinguished writers (including W. H. Auden, T. S. Eliot, Louise Bogan, Robert Lowell,

47. Arno Breker, *Bereit-schaft* (Readiness)

Katherine Anne Porter, Allen Tate, Robert Penn Warren, William Carlos Williams, and Archibald MacLeish) who had awarded the first Bollingen Prize to Pound. The attention Javits roused by his zealous outrage would one day elevate him to senatorial dignity. At the same time, the fact that Javits knew nothing whatever about poetry does not cancel the undoubted fact that Pound's poetry is grotesquely marred by hatred, bigotry, and malice. Pound's fulminations against usury are theoretically justified by Dante's repudiation of the practice, which, in turn, was based on strictures of Aristotle and Thomas Aquinas, both of them identifying usury as "unnatural" because money is made without any human industry being involved. To be sure, Pound had espoused a complete, and rather eccen-

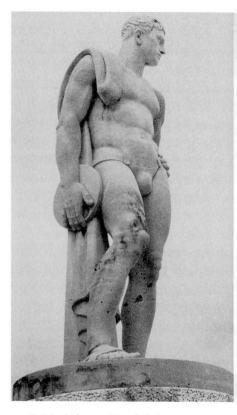

48. S. Canevari, *Ercole* 49. P. Morbiducci, *Discobolo in riposo*

tric, economic theory by which to purge society of usurious practices, but the chief target of his rancor was the Jews. He was able quite easily to forget how widespread and common is the practice of lending money at interest on the part of nations and states that issue bonds, of insurance and mortgage companies, and, among banks, one in particular that the good, orthodox Italian Catholics have named the Banco di Santo Spirito. Inasmuch as Pound was very far from embracing most of the tenets of the Roman Catholic faith, it is odd that he should so warmly have embraced Saint Thomas's Aristotelian scruples on this single point, and one may suspect his motives in this regard.

One may also do well to consider the reactions of some who are better qualified as literary experts than Representative Javits was, and less dema-

gogic than he. One of the members of the distinguished jury that awarded the Bollingen Prize to Pound was W. H. Auden. In April 1949, the *Partisan Review* raised serious questions about the choice of Pound, but also judiciously considered the various attacks upon the jury, made not just by Javits but by a poet of slender talent, Robert Hillyer, in the pages of the *Saturday Review of Literature.* One of the *Partisan Review* editors, William Barrett, made a strong case against Pound; in the following issue various members of the jury, Auden among them, were invited to make public statements about their decisions, which were published. Auden's could scarcely have been more evasive, clouded as it was in the most curious philosophic and theological generalizations, including the following set of assertions:

(a) All created existence is good.
(b) Evil is a negative perversion of created good.
(c) Man has free will to choose betwen good and evil.
(d) But all men are sinners with a perverted will.[13]

Whatever one may think of these propositions (and I am ill at ease with their purported logic, which suggests that everyone is equally at fault), they do not tell us as much as is revealed in a memoir about Auden by Wendell Johnson. Regarding Auden's *Partisan Review* apologia, Johnson reports:

> He was, in public, defending his view that poetry should not be judged on the basis of the poet's politics or ethics; he was also, in the specific defense, standing by his fellow judges. Privately, he thought Pound's poetry as a whole too diffuse and deliberately obscure for him to deserve the highest international prize more than a number of others (he was himself awarded it later); very privately, he wondered if a man whose bigotry and treason so marred, so embittered, his character could achieve the highest poetic integrity. (Yet he would not deny the power of the *Cantos* or the importance of Pound's poetic influence.) He was, no doubt, profoundly ambivalent on the whole matter. Finally, I can give no evidence from public utterance that Auden did vote against Pound. He told me quite clearly that he did, and why; I believed and believe him.[14]

For what it may be worth, I offer the following from an interview with John Ashbery in the journal *Oxford Poetry*: "Pound is totally antipathetic to me. . . . And all his 'statements' . . . I get very angry when people tell me what I'm supposed to do when I'm writing or what I'm supposed to feel

when I'm reading poetry. I once said to Helen Vendler, 'Why is it that I do like Pound's early things—the Chinese translations and "Mauberly" I like very much—but I just can't *read* the *Cantos?* It's not because they're unreadable, because I'm unreadable too, so why can't I read him?' And she said, 'It's perfectly all right, only Fascists like Pound.'"[15]

The reason that Pound's and Eliot's bigotries are serious is the reason famously articulated by Julien Benda in his 1927 manifesto, *The Treason of the Clerks,* and summarized in a modern work by Jean-François Revel called *The Flight from Truth,* in these words:

> The intellectual does not, by virtue of his calling, possess any preordained pre-eminence in lucidity. What distinguishes the intellectual is not sureness of choice but the scope of the conceptual, logical, and verbal resources he develops to justify his choices. What distinguishes him furthermore is his influence. Thanks to his perspicacity or blindness, impartiality or dishonesty, slyness or sincerity, he drags others in his wake. Being an intellectual does not therefore confer an immunity rendering everything forgivable; . . . it confers more responsibilities than rights, a responsibility at least as great as the freedom of expression he enjoys.[16]

It would be a mistake on my part, in addressing such a topic as art and morality, to fail to mention, however glancingly and inadequately, the recent scandals that have beset the National Endowment for the Arts. Let me refresh your memory and my own with facts acquired from the *Washington Post* accounts about what happened. On Saturday, February 22, of this year (1992), it was reported that John Frohnmayer, head of the Endowment, was summarily fired, though both he and the White House officially portrayed his departure as voluntary. The front-page article declared: "The firing was viewed by both critics and supporters of Frohnmayer as a response to Patrick Buchanan's strong showing in the New Hampshire primary. In a speech Thursday, Buchanan reiterated his intent to thrash the agency for 'subsidizing both filthy and blasphemous art' in his upcoming campaign swing through the south."

Buchanan was what Aristotle would call "the efficient cause" of Frohnmayer's defeat, but he was not the only populist demagogue to have attacked the arts, though it was he who referred to the Endowment as the "upholstered playpen" of the "Eastern liberal establishment." There were also enlisted under the banner of outrage Senator Jesse Helms and the Reverend Donald Wildmons, as there had once been Senator Smoot and Representative Javits, those self-appointed vigilantes and guardians of na-

tional morality. One cannot fail to note in passing that neither President Bush nor Mr. Buchanan has ever evinced any real or vigorous interest in the arts except as political issues.

It can, of course, be argued persuasively that in a nation with problems of the greatest urgency, the government has a moral obligation to attend first to the most pressing needs of its citizens, and the arts had better look for such support as they can muster to private patronage and such fine institutional benefactors as the Guggenheim Foundation. This seems to me a perfectly sound argument that could win my assent. Such an argument, however, is not the one advanced by Mr. Buchanan, Senator Helms, or the Reverend Wildmons.

In any case, there is an opposing view that maintains that all nations and cultures of any maturity or importance have prided themselves on the works of their artists; and they remember that their heroes, both military and athletic, are finally nothing more than performance artists, the memory of whose accomplishments is of the briefest duration, unless it were celebrated and immortalized in a work of art. Thus, though the achievements of Olympic champions of ancient Greece must have excited widespread admiration, their names are lost to us now except insofar as they were celebrated in the odes of Pindar.[17] Even the noble architecture of Greece and Rome has fallen into ruin, but Shakespeare could claim that "Not marble nor the gilded monuments / Of princes shall outlive this powerful rhyme." The humblest Italian citizen regards Dante and Michelangelo with reverence; and for Germans Bonn is not remembered as a sometime seat of government but as the home of Beethoven. If the United States is to boast of anything more honorable in its culture than soft drinks and Disney World, it may wish to do what many other nations, some of them far less wealthy, have unhesitatingly elected to do in the way of subsidizing the arts.

This question of money, however, raises another complicated point. Almost invariably the demagogues deplore the wasting of public funds on artistic projects of which, and artists of whom, they disapprove on what they claim to be high moral grounds. It is worth considering these grounds and their putative height. In 1991 the National Endowment for the Arts is reported to have spent $175 million. This comes, by the careful computation of one researcher, to less than two one-hundredths of one percent of the federal budget.[18] No doubt it is still a good deal of money, but since we are engaged in framing moral as well as fiduciary judgments, some other pertinent facts must be introduced, and I will invite the distinguished American historian C. Vann Woodward, writing in the *London Times*

Literary Supplement, to summarize these facts for me. He writes as follows:

The huge sums that the Western superpowers threw into the Cold War arms race and global power rivalry were largely borrowed. In its rapid transition from being the largest creditor nation to by far the largest debtor nation in the world, the United States piled up debts of unprecedented magnitude that remain unpaid and soar ever higher at compounded interest. Heedless of debts, deficits and desperate present needs, the government proceeded to reduce taxes on higher incomes and to defy anyone to increase them, especially in election years. No prospect of ending the growing national deficit appeared. Future generations were left to pay the bills and finance the debts, while those of the present generation who could afford to lived it up.

What was billed as the prosperous decade of the 1980s is seen by some economists as "a silent depression", in which the real income of workers and national well-being declined. Only the wealthiest made real gains. An illusory increase in productivity was largely the result of wives and mothers joining the workforce. Meanwhile, citizens were informed that for lack of funds the richest nation on earth could do nothing about shamefully neglected social needs. These included a decline in the education system, public health care and insurance, and public housing, all of which approached the lowest levels of performance among developed countries. National highways had fallen into disrepair and bridges had become hazardous. Cities deteriorated, and the best solution offered to mounting crime, drug traffic violence and gunfire in school halls and classrooms seemed to be more and more prisons. Continued recession helped account for, but did not fully explain, the great numbers of jobless and homeless people in the streets.

Along with the declining condition of life at the lower levels came deterioration of ethical standards in business, government and private life. Scandals were so common in executive and legislative branches of the federal government as to invite apathy or cynicism among voters, and to open opportunities for adventurers in demagoguery. In business circles, respected executives and long-established firms fell into disgrace. The number of bankruptcies equalled those of the Great Depression. Bank failures surpassed those levels, and hundreds more were expected. Savings and Loan banks, with deposits insured by the government, had to be bailed out by the taxpayer to the tune of

more than $500 billion. An unfavorable trade balance and a lagging ability to compete in foreign markets continued to plague the economy. Recovery and renewal required far more than waiting out the business cycle.[19]

To this sad litany of moral imperfections of one sort or another (Woodward made no mention, by the way, of Operation Ill Wind, and the corruption within the Pentagon and its suppliers) may be added one more grim observation, this one by Edward Luttwak: "As compared with America's *intifada*, with its annual total of 4.7 million assaults, million plus robberies, and 22,000 homicides at last count, the Gulf War was virtually bloodless."[20] Mr. Luttwak might have gone on to say that what American blood was actually shed in that war was largely drawn by friendly fire. And the war, which accomplished very little in the way of moral good or the establishment of permanent peace in the Middle East, entailed a budget that would have made glad the heart of the National Endowment for the Arts for many a long year to come. The Endowment would probably have rejoiced simply to be awarded the cost of victory parades. In any case, the tender moral sensibilities of Senator Helms and Mr. Buchanan remained serenely undisturbed in the face of these financial, moral, and expeditionary malfeasances.

When he was dismissed from the Endowment, Mr. Frohnmayer was represented in the press, without much protest to the contrary on his part, as a martyr to political expediency, caught helplessly between the pugnacity of Mr. Buchanan and the pusillanimity of President Bush. It is a touching role for an arts administrator, and one calculated to win sympathy, but it is, alas, unmerited. The papers reported that the immediate cause of Frohnmayer's dismissal was "the revelation that the NEA funded a poem that described a homoerotic act performed by Jesus Christ."[21] This was to put the case in terms best calculated to arrest the interest of a reader. In point of fact, the poem in question, also described in the *Washington Post* by the ludicrous solecism "long-form poem,"[22] was written by Ramona Lofton, whose pen name is Sapphire, and whose poem concerned the attack on the New York, Central Park white female jogger by a "wilding" group of black teenagers who brutally bludgeoned her, raped her, and left her unconscious with a fractured skull. Lofton's poem was deeply polemical. It did not dispute the harm done to the defenseless woman in the park, nor did it suggest that she in any way provoked the attack. What it did instead was to focus on the undeniable and protracted misery in which the black youth of Harlem (and elsewhere) are raised, and

from which they can almost never escape. And amongst the many privations, oppressions, and betrayals such young people endured, Lofton centered her attention on the claim that one of the accused boys, having always identified the sacramental office of the priest with Christ, and having been then lured into performing oral sex with a member of the clergy, felt, and was entitled to feel, utterly corrupted by everything that white, privileged, American society holds in highest reverence and esteem. The poem was an expression of powerful indignation, it reveled in the exquisite satisfactions of victimhood, but as a moral tract it presented its own set of problems.

It is difficult to state these problems objectively and dispassionately, but I shall try; and it seems to me that the poem tried to advance a view once expressed by Mme de Staël in the words *Tout comprendre c'est tout pardonner.* Yet it is not entirely clear what this eighteenth-century maxim, superficially so ecumenical in its mercy, actually means. Does it mean, for example, that God (who by definition understands everything) must of necessity forgive all crimes, and that we need therefore not trouble ourselves about anything so trifling as compunction or repentance? That would be a soothing antinomian doctrine. Does it, on the other hand, mean that, since an omniscient God forgives all crimes, and we are obviously not omniscient, we ought to behave as if we knew more than we actually do, and be universally merciful beyond our capacity to comprehend the grounds for such magnanimity? To act on such principles would be to eliminate even the possibility of any system of justice, and accordingly permit any crime. Does it, instead of the foregoing hypotheses, mean, with unconcealed cynicism, that since obviously no mortal understands everything, no mercy whatever is enjoined upon us? It shall not surprise you to learn that the poet never considers any of these possibilities. In her own words, as quoted in the *Washington Post*, "The feeling I had when I finished writing that was 'mission accomplished,'" and it is not accidental that Lofton employs police or military language about her sense of the poetic vocation. She sees herself as the militant defender of the underdogs of our society. But, as Robert Frost observed, "Griefs, not grievances, are the stuff of poetry."[23] While acknowledging that all the accused in the jogger assault were themselves genuine victims, I must leave unresolved the insoluble question of relative guilt, and turn instead to the question that should have been central to the National Endowment for the Arts, and which precipitated Frohnmayer's dismissal. The poem in question, which was titled "Wild Thing," is quite simply a very bad poem; if Frohnmayer staked his reputation and position on its merit as a work of

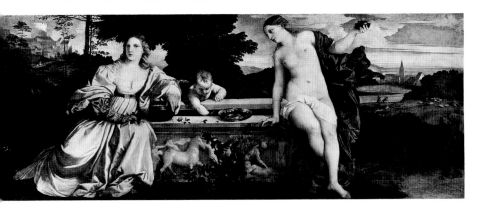

5̃0. Titian, *Sacred and Profane Love* (see note 26)

literary art, he made a very grave mistake. The poem is poorly written, rife with clichés and weary repetitions, alternately sentimental and infuriated, and almost entirely limp and unimaginative in its use of language. In my view, Mr. Frohnmayer was guilty of aesthetic rather than moral error.[24]

The poem fails on two levels, either one of which would be serious enough. The first is its truly undistinguished use of words. Equally serious is its single-minded posture of zeal and outrage. What is wrong with this is what William Blake warned against when he wrote the instructive couplet:

> Twofold always. May God us keep
> From single vision, and Newton's sleep![25]

It is, again, precisely what Yeats cautioned the poet against in a sentence I quoted in my previous lecture: "We make out of a quarrel with others, rhetoric, but out of a quarrel with ourselves, poetry." The poem called "Wild Thing" is, according to these views, which I share, not poetry at all, but rhetoric, and in this it exists on a level with the fulminations of Mr. Buchanan and Senator Helms.

I have left many of the puzzles about art and morality unmentioned, among them the delicate topic of what, if anything, is to be regarded as prohibitive or offensive in the way of art. This is a matter that sooner or later comes before the courts, and the courts have tried to address it by coming up with a difficult and vexing formula about "community standards."[26] There are clear troubles with this formula, of which perhaps a single instance will have to suffice. Nothing could be regarded by a pub-

lisher as a greater good fortune for the promotion of a book than to have it banned in Boston.[27] And not only do "community standards" vary from community to community, but they vary still more dramatically from one period to another; so that we sometimes have difficulty understanding what so shocked the first viewers of Manet's *Déjeuner sur l'herbe.*[28] In any case, the laws and the courts are human and fallible instruments, and in the nature of things sensitively susceptible to change, as indeed they ought to be, designed as they are to be of service to living men and women. But if art is what Yeats said it was, "a vision of reality," it aims to articulate something more durable and less changeable than "community standards" could ever desire to encompass. It wishes to negotiate, however imperfectly, with the permanent, and is likely to scorn the popular catchwords, the current jargon and conventions. And surely this is, among other things, what Marianne Moore meant in closing one of her finest poems with the words,

> Beauty is everlasting
> and dust is for a time.[29]

I said earlier that before I had done I would return to Velázquez's great painting, *The Rokeby Venus*, and I mean to do so, though I present her to you now in a hideously altered form.[30] The painting was mutilated in 1914 by someone who, like Lofton, was filled with the zeal of moral outrage, fanaticism, and righteous wrath. In this case it was an act of vandalism performed by a suffragette. That she had a clear moral, political, humane, and absolute right in respect to what she stood for could not be contested; and I would count myself among those who seriously hope that the wisdom and compassion that women may bring to the political arena may actually save this nation, and perhaps the world, from the imbecilities of men. Without question her cause was right; perhaps she regarded herself as an English Charlotte Corday. Certainly part of the symbolism of her protest was directed at a society governed politically, in terms of its social conventions, and its general mores, by males who valued women only as sexual chattels, the more voluptuous the more greatly valued; by implication, a woman's mind and spirit were dismissed if they were noticed at all. A representative example of this kind of thinking is Benjamin de Casseres' question: "Can you recall a woman who ever showed you with pride her library?" We may assume that the destroyer of the painting must have felt an abiding anger at this common view of womankind, and would not have been dissuaded from her mission by any arguments suggesting that some women had certainly enjoyed much in

the way of eminence, high esteem, and power from time to time. No catalogue of names would have been likely to deflect her, irrespective of their resonance and number. She had, in fact, elected for herself the severe and unlovely role of censor, and in doing so she numbered herself among the would-be reformers of society, including that band of puritans and fulminators whose names I have already placed before you, though perhaps one might be tempted to add the name of a vice president.[31]

Few poets or artists have thought more seriously and carefully than William Butler Yeats about the audiences they are addressing, and the kind of society from which those audiences are drawn, especially in a world of populist slogans, commonplace sentiments, .cheap political jargon—the world, that is to say, governed by the rhetoric of politics and the advertising that is no small part of election campaigns, conducted in a language largely determined by the public appetite for visceral excitement (which some take for aesthetic enjoyment, when it is not identified with religious rapture). It is a world in which learning and the arts themselves are manipulated by and for political ends, and questions of taste are referred directly to plebicite opinion. Two years after the desecration of the Velázquez painting, Yeats wrote a poem describing what he had innocently or foolishly once imagined he would have in the way of an understanding and appreciative audience for his poetry, and the discovery of what he actually found instead.

> All day I'd looked in the face
> What I had hoped 'twould be
> To write for my own race
> And the reality;
> The living men that I hate,
> The dead man that I loved,
> The craven man in his seat,
> The insolent unreproved,
> And no knave brought to book
> Who has won a drunken cheer,
> The witty man and his joke
> Aimed at the commonest ear,
> The clever man who cries
> The catch-cries of the clown,
> The beating down of the wise
> And great Art beaten down.[32]

NOTES

Preface

1. William Empson, *Argufying* (Iowa City: University of Iowa Press, 1987), 599–600.

2. Anthony Hecht, "Peripeteia," in *Millions of Strange Shadows* (New York: Atheneum, 1977), 36–37.

3. Robert Frost, "The Figure a Poem Makes," in *Complete Poems of Robert Frost* (New York: Henry Holt, 1949), v–viii.

4. C. S. Lewis, *English Literature in the Sixteenth Century, Excluding Drama* (Oxford: Oxford University Press, 1954), 97.

5. Samuel Johnson, *Lives of the English Poets* (New York: Dutton, 1964), 1:95–96.

6. W. H. Auden, *Letter to Lord Byron*, in *Collected Poems*, edited by Edward Mendelson (New York: Random House), 78.

I. Poetry and Painting

1. Plutarch, *Comm. bellone an pace clariores fuerint Athenienses* (Reiske), 7:366.

2. Ben Jonson, *Discoveries* (1641). Jonson is echoing Horace, who, in his *Ars poetica*, declares "Poetry is like painting." Sir Joshua Reynolds was later, in his *Discourses*, to make the same point.

3. Bernard Berenson, *Italian Painters of the Renaissance* (London: Phaidon Press, Ltd., 1952), 1:1.

4. Kenneth Clark, *Landscape into Art* (New York: Harper and Row, 1976), 64.

5. Nicolai Cikovsky, Jr., Linda Bantel, and John Wilmerding, *Raphaelle Peale Still Lifes* (Washington, D.C.: National Gallery of Art, 1988), 39.

6. From a letter of Constable to Archdeacon John Fisher (a close friend and loyal supporter of Constable), which begins: "Hampstead, October 23rd, 1821. . . . How much I wish I had been with you on your fishing excursion in the New Forest! What river can it be? But the sound of water escaping from mill-dams, etc., willows, old rotten planks, slimy posts, and brickwork, I love such things. Shakespeare could make everything poetical; he tells us of poor Tom's haunts among 'sheep cotes and mills'. As long as I do paint, I shall never cease to paint such places. They have always been my delight, and I should indeed have been delighted in seeing what you describe, and in your company, 'in the company of a man to whom nature does not spread her volume in vain.' . . . painting is with me but another form of feeling, and I associate 'my careless boyhood' with all that lies on the banks of the Stour; those scenes made me a painter, and I am grateful." C. R. Leslie, *Memoirs of the Life of John Constable* (Ithaca, N.Y.: Cornell University Press, 1980), 85–86.

7. W. H. Auden, in *The Episcopalian* (March 1974).

8. Robert Hughes, *The Shock of the New* (New York: Knopf, 1991), 320–21.

9. T. S. Eliot, "The Metaphysical Poets," in *Selected Essays, 1917–1932* (New York: Harcourt Brace, 1932), 247–48.

10. T. S. Eliot, "Hamlet and His Problems," in *Selected Essays, 1917–1932*, 124–25.

11. John Crowe Ransom, "Poetry: A Note in Ontology," in *The World's Body* (New York: Scribner's, 1938), 112–13.

12. Ibid., 124.

13. J. V. Cunningham, "For My Contemporaries," in *The Collected Poems of J. V. Cunningham* (Chicago: Swallow Press, 1971), 43.

14. Gustave Flaubert, *Madame Bovary*, translated by E. Marx Aveling (New York: Harper and Brothers, 1950), 23–24.

15. Joseph Conrad, preface to *The Nigger of the "Narcissus,"* in *The Portable Conrad*, edited by Morton Dauwen Zabel (New York: Viking, 1947), 705–8.

16. Horace, *The Art of Poetry*, translated by D. A. Russell, in *Classical Literary Criticism*, edited by D. A. Russell and M. Winterbottom (New York: Oxford University Press, 1989), 107.

17. Writing of John Dyer's poem "Grongar Hill" as a representative poem of the 1720s, Bonamy Dobrée points to "the appeal from the muse of poetry to her sister muse of painting to come to her help. The country poem is ceasing to be a Georgic, or a 'place', or 'estate' poem, or merely décor—and becoming a picture, a subject in its own right: writers are going to try to convert poetry

> Whate'er *Lorrain* light-touch'd with softening hue,
> Or savage *Rosa* dash'd, or learned *Poussin*, drew,
> [James Thompson, *The Castle of Indolence*,
> canto 1, sec. 38, ll. 8–9]

and luckily at that very moment they discovered for their palettes the whole spectrum which Newton had revealed to them in his *Opticks.*" Dobrée, *English Literature in the Early Eighteenth Century* (London: Oxford University Press, 1959), 479–80. It may be worth noting that Dyer was a painter as well as a poet.

18. Elizabeth Bishop, "Sandpiper," in *Elizabeth Bishop: The Complete Poems, 1927–1979* (New York: Farrar, Straus, and Giroux, 1983), 131.

19. Mary Jo Salter, "The Rebirth of Venus," in *Unfinished Painting: Poems* (New York: Knopf, 1989), 3–4.

20. Arthur Symons, "At Dieppe: Grey and Green," in *The Symbolist Poem: The Development of the English Tradition*, edited by Edward Engelberg (New York: Dutton, 1967), 250.

21. In his introduction to the Everyman edition of *The Poems of W. B. Yeats* (London: J. M. Dent, 1990), Daniel Albright comments, "Much of the advanced contemporary poetry of Yeats's youth (such as that of Oscar Wilde and Arthur Symons) was influenced by Whistler and by French impressionistic painting" (xx).

22. Walter Sickert (1860–1942) was a "realist" painter, and founder of a group of like-minded artists who vigorously repudiated the "lilies and langours" of the well-established Pre-Raphaelites, devoting themselves to representing the tired faces of poor, working-class people in realistic and impoverished domestic settings, unromanticized urban scenes, and low-class entertainers in music halls. Yet for all his putative realism, his work bears a striking resemblance to the haziness and evasiveness of the great Impressionists. Max Kozloff, in an article titled "Sickert's Unsentimental Journey," in *The Grand Eccentrics*, edited by Thomas B. Hess and John Ashbery (New York: Collier, 1966), writes: "In the most distinctive of Walter Sickert's paintings, one

finds a curious kind of drawing, half a slowly departing fizz, and half a smudge-work of blunted touches. . . . This draftsmanship almost conceals itself, or rather, fudges the image. For Sickert was, paradoxically, as much concerned with the obliqueness of definition as he was with a species of the documentary, and there is always in his figures a serious incompletion, a sense of something just having jumped optically into the shadows, or off the 'side' of the eye's focus."

23. Wallace Stevens, "Sea Surface Full of Clouds," in *The Collected Poems of Wallace Stevens* (New York: Knopf, 1974), 98–102.

24. William Wordsworth, "The World Is Too Much with Us," in *Selected Poems and Prefaces*, edited by Jack Stillinger (Boston: Houghton Mifflin, 1965), 182.

II. *Poetry and Music*

1. Quoted by B. H. Haggin in *The Listener's Musical Companion* (New York: Oxford University Press, 1991), 112.

2. Igor Stravinsky, *The Poetics of Music* (Cambridge, Mass.: Harvard University Press, 1942), 62. Baudelaire's view was still more severe: "I love Wagner; but the music I prefer is that of a cat hung up by its tail outside a window and trying to stick to the panes of glass with its claws."

3. Igor Stravinsky and Robert Craft, *Conversations with Igor Stravinsky* (Berkeley and Los Angeles: University of California Press, 1958), 75.

4. Aristotle, *Metaphysics* 1.5, translated by W. D. Ross, in *The Basic Works of Aristotle*, edited by Richard McKeon (New York: Random House, 1941), 698.

5. This account of the mathematics of the *Timaeus* and the educative system of the *Republic* is indebted to commentaries by Alfred Edward Taylor in the *Encyclopedia Britannica* as well as those of Meyer Reinhold in *Classics, Greek and Roman* (Great Neck, N.Y.: Barrons, 1946). The idea of a cosmic mathematics as the presiding design within all parts of the universe, though perhaps originating with Pythagoras, went through many elaborations in the course of time. Frances Yates offers this Renaissance version of Francesco Giogi's: "The secret of Giogi's universe was number, for it was built, so he believed, by its Architect as a perfectly proportioned Temple, in accordance with unalterable laws of cosmic geometry. . . . Giogi's *De harmonia mundi* was not the work of a fantastic eccentric. It belonged to the centre of Renaissance thought at its most productive." Yates, *The Occult Philosophy in the Elizabethan Age* (Boston: Ark, 1979), 30.

6. Giorgio Vasari, *Life of Piero della Francesca*, in *Vasari's Lives of the Artists: Biographies of the Most Eminent Architects, Painters, and Sculptors of Italy*, edited by Betty Burroughs (New York: Simon and Schuster, 1946), 93, 95. According to Arthur M. Hind (*A History of Engraving and Etching*, New York: Dover, 1963) this Venetian artist traveled widely throughout Europe, working at various times at Wittenberg, Augsburg, and parts of Saxony, visiting Nuremberg, Frankfurt, and Burgundy. In Nuremberg he was known as Jacob Walch, i.e., Jacob the "foreigner," for which his Italian name is the equivalent.

7. Kenneth Clark, *Piero della Francesca* (New York: Phaidon, 1969), 81 n. 68.

8. Thomas Campion, "Obseruations in the Art of English Poesie," in *Campion's Works*, edited by Percival Vivian (London: Oxford University Press, 1909), 50–51.

9. *American Heritage Dictionary of the English Language*, s.v. "cadence."

10. This Vitruvian idea figures centrally in Yeats's late poem "The Statues." Nicholas Gibbens, in *Questions and Disputations concerning the Holy Scripture* (London: Felix Kyngston, 1610), writes of "that noble forme, wherby it was indued with life and sence, and became to have such excellent proportions, so marveilous, so beautifull, as no creature in the world may be compared with it: and the Scriptures themselves doe so greatly praise it. This very perfection of the bodie, which is as it were the perfection of all visible creatures, is the image of Gods perfection. . . . Moreover, the sound temperature thereof, by which it would have continued for ever without corruption, carieth the savour of Gods eternitie. The strength of the bodie, wherein it was created, did evidently beare shew of the power of the Creator." In his *De civitate Dei*, Augustine makes a perfect analogy between the mathematical proportions of Noah's ark and the human body. In the Gospel of John (2:13–21) the body is compared to a temple, and Paul in his epistles (1 Cor. 3:16–17) repeats the comparison.

11. Vitruvius, *The Ten Books on Architecture*, translated by Morris Hicky Morgan (New York: Dover, 1960), book 3, chap. 1, 72–73.

12. Johann Joachim Winckelmann, *History of Ancient Art*, 4 vols. in 2 (New York: F. Ungar, 1969), book 8, chap. 1.

13. John F. Pile, *Interior Design* (New York: Prentice-Hall, 1988), 58.

14. Verlaine, "Art poétique," in *Anthologie de la poésie française*, edited by André Gide (New York: Pantheon, 1949), 578. Translation by Daniel Albright.

15. William Wordsworth, *The Prelude, or Growth of a Poet's Mind*, edited by Ernest de Sélincourt (London: Oxford University Press, 1947), xv n. 2.

16. Alexander Pope, "The Dunciad," in *The Poems of Alexander Pope*, Twickenham text, edited by John Butt (New Haven: Yale University Press, 1963), 368.

17. Frank Kermode, *The Genesis of Secrecy* (Cambridge, Mass.: Harvard University Press, 1979), 64.

18. W. H. Auden, *The Dyer's Hand* (New York: Random House, 1962), 58.

19. Robert Frost, *Complete Poems*, vi.

20. Comparing Dante's terza rima account of the character of love to Aquinas's account in prose of the same thing, John Frederick Nims, in *A Local Habitation* (Ann Arbor: University of Michigan Press, 1985), says, after quoting from the first canto of the *Paradiso*, "Lines like Dante's make us realize how right Baudelaire was in saying 'prosodies are not arbitrarily invented tyrannies, but a collection of rules demanded by the very organization of the spiritual being, and never have prosodies and rhetorics kept originality from fully manifesting itself. The contrary, . . . that they have aided the flowering of originality, would be infinitely more true'" (75). One is led to think of those many contemporary poets who could not observe the most elementary laws of prosody to save their necks (I once taught a graduate seminar in poetry writing to a group of students who flatly refused to read Paul Fussell's *Poetic Meter and Poetic Form*), and to recall the old tradition of "neck verse." The law of benefit of clergy conferred the privilege of exemption from trial by secular courts, allowed to or claimed by clergymen arraigned for felony; in later times the privilege, in the case of certain offenses, might be pleaded on a first conviction by everyone who could read. The text traditionally used for "reading" was a Latin verse (usually the beginning of the Fifty-first Psalm), by the reading of which they might save their necks. If the analogous use of prosodic tests were required of poets today, a good deal of doubtful verse might be discouraged.

21. To Roger, Earl of Orrery; preface to *The Rural Ladies* (1664), in John Dryden,

Of Dramatic Poesy and Other Critical Essays, edited by George Watson (New York: Dutton, 1962), 1:8.

22. George Gordon, Lord Byron, "Don Juan," in *Byron's Poetry*, edited by Frank McConnell (New York: W. W. Norton, 1978), dedication, stanza 4, 184.

23. Johan Huizinga, *Homo Ludens* (Boston: Beacon Press, 1955), 8–13.

24. Joseph H. Summers, "The Masks of Twelfth Night," in *Shakespeare: Modern Essays in Criticism*, edited by Leonard Dean (New York: Oxford University Press, 1967), 142.

25. Thomas Hardy, "During Wind and Rain," in *Selected Poems of Thomas Hardy*, edited by John Crowe Ransom (New York: Collier, 1961), 68.

26. Ibid., xxvi.

27. "Sir Patrick Spens," in *The Norton Anthology of English Literature*, edited by M. H. Abrams et al., 4th ed. (New York: W. W. Norton, 1979), 1:396.

III. *Paradise and Wilderness*

1. George Herbert, "Sunday," in *The Works of George Herbert*, edited by F. E. Hutchinson (Oxford: Clarendon Press, 1941), 75.

2. Much of this garden lore is derived from Teresa McLean, *Medieval English Gardens* (New York: Viking, 1980).

3. John Prest, *The Garden of Eden: The Botanic Garden and the Re-creation of Paradise* (New Haven: Yale University Press, 1981), 24.

4. Ibid.

5. Sir Philip Sidney, "The Fourth Eclogues," in *The Poems of Sir Philip Sidney*, edited by William A. Ringler, Jr. (Oxford: Oxford University Press, 1962), 112, 113.

6. Michael Drayton, "To the Virginian Voyage," in *Poetry of the English Renaissance, 1509–1660*, edited by J. William Hebel and Hoyt H. Hudson (New York: Appleton-Century-Crofts, 1929), 296–97.

7. John Donne, "To His Mistress Going to Bed," in *The Elegies and the Songs and Sonnets*, edited by Helen Gardner (Oxford: Oxford University Press, 1965), 15.

8. Michel de Montaigne, "Of Cannibals," in *Essays*, translated by E. J. Trechmann (New York: Random House, 1946), 177–80.

9. Ibid., p. 177.

10. William Strachey, *True Repertory of the Wracke* (July 15, 1610), in "Strachey, Jourdain, and *The True Declaration*," appendix A to William Shakespeare, *The Tempest*, edited by Frank Kermode (Cambridge, Mass.: Harvard University Press, 1954), 137.

11. Sylvester Jourdain, *A Discovery of the Barmudas* (1610), in "Strachey, Jourdain, and *The True Declaration*," appendix A to Shakespeare, *The Tempest* (ed. Kermode), 141.

12. John Summerson, *Inigo Jones* (New York: Penguin, 1983), 21–22.

13. Bernard Knox, "*The Tempest* and the Ancient Comic Tradition," in *Word and Action* (Baltimore: Johns Hopkins University Press, 1979).

14. Andrew Marvell, "Bermudas," in *Andrew Marvell*, edited by Frank Kermode and Keith Walker (Oxford: Oxford University Press, 1990), 16–17.

15. "Fifty years after their marriage Whitehead wrote that his wife's vivid life had taught him 'that beauty, moral and aesthetic, is the aim of existence, and that kind-

ness, and love, and artistic satisfaction are among the modes of its attainment.'" Joseph
Gerard Brennan, "Alfred North Whitehead: Plato's Lost Dialogue," in *Masters: Por-
traits of Great Teachers*, edited by Joseph Epstein (New York: Basic Books, 1981), 61.

16. William Shakespeare, *The Tempest*, edited by Stephen Orgel (New York: Ox-
ford University Press, 1987), note on 1.2.350–61.

17. Shakespeare, *The Tempest* (ed. Kermode), note on 2.2.34.

18. Roger Shattuck, *The Forbidden Experiment: The Story of the Wild Boy of
Aveyron* (New York: Pocket Books, 1980). This account, from the beginning of the
nineteenth century, is not for that reason to be thought irrelevant to the character of
Caliban, or his relationship to Prospero. A late-medieval romance, *Valentin et Orson*,
presents a set of twins parted at infancy. Orson has been raised by a bear. "The bear
showed great affection for the child and suckled it for an entire year. Because of this
feeding, the child became as hairy as a wild beast and ate raw meat." Orson, the
"savage child, is vanquished by his already acculturated brother. He then acknowl-
edges an allegiance that casts Valentin in the role of lord: Orson 'reached out his hands
toward his brother Valentin, begging his pardon in sign language and indicating that
henceforth he wishes to obey and satisfy his brother's wishes. And he shows him by
signs that he shall never fail to respect his brother's person and property.'" Danielle
Régnier-Bohler, "Imagining the Self," in A *History of Private Life*, edited by Philippe
Ariès and Georges Duby, vol. 2, *Revelations of the Medieval World* (Cambridge,
Mass.: Harvard University Press, 1988), 342. If Valentin and Orson are brothers, Pros-
pero is a virtual father-surrogate to Caliban, and says of him, "This thing of darkness I
acknowledge mine" (5.1.275–76), as a confirmation of their linkage, and as a recogni-
tion of something within himself.

19. Shattuck, *The Forbidden Experiment*, 154–55.

20. Ibid., 146.

21. Perhaps this is not altogether mistaken, but I think mistaken nevertheless. This
is to say that I disagree with W. H. Auden, who, in an essay called "Balaam and His
Ass," in *The Dyer's Hand*, writes, "*The Tempest* seems to me a manichean work, not
because it shows the relation of Nature to Spirit as one of conflict and hostility, which
in fallen man it is, but because it puts the blame for this upon Nature, and makes the
Spirit innocent" (130).

22. Shakespeare, *The Tempest* (ed. Orgel), note on 4.1.148–58.

23. William Wordsworth, "Composed upon Westminster Bridge, September 3,
1802," in *Wordsworth: Representative Poems*, edited by Arthur Beatty (New York: Od-
yssey Press, 1937), 456.

24. Percy Bysshe Shelley, "Julian and Maddalo," in *The Complete Poetical Works of
Shelley*, edited by George E. Woodberry (Boston: Houghton Mifflin, 1901), 153, ll.
91–92.

IV. *Public and Private Art*

1. "It is the lowest style only of arts, whether of painting, poetry, or music, that may
be said, in the vulgar sense, to be naturally pleasing. The higher efforts of the arts, we
know by experience, do not affect minds wholly uncultivated." Sir Joshua Reynolds,
Discourse XIII, in *The Great Critics*, edited by James Harry Smith and Edd Winfield
Parks (New York: W. W. Norton, 1939), p. 486.

2. The long-standing mistrust between the Roman Catholic Church and the Masonic Order is something of a scandal of suspicion and misconception. As reported by Iver Peterson in the *New York Times*, June 6, 1993: "The Catholic Church's principal objection to its members becoming Freemasons is that the fraternity practices a 'natural religion' that lumps the Gospel with other philosophies and religions. . . . In 1985, the Roman Catholic bishops of the United States, alarmed by evidence of widespread Catholic membership in the Masons, restated more than 200 years of papal condemnation of Catholics becoming Masons. The National Conference of Catholic bishops said it took the action because many Catholics had apparently thought the church had softened its opposition." For their part, the Masons have been trying to divest themselves of their former secrecy, not least because their numbers have dwindled dangerously. They maintain that there are only two forbidden topics of discussion within the lodge: business and religion. They furthermore claim that the rituals, oath words, and insignia are not (as their enemies take them to be) sinister emblems of a cult (though drawn from many exotic and non-Christian sources; the Masonic flavor of *The Magic Flute* is unambiguously Egyptian), but only "ceremonial methods of recognition." Nevertheless, the Masons were deeply distressed when, in *War and Peace*, Tolstoy revealed their initiation rites.

3. Erwin Panofsky discusses the engraving at length in *The Life and Art of Albrecht Dürer*, 4th ed. (Princeton: Princeton University Press, 1971), 156–71. Frances Yates composes a chapter of vigorous dissent, "The Occult Philosophy and Melancholy: Dürer and Agrippa," in *The Occult Philosophy*, 49–59. Jay Levenson's brief comment, in Albrecht Dürer, *Dürer in America: His Graphic Work*, edited by Charles W. Talbot (New York: Macmillan, 1971), politely qualifies the views of these earlier commentators, adjudicating between their rival claims for the importance of the influence of Marsilio Ficino and of Cornelius Agrippa of Nettesheim.

4. Robert Frost, "Education by Poetry," a talk delivered at Amherst College and published in the *Amherst Graduates' Quarterly* (February 1931). Reprinted in *Selected Prose of Robert Frost*, edited by Hyde Cox and Edward Lathem (New York: Collier, 1968), 36.

5. Hoyt Hopewell Hudson, "The Folly of Erasmus," in Desiderius Erasmus, *The Praise of Folly*, edited and translated by Hoyt Hopewell Hudson (Princeton: Princeton University Press, 1969), xiii.

6. The news of actual combat during the Persian Gulf war was carefully sanitized for public consumption, as is the case in all modern wars (in which morale of both the troops and the home front is maintained by elaborate Madison Avenue public relations methods), so that only long after the events, if at all, does the truth come to light. In the *New York Times* of September 15, 1991, Eric Schmitt presented the following report, which had not been allowed to spoil the victory parade of General Norman Schwartzkopf by earlier release:

"United States Army forces buried alive scores of Iraqi soldiers in their trenches in the early hours of the allied ground attack that ended the Persian Gulf war, Army commanders said this week.

"The deaths took place during the operation in which American M1-A1 tanks of the First Infantry Division cut lanes through a 10-mile-wide stretch of barbed wire, minefields, bunkers and trenches north of the Iraqi–Saudi Arabian border on Feb. 24 as the allied offensive unfolded.

"Army officials said Iraqi soldiers who died remained in their trenches as plow-

equipped tanks dumped tons of earth and sand onto them, filling the trenches to insure that they could not be used as cover from which to fire on allied units that were poised to pour through the gaps.

"The Army said it knew the operation would kill Iraqis who did not surrender or otherwise get out of the way, but said the tactic spared the lives of American soldiers who would have had to leave the safety of their armored vehicles and fight Iraqi troops hand to hand in the trenches.

"'People somehow have the notion that burying guys alive is nastier than blowing them up with hand grenades or sticking them in the gut with bayonets,' said Col. Lon Maggart. 'Well it's not.'

"Colonel Maggart, commander of one of the two brigades that led the assaults on a key line of Iraqi defenses, said in a telephone interview from Fort Riley, Kan., that between 80 and 250 Iraqis had been buried alive."

7. Letter dated circa April 19, 1932, from Amherst, in *Selected Letters of Robert Frost*, edited by Lawrance Thompson (New York: Holt, Rinehart, and Winston, 1964), 385.

8. Matthew Prior ingeniously boasts of this poetic duplicity:

> The merchant, to secure his treasure,
> Conveys it in a borrow'd name;
> Euphelia serves to grace my measure;
> But Chloe is my real flame.

From "An Ode" (1718), in *Eighteenth-Century Poetry and Prose*, edited by Louis Bredvold, Alan McKillop, and Lois Whitney (New York: Ronald Press, 1956), 151.

9. Headnote to Robert Herrick's poems in *Norton Anthology of English Literature*, 4th ed., 1:1316. George Saintsbury, whose sense of prose rhythm sometimes deserted him, wrote, in an essay on the poetry of Herrick published in *A Saintsbury Miscellany* (New York: Oxford University Press, 1947), of the poet's terser verses, "These epigrams are made up for the most part of brief, excessively foul-mouthed, and for the most part very defectively witty lampoons on persons who are asserted by tradition or guesswork to have been, for the most part, parishioners of Dean Prior" (112).

10. Robert Herrick, "Upon Julia's Breasts," in *The Poetry of Robert Herrick*, edited by L. C. Martin (New York: Oxford University Press, 1965), 96.

11. Robert Herrick, "His Prayer to Ben Jonson," in ibid., 212.

12. Robert Graves, "Mother Goose's Lost Goslings," in *The Crowning Privilege* (New York: Doubleday, 1956), 148.

13. William and Ceil Baring-Gould, *The Annotated Mother Goose* (New York: New American Library, 1967), 62 n. 49.

14. The distinction between private and public poetry is not a new one, and the two flourished side by side among the troubadours of the twelfth century. They developed a mode of love poetry that, as regards its sentiments, was almost tediously regularized and inflexible. As Maurice Valency declares in *In Praise of Love: An Introduction to the Love-Poetry of the Renaissance* (New York: Farrar, Straus, and Giroux, 1975), "With disarming frankness, the troubadours divulge to the world the innermost secrets of the heart; but these secrets are always the same secret, the heart is the heart of nobody in particular. It is the heart of all the troubadours" (117). In search, therefore, of some means of novelty in so conventional a mode, two forms of poetry were devel-

oped, one called *trobar ric*, the other *trobar clus*. The former abided by the established and formulaic sentiments, but attempted to give them new interest by purely formal elaboration, ingenuity of rhyming pattern, elegance of diction. It endeavored to be a technical tour de force. As Valency remarks, "in a great deal of the troubadour poetry, as in most of the lyric poetry of the sixteenth century which was derived from it, the intellectual content of the poem—the substance—was really no more than the material vehicle in which the form of the poem was realized. . . . The matter was, or in the course of time became, conventional. It was the design, in sound, color, and poetic texture, that chiefly interested the poet" (123). By contrast, the *trobar clus*, as Valency describes it, "was a somewhat different style. Here the poet was concerned not with verbal music but with the effect of mystery. . . . The poem was not difficult to write; it is difficult to read. . . . the poet has erected an intellectual barrier between himself and his audience. Often enough, the words are clear. We simply cannot decide what they mean" (125). One of the Provençal poets, Giraut de Bornelh, whose excellence rivaled that of Arnaut Daniel, flatly declared in one of his songs, "My belief is that the best songs are never understood the first time. . . . to set my song better, I seek out and bring back as if by the bridle, beautiful words laden with strange and natural meaning, which not everyone can discover" (128–29). Such a view of poetry should recall the lines of Dante affixed as an epigraph to this lecture.

15. W. H. Auden, "Under Which Lyre," in *Nones* (New York: Random House, 1951), 64.

16. Robert Penn Warren, introduction to the collection of poems entitled *The Essential Melville* (New York: Ecco Press, 1987), 11–12.

17. W. H. Auden, "The Prolific and the Devourer," in *The English Auden*, edited by Edward Mendelson (New York: Random House, 1977), 396.

18. George Santayana, "On Self-Government," in *Dialogues in Limbo* (New York: Scribner's, 1948), 97–98.

19. *Of Poetry and Power*, edited by Erwin A. Glikes and Paul Schwaber (New York: Basic Books, 1964).

20. George Herbert, "Bitter-Sweet," in *Works of George Herbert*, 171.

21. Izaak Walton, *The Lives of Dr. John Donne, Sir Henry Wotton, Mr. Richard Hooker, Mr. George Herbert, and Mr. Robert Sanderson* (New York: Oxford University Press, 1927), 314.

22. Robert Frost, *In the Clearing* (New York: Holt, Rinehart, and Winston, 1962), 39.

23. Christopher Smart, "Jubilate Agno," in *Selected Poems*, edited by Karina Williamson and Marcus Walsh (New York: Penguin Books, 1990), 52–53.

24. Michel Foucault, *Madness and Civilization: A History of Insanity in the Age of Reason* (New York: Vintage, 1965), 68.

25. Anne Sexton, "Her Kind," in *To Bedlam and Part Way Back* (Boston: Houghton Mifflin, 1960), 21. Copyright renewed 1988 by Linda G. Sexton. Reprinted by permission of Houghton Mifflin Co. All rights reserved.

26. Quoted by John Dover Wilson in *Life in Shakespeare's England* (London: Penguin Books, 1949), 60–61.

27. Thomas Wyatt, *Collected Poems of Sir Thomas Wyatt*, edited by Kenneth Muir (Cambridge, Mass.: Harvard University Press, 1960), 7.

28. James Anthony Froude, *The History of England from the Fall of Wolsey to the Death of Elizabeth* (New York: Scribner's, 1866), 2:445.

29. Petrarch, "CXC: *Una candida cerva*," in *Sonnets and Songs*, translated by Anna Maria Armi (New York: Pantheon, 1946), 283.

V. *The Contrariety of Impulses*

1. Arthur Schopenhauer, *The World as Will and Idea*, translated by R. B. Haldane and J. Kemp, in *Philosophies of Art and Beauty: Selected Readings in Aesthetics from Plato to Heidegger*, edited by Albert Hofstadter and Richard Kuhns (New York: Random House, 1964), book 3, sec. 43.

2. Robert Venturi, *Complexity and Contradiction in Architecture* (New York: Museum of Modern Art, 1977), 16.

3. I. A. Richards, "The Poetic Experience," in *Science and Poetry*, quoted in *Modern Literary Criticism*, edited by Lawrence Lipking and A. Walton Litz (New York: Atheneum, 1972), 152.

4. I. A. Richards, *Principles of Literary Criticism* (New York: Harcourt, Brace, 1950), 109–13.

5. Conrad Aiken, *Collected Criticism* (New York: Oxford University Press, 1968), 76.

6. Samuel Taylor Coleridge, *Biographia Literaria* (Oxford: Oxford University Press, 1907), 2:12. It was only after having composed and delivered this lecture that it struck me that what I was saying here must bear some resemblance to a thesis enunciated by Cleanth Brooks in *The Well Wrought Urn* (New York: Harcourt, Brace, and World, 1947), which I had not read for many years, though I had of course admired it. A rereading of the first chapter, "The Language of Paradox," revealed that Brooks had cited this very passage of Coleridge. It is possible, of course, that his insights lingered unattributed in my unconscious. But a careful reader will, I venture to think, find that Brooks and I are advancing ideas that, while similar, are not identical.

7. W. B. Yeats, *The Poems of William Butler Yeats*, edited by Richard J. Finneran (New York: Macmillan, 1983), 160–62.

8. W. H. Auden, *New Year Letter* (London: Faber and Faber, 1941), note on line 829.

9. Robert Frost, preface to *A Way Out*, in *Selected Prose of Robert Frost*, 13. Frost and Eliot were not much disposed to agree on anything, but on this matter they seem to have seen eye to eye. In his "Dialogue on Dramatic Poetry" in *Selected Essays*, Eliot has one of his speakers say: "what great poetry is not dramatic? Even the minor writers of the Greek Anthology, even Martial, are dramatic. Who is more dramatic than Homer or Dante? We are human beings, and in what are we more interested than in human action and human attitudes? Even when he assaults, and with supreme mastery, the divine mystery, does not Dante engage us in the question of the human attitude towards this mystery—which is dramatic?" (38).

10. T. S. Eliot, "The Social Function of Poetry," in *On Poets and Poetry* (New York: Farrar, Straus, and Giroux, 1979), 6.

11. W. H. Auden, *A Certain World* (New York: Viking, 1970), 87.

12. T. S. Eliot, "The Perfect Critic," in *The Sacred Wood* (London: Methuen, 1920), 15.

13. "Poetry is in its essence an act of reflection, of refusing to be content with the

interjections of immediate emotion in order to understand the nature of what is felt."
W. H. Auden, "Notes on Music and Opera," in *Dyer's Hand*, 472.

14. Edgar Wind, "The Medal of Pico della Mirandola," in *Pagan Mysteries in the Renaissance* (London: Penguin Books, 1958), 49.

15. Michel de Montaigne, "Of the Education of Boys," in *Essays*, 138.

16. Wind, *Pagan Mysteries in the Renaissance*, 49 n. 51.

17. Cornelius Agrippa, *De occulta philosophia*, quoted in Yates, *The Occult Philosophy*, 53.

18. I am compositely indebted for this learned lore to Frances Yates, Erwin Panofsky, Jay Levenson, and Edgar Wind.

19. Plato, *Symposium*, in *The Dialogues of Plato*, translated by Benjamin Jowett (New York: Random House, 1937), 1:345.

20. Joseph H. Summers, *Dreams of Love and Power: On Shakespeare's Plays* (Oxford: Oxford University Press, 1984), 5.

21. Randall Jarrell, introduction to William Carlos Williams, *The Selected Poems of William Carlos Williams* (New York: New Directions, 1969), ix.

22. William Carlos Williams, "Tract," in *Selected Poems of William Carlos Williams*, 12.

23. Johan Huizinga, *The Waning of the Middle Ages* (New York: Doubleday, 1954), 53.

24. "A poem is a rite; hence its formal and ritualistic character. Its use of language is deliberately and ostentatiously different from talk. Even when it employs the diction and rhythms of conversation, it employs them as a deliberate informality, presupposing the norm with which they are intended to contrast. The form of a rite must be beautiful, exhibiting, for example, balance, closure and aptness to that which it is the form of." W. H. Auden, "Making, Knowing, and Judging," in *The Dyer's Hand*, 58.

25. W. B. Yeats, "Adam's Curse," in *Poems of William Butler Yeats*, 80.

26. *The Norton Anthology of Modern Poetry*, edited by Richard Ellmann and Robert O'Clair (New York: W. W. Norton, 1973), 121 n. 5.

27. Ibid., 121 n. 6.

28. W. B. Yeats, "A Prayer for My Daughter," in *Poems of William Butler Yeats*, 188–90.

29. Huizinga, *The Waning of the Middle Ages*, 110–12.

VI. *Art and Morality*

1. E. H. Gombrich, *The Story of Art* (New York: Phaidon, 1966), 306.

2. Giorgio Vasari, *Lives of the Painters*, edited by Betty Burroughs (New York: Simon and Schuster, 1962), 276.

3. Rudolf and Margot Wittkower, *Born under Saturn* (New York: W. W. Norton, 1963), 177.

4. Kenneth Clark, *The Nude* (New York: Doubleday, 1959), 178–81.

5. W. B. Yeats, "Nineteen Hundred and Nineteen," in *Poems of W. B. Yeats*, 206.

6. Anne Hollander, *Seeing through Clothes* (New York: Avon, 1980), 178.

7. John Canaday, in the *Smithsonian Magazine* (September 1983), writes: "the model, obviously posed in a studio, is only perfunctorily united with the woodsy land-

scape behind her. (Manet, as usual, was lost out-of-doors, although he never went as far as his friend, Degas, who claimed that fresh air didn't agree with him)" (98).

8. E. H. Gombrich, *Art and Illusion* (Princeton: Princeton University Press, 1961), 322–23.

9. Wayne Andersen, *My Self* (Geneva, Switzerland: Fabriart, 1990), 432–33.

10. Noel Annan, *Our Age* (New York: Random House, 1990), 130.

11. Quoted from a review by Jonathan Yardley in the *Washington Post World* of *Girls Lean Back Everywhere: The Law of Obscenity and the Assault on Genius*, by Edward de Grazia (New York: Random House, 1992).

12. T. S. Eliot, *The Use of Poetry and the Use of Criticism* (Cambridge, Mass.: Harvard University Press, 1964), 82–83.

13. W. H. Auden, in *Partisan Review* (May 1949): 513.

14. Wendell Stacy Johnson, *W. H. Auden* (New York: Continuum, 1990), 156 n. 11.

15. John Ashbery, in *Oxford Poetry* 6, no. 2 (Winter/Spring 1992): 61.

16. Quoted in the *New York Times Book Review* from a review of *The Flight from Truth* by Jean-François Revel (New York: Random House, 1991).

17. Who today would remember the pugilist Diagoras of Rhodes but for the mention of his name in Pindar's "Seventh Olympian Ode"?

18. There is another way, according to Mr. Frohnmayer, of calibrating the value placed on the arts by Congress. He noted in the *New York Times*, "Military bands receive more money from Congress than the entire budget of the Arts Endowment."

19. *Times Literary Supplement* (London), May 22, 1992, 3.

20. Ibid., 7.

21. *Washingtonn Post*, March 1, 1992, Show Section. "Wild Thing" by Ramona Lofton ("Sapphire") appeared in the "Queer City" issue of *The Portable Lower East Side*, a journal that publishes work of gay, Latino, Asian, and African-American writers.

22. Ibid. One of the minor indignities that the arts must suffer in our country is that, on those few occasions that they become newsworthy, they are usually covered by writers who are artistically illiterate. And this is not something that greatly troubles the writers or the papers for which they work. The article using the term "long-form poem" appeared under a byline.

23. Quoted in Scott Donaldson, *Archibald MacLeish: An American Life* (Boston: Houghton Mifflin, 1992), 275.

24. A few passages from the poem, "Wild Thing," may convey some idea of its quality.

> And I'm running
> running wild
> running free,
> like soldiers down
> the beach
> like someone
> just threw me
> the ball.

My thighs pump
thru the air
like tires
rolling down
the highway
big and round
eating up the ground
of America
but I never been any
further than 42nd St.
Below that is as
unfamiliar as my
father's face.

.

My sneakers glide off
the cement like
white dreams
looking out at the world
thru a cage of cabbage
and my mother's fat,
hollering don't do this
don't do that

.

Her welfare check buys me $85
sneakers
but can't buy me a father.
She makes cornbread from Jiffy
box mix
buys me a new coat
$400
leather like everybody else's
I wear the best man!
14 Karat gold chain
I take off
before I go
wildin'.

25. William Blake, *Letters*, edited by Geoffrey Keynes (New York: Macmillan, 1956), 79.

26. "Community standards" vary from place to place as well as with the passage of time. In Pliny's *Natural History* it is reported that a nude Venus by Praxiteles was rejected by the islanders of Cos, but eagerly purchased by those of Cnidos. Most modern viewers, beholding Titian's *Sacred and Profane Love* for the first time, are inclined to be surprised at learning that it is the unclad figure who represents Sacred Love, and the fully clothed one who symbolizes Profane Love. But this would have consorted perfectly with the views of the Renaissance humanists, to whom the idea of

"the naked truth" was a supreme value. Shakespeare's Lear has some penetrating things to say about the superfluity as well as the hypocrisy that clothing represents: "Is man no more than this? Consider him well. Thou ow'st the worm no silk, the beast no hide, the sheep no wool, the cat no perfume. Ha! here's three on's are sophisticated. Thou art the thing itself; unaccommodated man is no more but such a poor, bare, forked animal as thou art. Off, off, you lendings! Come, unbutton here" (3.4.103–11). There was thought to be candor in nakedness and, by biblical imputation, a suggestion of the innocence that Adam and Eve enjoyed before the Fall, still to be seen in infants and little children. For some Renaissance painters it represented a contempt for the world, its riches, vanities, and all symbols of earthly transience. Richard Lovelace celebrates the unclad innocence of the Golden Age in a poem called "Love Made in the First Age," which includes the lines "Naked as their own innocence, / And unimbroyder'd from Offence / They went, above poor Riches, gay." In *The Poems of Richard Lovelace*, edited by C. H. Wilkinson (Oxford: Oxford University Press, 1930), 147.

27. As an instance of hilarious prudishness and bowdlerization, I joyfully direct the reader to the following item from an Irish newspaper of 1793, brought to my attention by a colleague of mine at Georgetown University, Raymond Reno.

THEATRE ROYAL, KILKENNY, IRELAND (Irish Players) On Saturday, May 4, will be performed by command of several respectable people in the learned metropolis, for the benefit of Mr. Kearns, the tragedy of HAMLET, originally written and composed by the celebrated DAN HAYES of LIMERICK, and inserted in Shakespeare's works. HAMLET by Mr. Kearns, (being his first appearance in that character), who, between the acts, will perform several solos on the potent bag-pipes, which play two tunes at the same time. OPHELIA by Mrs. Prior, who will introduce several familiar airs in character, particularly THE LASS OF RICHMOND HILL and WE'LL ALL BE HAPPY TOGETHER from Rev. Mr. Dibdin's ODDITIES. The parts of the KING and QUEEN, by direction of the Rev. Mr. O'Callagan, will be omitted, as too immoral for any stage. POLONIUS, the comical politician, by a Young Gentleman, being his first appearance in public. THE GHOST, THE GRAVEDIGGER and LAERTES, by Mr. Sampson, the great London comedian. The characters will be dressed in Roman Shapes.

To which will be added an interlude of sleight of hand tricks, by the celebrated surveyor, Mr. Hunt. The whole to conclude with a farce, MAHOMET THE IMPOSTER, Mahomet by Mr. Kearns.

Tickets to be had of Mr. Kearns at the sign of the Goat's Beard, in Castle Street. The value of the tickets to be taken (if required) in candles, butter, cheese, soap, etc. as Mr. Kearns wishes in every particular to accommodate the public. No person will be admitted to the boxes without shoes or stockings.

28. In a review of *Olympia: Paris in the Age of Manet*, by Otto Friedrich (New York: HarperCollins, 1992), in the *New York Times Book Review* of March 22, 1992, the reviewer, Nicholas Fox Weber, wrote: "Manet's problems had begun in 1863 with his 'Déjeuner sur L'Herbe.' Instead of depicting a group of naked gods and goddesses, which would have been acceptable, that canvas showed a nude woman next to, according to one contemporary account, 'two dandies dressed to the teeth' who 'look like

schoolboys on a holiday.' The effect of those companions was to transform the woman from a proper allegorical subject into a harlot."

29. Marianne Moore, "In Distrust of Merits," in *Collected Poems of Marianne Moore* (New York: Macmillan, 1944), 14. Copyright renewed 1972 by Marianne Moore. Reprinted with permission of Simon & Schuster.

30. At the time this lecture was delivered—November 15, 1992—I was able to use as an illustration a black-and-white image of the severely lacerated *Rokeby Venus*, projected upon the huge screen of the auditorium of the East Wing of the National Gallery in Washington. The effect was deeply shocking. Between that time and the publication of this book, the National Gallery of Art, London, which now owns the Velasquez, has altered its policy and no longer permits the reproduction of that work in its vandalized condition.

31. Lest a well-merited obscurity shield from the reader this particular vice president, let me reveal that it is Dan Quayle.

32. W. B. Yeats, "The Fisherman," in *Poems of W. B. Yeats*, 148–49.

LIST OF ILLUSTRATIONS

INDEX

THE ANDREW W. MELLON LECTURES IN THE FINE ARTS

DELIVERED AT THE NATIONAL GALLERY OF ART,

WASHINGTON, D.C.

The Andrew W. Mellon Lectures in the Fine Arts